The Confused Photographer's Guide to On-Camera Spotmetering

Bahman Farzad

CONFUSED PHOTOGRAPHER'S GUIDE
CPG
BOOKS

Third edition.

Library of Congress Catalog Card Number: 97-094505

ISBN: 0-9660817-0-6

Published by:

Confused Photographer's Guide Books,

P.O. Box 660014, Birmingham

AL 35266

(205) 879-4931

Printed and bound in the United States of America

Cover design by Bahman Farzad

Edited by Linda Voychehovski and Ron Smith

Design and production by Bahman Farzad

Nikon™, Canon™, Pentax™, Minolta™, Kodak™, Fuji™,
Agfa™, Ilford™, Sony™, and other brand names are trademarks
of their respective companies.

1 2 3 4 5 6 7 8 9 10

To my family

There are two types of photographers:
Those who *take* what their camera gives them and
those who *make* what their camera gives them.
What separates the two is *skill*!

Acknowledgments:

I am thankful to Linda Voychehovski for editing the book, Ron Smith for his repeated reviews and corrections and my daughter Parastoo for the book's final revision. I would like to thank all people at Digital Prepress Services of Birmingham for their help, direction and suggestions in publishing this book.

I am also thankful to my students as well as the local camera stores who let me borrow their cameras for evaluation (Appendix C.)

I would like to dedicate this book to many people. These include:

❑ My students whose lack of understanding of exposure provided me the fuel and the energy to go on.

❑ My uncle who gave me my first camera at the age of eight.

❑ My parents who always encouraged me and paid for my expensive hobby of photography as I was growing up in the Southern parts of Iran in the 1950s and the early 1960s.

❑ My family, without whose love, support, and patience, the writing of this book would not have been possible.

Finally, in the mid 1970s, when I was lost in the jungle of exposure disinformation, a small booklet by Glen Fishback helped me to understand the concept of seeing and interpreting light. It gave me confidence, built my skills, and changed my vision forever. I hope this book does the same for you.

Bahman Farzad
November 1, 2004
Birmingham
Alabama

What is covered in this book?

TABLE OF CONTENTS

Cheat Sheet:

Introduction:

Chapter 1:

Chapter 2:

Chapter 3:

Appendix A:
Image Detail

Appendix B:
Digital Photography

A brief review of Spotmetering and Digital Photography: With a special reference to Nikon CoolPix 990. The review is intended for those photographers using a *Manual* Digital Camera with spotmetering and are familiar with the basics of digital photography.

Appendix C:
Cheat Sheets for Film and Digital cameras

Canon EOS 10D Digital Slr, Canon EOS 20D Digital Slr, Canon EOS 3, Canon EOS A2/A2E, Canon EOS Elan 2E, Canon EOS Elan 7E, Canon EOS Rebel 2000, Canon EOS Rebel Ti/300V, Canon PowerShot G3 Digital, Canon PowerShot G5 Digital, Minolta Maxxum 5, Minolta Maxxum 7, Minolta Maxxum 9, Minolta Maxxum StSi, Nikon CoolPix 990 Digital, Nikon CoolPix 995 Digital, Nikon CoolPix 4500 Digital, Nikon CoolPix 5700 Digital, Nikon Coolpix 5000 Digital, Nikon Coolpix 8700 Digital, Nikon D70 Digital Slr, Nikon F4, Nikon F5, Nikon F100, Nikon N50, Nikon N55, Nikon N60, Nikon N6006, Nikon N65, Nikon N70, Nikon N75, Nikon N80, Nikon N8008s, Nikon N90/N90s, Pentax *ist, Pentax *ist-D Digital SLR, Pentax 645N Medium Format, Pentax MZ-S, Pentax PZ-1P, Pentax ZX-5N, and Sony DSC-F717 Digital.

Appendix D:
Average Metering, Partial Metering, and Spotmetering

References
Index

The entire book condensed on to one page!

This is a self test:
Please read the next two pages. If you understand everything about the technique, don't waste your money. Otherwise welcome to the creative world of spotmetering!

If you do not want to read this book, simply read the next page:

The on-camera spotmeter is the most powerful exposure tool in the world. Read the following page and decide for yourself if you understand the concept. If you do understand everything on the next page, you can apply the technique described, and produce correctly exposed images, then that is the only page you need to read! If, however, you even have the slightest doubt about this technique, or if you are still the least bit confused, this book is for you.

Remember: either you know how to use your on-camera spotmeter effectively or you don't. There is no in-between! I believe this is the simplest, easiest, best illustrated, and most practical book about on-camera spotmetering in the world. Good luck with creating your own beautiful and correctly exposed images.

Cheat sheet

The entire book condensed onto one page

Put a roll of 100 ISO film in your camera and choose an outdoor subject. Activate the Spotmetering/Partial Metering option on your camera and set your camera's mode to manual and the shutter speed to 1/125 sec. To avoid confusion, in this book we will increase and decrease the exposure by opening-up and closing-down the aperture. The *shutter speed* will remain *fixed*.

Observe your subject and break it down into its simple subject (single tone) components. Choose a Reference Tone. A Reference Tone is usually chosen from the most important part of the subject. Once you have selected the Reference Tone, point your spotmeter at this tone and find its normal exposure. If your subject does not have a distinct single tone and you are using slide film, pick out a tone that is medium gray or brighter. If you are using a negative film, pick out a tone that is medium gray or darker.

Let's assume the "normal exposure" indicated by your camera for this Reference Tone is 125@f-8 (i.e., 1/125 sec. at an aperture setting of 8). As you know, the spotmeter's "normal exposure" from any simple (single toned) surface will always provide the photographer with an 18% gray image tone. The image tone that your normal exposure provides is independent of the original tone of your subject. In spotmetering, converting the "normal exposure" to the "correct exposure" is what a photographer must do. In other words, the "normal exposure" readings of the spotmeter must be interpreted by the photographer to determine the subject's "correct exposure." The principle behind this simplified technique is that *if one tone of a complex subject is exposed correctly, the rest of the tones follow and will also be correctly exposed* . Now decide which one of the following tones would most closely matches your Reference Tone: Black, Dark Gray, Medium Gray, Light Gray or White. With this simplified technique you must choose one of these five tones. Once you have decided which one of these five tones best matches your Reference Tone, then adjust your camera settings accordingly:

❏ If you chose Black, you need to let in less light by two stops. Closing- down the aperture by two stops darkens the 18% gray image tone to **Black**. The correct exposure is now 125@f-16.

❏ If you chose Dark Gray, you need to let in less light by one stop. Closing- down the aperture by one stop darkens the 18% gray image tone to **Dark gray**. The correct exposure is now 125@f-11.

❏ If you chose Medium Gray, leave the aperture and shutter speed as they are since the meter is already creating an 18% gray (**Medium Gray**) image tone, i.e., the tone of the image matches the approximate tone of the Reference Tone. Also remember that when metering from a medium gray surface, the "normal exposure" and "correct exposure" settings are approximately the same.

❏ If you chose Light Gray, you need to let in more light by one stop. Opening-up the aperture by one stop lightens the 18% gray image tone to **Light Gray**. This results in a correct exposure of 125@f-5.6.

❏ If you chose White, you need to you need to let in more light by two stops. Opening-up the aperture by two stops lightens the 18% gray image tone to **White**. The correct exposure is now 125@f-4.

GALLERY

Why spotmetering?

Introduction:

Why spotmetering?

Exposure, by definition, is the determination of the amount of light to reach the film in order to produce a correct image. In other words, to have a correctly exposed image we have to have the exact amount of light entering the camera in order to register the correct image on film. Remember that light is the most important element of any photograph. Without it we have nothing. With too much of it you have an overexposed and washed-out image. With too little of it you have a dark and underexposed image. In neither case can we have an image that would truly represent the subject. Now let us try a simple experiment. *Step outside, and point three different brands of cameras at the same scene*. It is possible that the three cameras show exactly the same exposure. It is also possible that you will get three different exposures. Another possibility is that two of them show the same exposure and the other shows a different exposure. ***In none of these cases can one be totally sure which of (if any) the cameras is indicating the correct exposure.***

"Meter over mind" scenario

Most cameras use some type of logic circuit to determine a subject's exposure. Each of these designs is good at capturing certain types of images. Considering that we live in a mass-produced world, no one can come up with a metering pattern that fits your exact subject every time. Since this is a book about spotmetering, I will not bother you with different patterns, complex math, and their confusing details. The bottom line is that with all of these metering systems, ***it is the meter that determines the final exposure and not the unskilled photographer***.

"Mind over meter" scenario

A spotmeter is a very narrow angled meter capable of giving an exact exposure from a simple subject. Examples of simple subjects are a piece of white paper, a uniformly lit wall, snow, or a portion of the blue sky. Usually this exact exposure is changed at the discretion of the skilled photographer before the picture is taken; the photographer manually overrides the meter's reading to create his or her own exposure to create the desired image. This is the **"mind over meter"** scenario. Spotmetering, unlike broad-angel metering contained on many cameras, will always provide you with a consistent exposure. This consistency will give the skilled photographer the starting point, or the base that he or she needs to create the desired image. To understand how our on-camera spotmeter functions, we must educate ourselves with camera basics and general exposure.

In the following sections, I have tried to explain all I can to build this foundation for you. Since some of the elements are interrelated, you may have to read this section more than once to grasp the concept. As simple as spotmetering is, you have to understand its foundations before you can apply it effectively. Miss one link in this chain and you will be scratching your head for a while. If you do not understand a section, chances are that you have missed something in the previous sections.

Glossary and explanation of terms

What will you learn in this chapter?
In this chapter we will explain the foundations of the camera and of exposure. We will discuss such terms as incident light, reflected light, simple and complex subjects, the 18% gray card, the camera, the built-in spotmeter, and exposure consistency.

1.1 Incident and Reflected Light

The light we get from the sun or any other light source is called incident light. It is the light that strikes, or falls upon, a subject. Light that bounces off a surface is called reflected or reflective light. In spotmetering, we use this reflective property to find the proper exposure of a subject.

In our world, what enables us to see is the reflectivity of subjects or surfaces. Without this property, even with all the light that surrounds us, we would be living in total darkness. If you do not believe this, just look at the sky on a clear, moonless night. There is as much sunlight above as there is on a clear day. However, unlike earth, outer space has no reflective particles such as air, pollution, dust, or water vapor. Therefore, we cannot see the sunlit space in the same manner that we can see our blue sky.

The reflectivity of a subject is measured in percentages. A highly reflective material such as white paint, white paper, or white cloth reflects more than 70% of the light. Consequently, white or lightly colored (toned) clothing keeps us cool in the summer. Materials with low reflectivity, such as black velvet or dull black paint, reflect less than 4% of the light. The light that is *not reflected* by the surface will help to heat up the black or dark subject. This is the main reason people wear dark clothing in the winter.

If you are one of the people who is frightened by the term "percentages," you do not need to be. Here is an example that I am sure you will understand. Assume you deposit $100 in your savings account. Also assume that the bank pays a yearly interest of 5% on saving accounts. This means you collect $5 (5% of $100 is $5) interest at the end of every year from the bank. If the bank pays an annual interest of 18% (I wish!) on your $100, then your annual income would be $18 (18% of $100 is $18). The interest you collect at the end of the year is very much like the light that is reflected from the surface. Your original $100 is the equivalent of 100 rays of light that fall on a surface. A 5% reflective surface will only reflect 5 of them, and an 18% reflective surface will reflect 18.

Another example is to throw 100 balls from a tall building on a hard pavement. Since most of the balls would bounce back, the hard pavement represents a white surface with a high degree of reflectivity. Now let's throw the same number of balls on a pavement covered with thick, hot, sticky tar. Chances are most of the balls will stick to the pavement and would not bounce. The pavement with hot sticky tar represents a black surface that absorbs most of the incident light and reflects very little of it.

Section 1.1 Summary:

The incident light is a light that falls on a subject. A reflective (or reflected) light is a light that is reflected (bounced back) from a surface. Brighter subjects reflect most of the incident light and absorb very little of it. Darker subjects absorb most of the light and reflect very little of it.

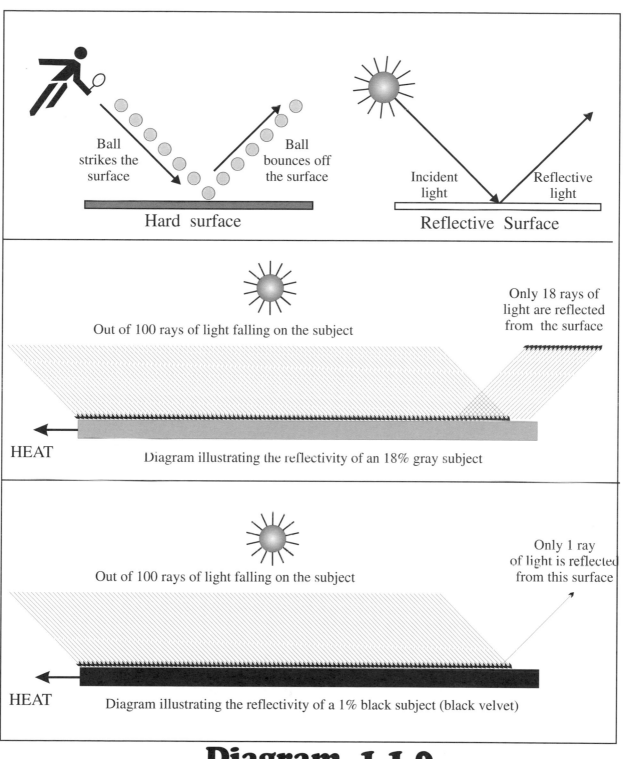

Ball strikes the surface

Ball bounces off the surface

Hard surface

Incident light

Reflective light

Reflective Surface

Out of 100 rays of light falling on the subject

Only 18 rays of light are reflected from the surface

HEAT

Diagram illustrating the reflectivity of an 18% gray subject

Out of 100 rays of light falling on the subject

Only 1 ray of light is reflected from this surface

HEAT

Diagram illustrating the reflectivity of a 1% black subject (black velvet)

Diagram 1.1.0

Diagram illustrating incident and reflected light for different tones.

1.2 What do we mean by a tone?

As far as we are concerned, the tone or density of the subject is its degree of grayness. To photograph a subject, you point your camera at it and press the shutter release button. When you do this, you are converting your **subject tones** to their corresponding **image tones**. Subject tones are the tone density of what you see and image tones are the density of what is captured on your film. Please look at the opposite page's illustration. Make sure that you understand the relationship between colors and their gray tones.

1.2.1 A subject Tone

A subject tone can be defined as the subject's degree of grayness. If the subject has color, imagine taking away its color; what remains is its tone. Absence of any tone makes a subject bright (light gray/white). The presence of a tone makes it dark (dark gray/black). A white wall or a white piece of paper (lightly shaded) has almost no tone, whereas black velvet has a dense (heavily shaded) tone. That is why it looks black. If you choose a colored subject like the blue sky, simply take away its color and imagine it in black and white. The tone of a blue sky at times could approximate what we call a medium gray, i.e., it is neither black nor white. In this simplified book, we have five major categories for a tone. The tone is either black, dark gray, medium gray, light gray or white. I define gray, black, or white surfaces as subjects that have only gray density (no color). Any colorful subject can be considered as painted gray tones. If you wonder what the "gray tone" of a colored subject looks like, take away its color and imagine the subject in black and white.

Exercise: Pick out ten different colored subjects around you and guess their tones. If you have a hard time deciding, try to place each one of them in the following five categories: Black, dark gray, medium gray, light gray and white.

1.2.2 An image tone

An image tone is defined as the tone on the slide film or negative film that corresponds to the tone of the subject. Subject tones and image tones for slide film are illustrated in diagram 1.2.1.

1.2.3 The image detail

In many photographs, the image tone and image detail (degree of image clarity for bright and/or dark tones) for a textured (non-smooth) go hand-in-hand. Since in this book we will be more involved with the process of tone reproduction, to keep things simple, the concept of image detail for textured subjects and its relationship with the image tone has been covered separately in Appendix A.

Section 1.2 Summary:

The tone is the gray density of a subject. If a subject is colored, to determine its tone, simply take away its color. A light red surface has a tone of light gray. A dark green surface has a tone of dark gray and so on.

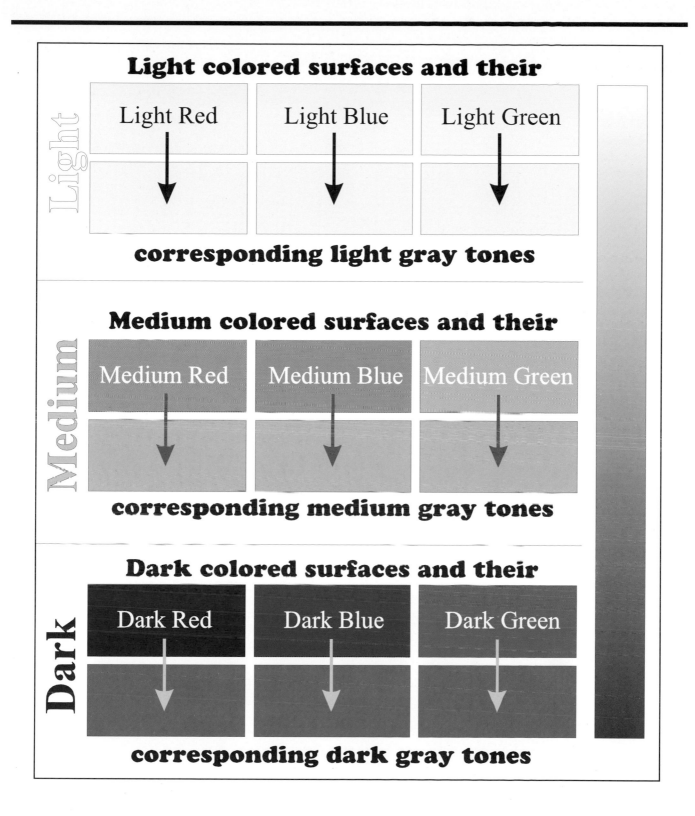

Light colored surfaces and their

Light Red

Light Blue

Light Green

corresponding light gray tones

Medium colored surfaces and their

Medium Red

Medium Blue

Medium Green

corresponding medium gray tones

Dark colored surfaces and their

Dark Red

Dark Blue

Dark Green

corresponding dark gray tones

Light

Medium

Dark

Color versus Tone illustration

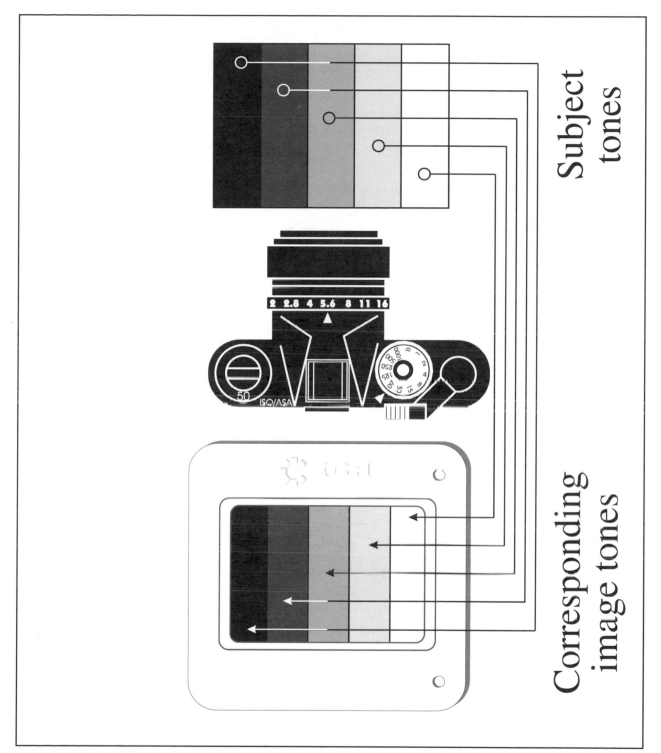

Diagram 1.2.1

Diagram illustrating Subject Tones and their corresponding Image Tones as are captured on slide film.

1.3 The Standard 18% Gray Card

Let's assume you want to measure the width of a house in yards. To do this, you can use a yardstick and obtain an approximate measure. In this process, a yard is the unit of our measurement. Since in photography we will be reproducing tones, we must have some type of standard for comparing and measuring tones. The most widely accepted standard in exposure determination and tone reproduction is called the 18% gray tone. You can purchase a gray card with an 18% gray tone from your local camera store.

What 18% reflectivity means is that if 100 rays of light hit the card's surface, only 18 of them will reflect and the rest (other 82) will heat up the gray card!

Where this magic 18% number comes from, no one knows for sure. Why it is 18% and not another number is anybody's guess. In the literature of 1950s and 1960s, the 18% number has been loosely associated with the average reflectivity of the planet earth as well as the reflectivity of an average subject, none of which should concern you.

What we must care about is that the 18% gray tone falls exactly in the middle of our black and white tones.

Section 1.3 Summary:

The 18% gray (***Middle Gray***) card has been around for decades. The two most important features of this ***tone*** that should concern you and your exposures are:

1) It is the unofficial standard for many light metering devices.

2) In this book it is the ***middle*** of our ***black*** and ***white*** tones.

Both of these issues will be extensively covered in this book.

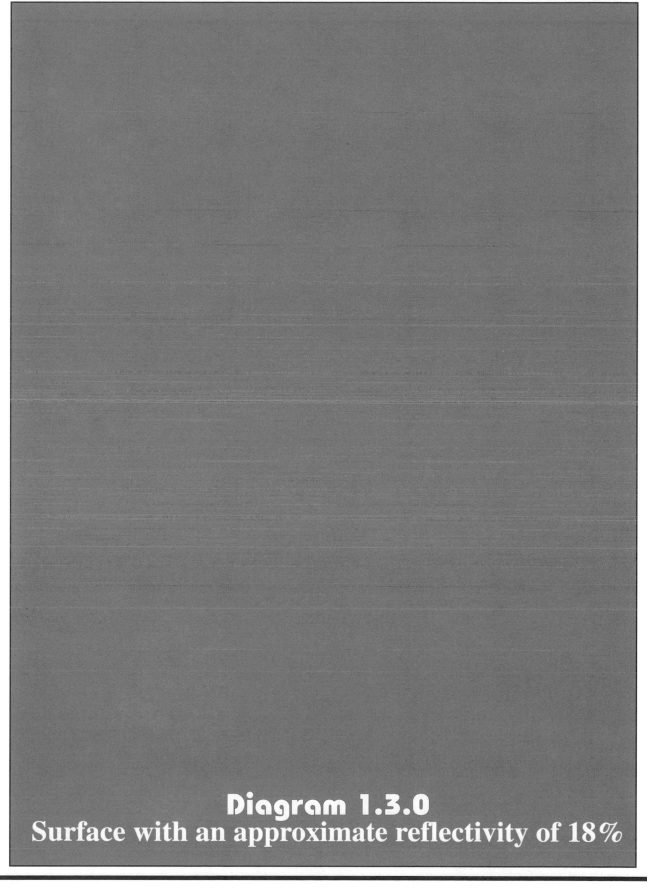

Diagram 1.3.0
Surface with an approximate reflectivity of 18%

1.4 Adding white paint to black to create different shades of gray

Assume that you have a bucket of black paint and many buckets of white paint.

If we add one bucket of white paint to the bucket of black paint, we can watch its tone become a lighter shade of gray. If we keep on adding white paint, eventually we will get paint that looks almost white.

This illustration, as crude and non-scientific as it sounds, gets the point across. The point is that by adding more and more white paint to black, we can create lighter shades of gray. By the same token, if we could gradually take away the white paint that we added, we will end up with the original black paint.

In photography, we can use the same technique to create different image tones (shades of gray).

With paint, we started with black and then added white to get different shades of gray. In photography, we start with a gray image tone and by adding light (white) we can create lighter image tones (shades of gray), the extreme of which would be white.

Conversely by taking away light (white) from a gray image tone, we end up with darker image tones (shades of gray), the extreme of which would be black.

As simple as it sounds, please take time to review this. The process of adding or subtracting light to control photographic image tone is the key element of spotmetering.

Section 1.4 Summary:

In photography, all shades of gray can be created by adding or subtracting white from a medium gray tone. This very important property is the foundation of spotmetering, and we will be dealing with it throughout this book.

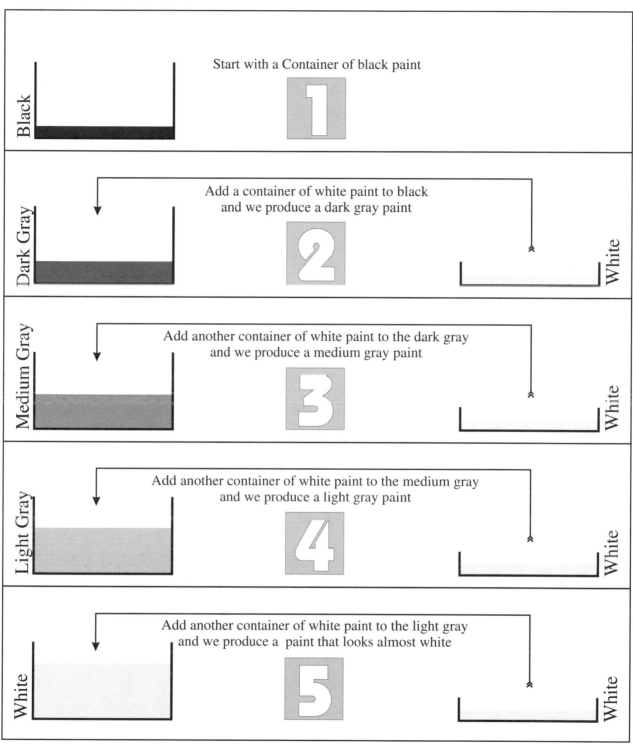

Black

Start with a Container of black paint

1

Dark Gray

Add a container of white paint to black
and we produce a dark gray paint

2

White

Medium Gray

Add another container of white paint to the dark gray
and we produce a medium gray paint

3

White

Light Gray

Add another container of white paint to the medium gray
and we produce a light gray paint

4

White

White

Add another container of white paint to the light gray
and we produce a paint that looks almost white

5

White

Diagram 1.4.0

By adding white paint to black, we can create different shades

In this example, we start with a container of black paint and in each step we add a container of white paint to the original black paint bucket.

As crude as this experiment seems, by adding white paint to black in each step, we create a brighter tone (shade) of gray.

1.5 Simple and Complex subjects

In this book we will be discussing two types of subjects: a simple subject and a complex subject.

1.5.1 A simple subject

By definition, a simple subject is an evenly lit subject that has only one tone. A white wall, portions of the blue sky, snow, a forehead, an 18% gray card, and a piece of black velvet are examples of a simple subject.

1.5.2 A complex subject

By definition, a complex subject is a subject that has *more than one tone*. To see an example of a complex subject, simply look around!

1.5.3 How do simple and complex subjects relate to one another?

By definition, every complex subject is made up of two or more simple subjects. By the same logic, every complex subject can be divided into two or more simple subjects.

Later on, this very important property will enable us to break down a complex subject into its simple subject components. By finding the correct exposure for one of these simple subject components, we can then determine the correct exposure for the entire subject. If the last few sentences confused you, don't worry. We will get back to these topics shortly.

Section 1.5 Summary:

A simple subject has only one tone. Any subject which has more than one tone is a complex subject. By definition, every complex subject can be broken down to its simple subject components. We will be using this important property to find the correct exposure for our complex subjects.

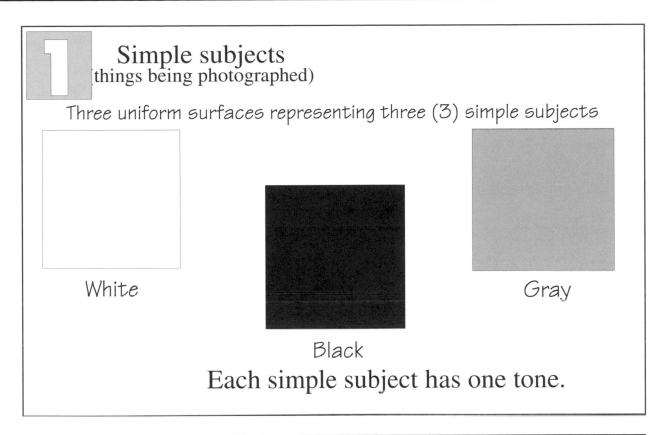

1 Simple subjects
(things being photographed)

Three uniform surfaces representing three (3) simple subjects

White

Black

Gray

Each simple subject has one tone.

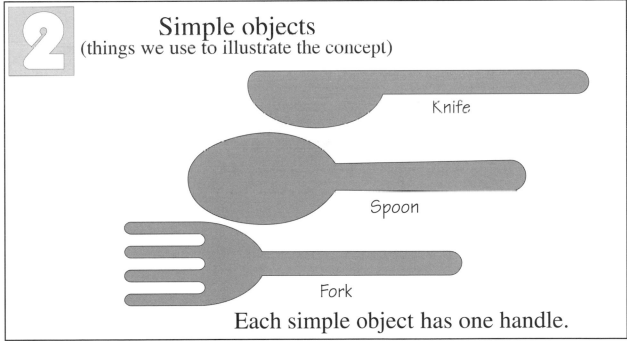

2 Simple objects
(things we use to illustrate the concept)

Knife

Spoon

Fork

Each simple object has one handle.

Diagram 1.5.1

Diagram illustrating simple subjects and their association with simple objects

Practical examples of a simple subject

Although most of these surfaces do not qualify as true simple tones, for practical applications, when the majority of these subjects are viewed from far away as a group, they can be approximated to a simple subject.

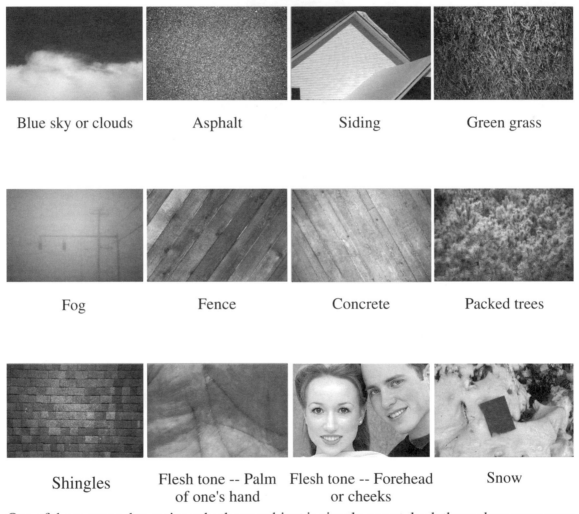

Blue sky or clouds Asphalt Siding Green grass

Fog Fence Concrete Packed trees

Shingles Flesh tone -- Palm Flesh tone -- Forehead Snow
 of one's hand or cheeks

One of the ways to determine whether a subject is simple or not, look through your camera and move the spotmetering frame (circle) within the boundaries of the tone that you think represents a simple subject. If the reading of your meter remains the same (i.e., the needle / Exposure Index indicates the same exposure reading) the subject is simple, if it does not (i.e., it changes as you move the camera), the subject is complex. If I just lost you, please read on. These concepts will be extensively covered in sections 1.7 and 1.16.

Images for section 1.5.2

1 A complex subject
(subject being photographed)

Three simple subjects sewn together to make a quilt.
The quilt is considered to be a complex subject.

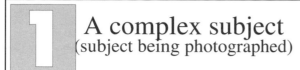

White Black Gray

This complex subject has three distinct tones.

2 A complex object
(what we use to illustrate the concept)

Three simple objects fastened together to make a complex object

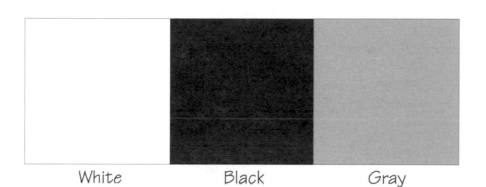

Fork

Knife

Spoon

This complex object has three distinct handles.

Diagram 1.5.3

Diagram illustrating complex subjects and their association with complex objects.

1.6 The Film

Film is one of the basic elements of a photograph. It is the medium that captures the image of a subject. There are two popular types of silver based film that are currently on the market: negative (or print) film, which includes color as well as black and white, and slide (or transparency) film.

As the type of film signifies, negative film represents the image in a "reverse" way. For example, if the subject is white its image tone will be black. If the subject is black its image tone is white and so on. On the other hand, *color slide film captures images as we see them,* or in a positive way. In my experience, negative film almost always confuses the beginning photographer. This is the main reason why I have based this book on color slide film. To process negative film, the film goes through two separate steps: 1) Developing the film and 2) Printing the image on photographic paper. It is during the second step that an operator or a machine determines the secondary exposure of the film and provides you with an image that the operator or machine thinks to be right, rather than the image that you think to be right. Simply stated:

With negative film "What you take is <u>NOT</u> necessarily what you get!"

Unlike the negative, the slide film goes through a one step process; the film enters a tightly monitored processor and the final product exits the other end. With slide film processing the operator intervention is minimal and the final image is all yours! Simply stated:

With slide film "What you take is what you get!"

Since consistency of exposure should be our most important objective, we will be using slide film throughout this book. Please think of slide film as the training wheels of your bicycle. Once you know how to ride, simply take them off and throw them away. In this book, to simplify things and avoid confusion, in most examples we will be using 100 ISO color slide film.

DIGITAL FOOTNOTE: For those readers who like to learn the spotmetering applications using their digital camera in Manual exposure mode (like Pentax *ist-D, Canon 20D, and Nikon D70), I have added a few notes throughout the book. If you are interested, please read Appendix B. *Otherwise please SKIP over the material.*

Section 1.6 Summary:

There are two types of silver based films that are currently on the market: negative film and a positive (slide/transparency) film. Since the slide film is a more exact medium and "What you take with a slide film is what you get" it is used to illustrate the techniques of light measurement in this book.

2.2GB MagicStor
CompactFlash

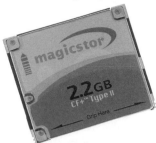

256MB CompactFlash and
a PCMCIA adapters for laptops

A sample of standard color negative, black and white negative, and color slide films from different manufacturers. These films are capable of recording up to 36 images on each roll.

Diagram 1.6.0

SPECIAL NOTE ON DIGITAL FILM/MEMORY

If you are interested in a brief overview of spotmetering with Digital Cameras, please refer to Appendix B *after* you have completed the book! **Otherwise, please skip over this material! The material is intended as an overview for photographers already using a digital camera, but lack the spotmetering skills.**

Photographed is a 2.2GB (accommodating 2,200,000,000 characters/pixels) digital film/memory (CompactFlash Memory card) used by many of the new digital cameras/D-SLRs. These include Pentax, Canon, and Nikon. With a 6 MegaPixel camera, this film/memory is capable of recording about 116 high-resolution (3000X2000 Pixel images in TIFF (.TIF) format), 512 high resolution images in JPEG (.jpg) format, or 999 lower resolution images in JPEG format (your camera's numbers may be different). Each high-resolution image is capable of producing a perfect 11X14 inch or an acceptable 16X20 inch color print on a high quality color printer.

These images are generally transferred to your computer either by using a USB (Universal Serial Bus) adapter (usually no installation is necessary) or by using the camera's direct USB connection. In this case, before the images can be downloaded, your computer must recognize the camera. To achieve this, you must install a specific program/driver that comes with your camera.

1.7 Exposure: "Normal" versus "Correct" and "Desired"

Although we will be covering the camera components shortly, we need to talk about exposure. Exposure is the method of letting an exact amount of light to enter the camera in order to produce an image that looks and feels much like the original subject.

1.7.1 Normal Exposure

The "normal exposure," by definition, is the exposure setting that is suggested by the meter in the camera. The **unskilled** photographer uses this setting (a combination of aperture opening and the exposure time for a given film) to take his or her picture. Different meters indicate a "normal exposure" by various mechanisms. These include placing a needle in the middle, a green light, matching two needles, an arrow pointing at the center '0', or other mechanisms. *I have included a list for some of the more popular cameras at the end of the book.* To use your meter, is absolutely essential that you know how to use your camera and how the camera's viewfinder (exposure index) indicates a "normal exposure." If you do not know, read your manual. Some manuals may erroneously call this a correct exposure (I wish!) If you do not have a manual, write or call the manufacturer, or go to a good, professional camera store and chances are somebody there can help you. If all your efforts fail, put an ad in your local camera store. Without knowing the basic operation of your camera, reading this book will be confusing and will be a waste of your time. The general overall image tone of such "normally exposed" subjects tend to be medium grayish. Many auto-everything cameras work on this principle. What is important is that "normal exposure" does not necessarily produce the "correct exposure" every time. This will be specially true when you are photographing subjects that are too light (white) or too dark (black).

1.7.2 Correct exposure

The correct exposure, by definition is an exposure that produces correctly exposed image tones. This means that to the eye, the image closely resembles the subject that was photographed. This is the ultimate goal of many photographers. In many cases the "normal exposure" reading of a subject is used as a starting point or a platform from which the skilled photographer determines the "correct exposure" of the subject. **Remember:** *Technically speaking, the majority of subjects have only one "correct exposure."*

1.7.3 Desired exposure

The "desired exposure" is an exposure that is neither "normal" nor "correct." With this type of exposure, the photographer, for artistic or other reasons, determines the look of the final image. Photographing the silhouette of a person's face is such an example. The darkened flesh tone is neither "normal" nor "correct" but is "desired" by the photographer. In this book, unless stated, "correct exposure" and "desired exposure" are identical. The **skilled** photographer uses the "normal exposure" as the base (starting point) to create this "desired exposure."

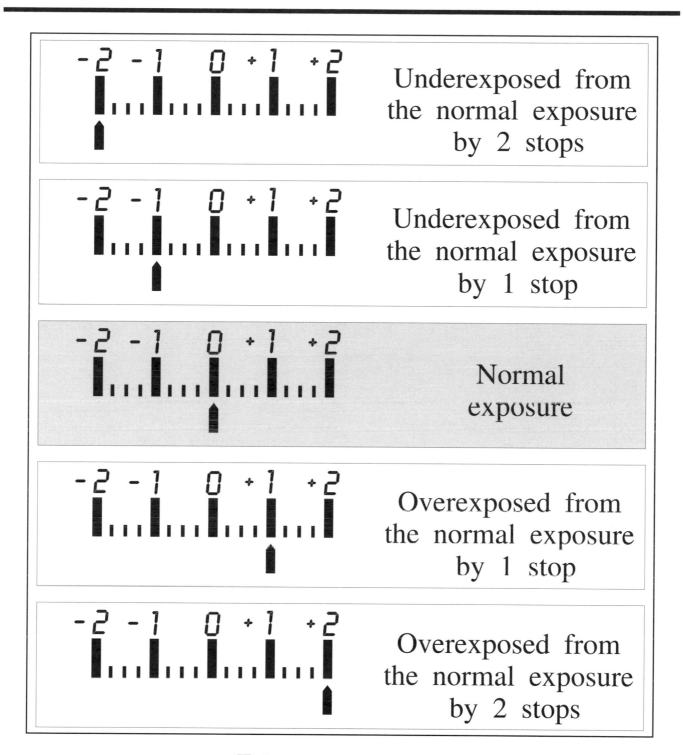

-2 -1 0 +1 +2 Underexposed from the normal exposure by 2 stops

-2 -1 0 +1 +2 Underexposed from the normal exposure by 1 stop

-2 -1 0 +1 +2 Normal exposure

-2 -1 0 +1 +2 Overexposed from the normal exposure by 1 stop

-2 -1 0 +1 +2 Overexposed from the normal exposure by 2 stops

Diagram 1.7.1

Diagram illustrating the generic exposure index in the viewfinder for many of the newer cameras. The middle diagram illustrates the "normal exposure." Please note that with the "normal exposure" the small pointer is located in the middle of the scale under the digit [0].

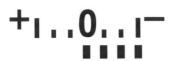

Underexposure by one stop

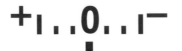

Normal Exposure

+Ⅰㆍㆍ0ㆍㆍㅣ⁻

Overexposure by one stop

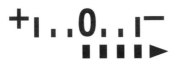

Underexposure of
more than 1 stop

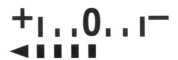

Overexposure of
more than 1 stop

Generic exposure index illustration
for popular Nikon cameras such as N6006,
N70, and N90 models.

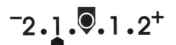

Underexposure by 1 stop

⁻2ㆍ1ㆍ◉ㆍ1ㆍ2⁺

Normal Exposure

⁻2ㆍ1ㆍ◉ㆍ1ㆍ2⁺

Overexposure by two stops

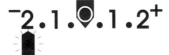

Blink -- Underexposure of
more than 2 stops

Blink -- Overexposure of
more than 2 stops

Generic exposure index illustration for some popular
Canon cameras such as EOS Rebel and
EOS Elan models.

Diagram 1.7.2

Diagram illustrating the exposure index for many of the newer Nikon and Canon cameras. The objective of this illustration is to teach the photographer what to look for in the viewfinder or on the LCD screen and how to recognize the camera's normal exposure.

Section 1.7 Summary:

There are three types of exposure: The "Normal exposure," the "Correct exposure" and the "Desired exposure."

In the **"Normal exposure,"** the metering system of the camera decides how to expose the film in order to capture what the *camera thinks* is the best exposure.

In the **"Correct exposure"**, the skilled photographer uses the "Normal exposure" as a starting point and he or she determines the best exposure for that specific subject. Please remember that ***most subjects have only one technically "Correct exposure."*** This means the image and the subject's tone resemble one another and that the image closely resembles the original subject.

The **"Desired exposure"** is an exposure that is neither "Normal" or "Correct." A darkened silhouette of a model is such a case. In this case the image of the skin tone is neither "Normal" or "Correct" but it is what the photographer desires.

1.8 The camera

The camera can be described as a tone reproduction machine. By this I mean that the intended function of the camera is to convert the subject tones to image tones. For the camera to perform this, it gets help from four of its major components. These components are:

1) The aperture opening dial whose major function is to control the amount of light that passes through the lens by increasing or decreasing its opening.

2) The exposure time dial (commonly and mistakenly referred to as the shutter speed) whose major function is to control the amount of light reaching the film by controlling its exposure time.

3) The ISO dial which sets the film speed (please see section 1.11).

4) The built-in light meter or in our case, the built-in spotmeter (please refer to Appendix D). The objective of the camera's built-in light meter/spotmeter/partial meter is to use the aperture opening, the exposure time, the ISO *and your skill* to capture a correctly exposed image. If you do not know the difference between a "spotmeter" and a "partial Meter," here is a brief explanation:

Spotmeter (Spot meter):

A spotmetering frame (a circle in the middle of the viewfinder) usually has an area that occupies *up to 3% of the entire viewfinder area.* With many spotmeters, 100% of the light within the spot frame is measured by the camera's meter. Typical cameras with a spotmetering feature and a *distinct spot frame* include: Nikon N90, F-4, N70, N8008s, and N6006; Pentax ZX-5N, PZ-1P, *ist, and 645N; Minolta Maxxum 7, 9, and STsi; Canon EOS 1n and EOS 3; Olympus OM-3 and OM-4.

Partial Meter:

A Partial Metering region (usually not marked on many of the cameras and is less accurate for critical work than a spotmeter) is larger than the spot frame and usually occupies *about 7% to 13% of the viewfinder area.* Most cameras with partial metering feature are made by Canon. These include many of Rebel series (such as Rebel g and Rebel 2000), Elan II E, and Elan 7 E. Low-end/amateur Nikon cameras such as N50, N55, N60, and N65 have a distinct 12mm partial metering circle. For a list of spotmetering and partial metering specifications for different cameras please refer to Appendix D.

Section 1.8 Summary:

Modern cameras have four major components that helps them in their tone reproduction function. These include: 1) Aperture opening dial controlling the amount of light that enters through the lens, 2) Exposure time (shutter speed) dial that controls the duration of the exposure of film to light, 3) The ISO (film sensitivity) setting of the film, and 4) The exposure meter. On-camera spotmetering (narrow angle metering / partial metering) is a specialized function of many of the newer cameras.

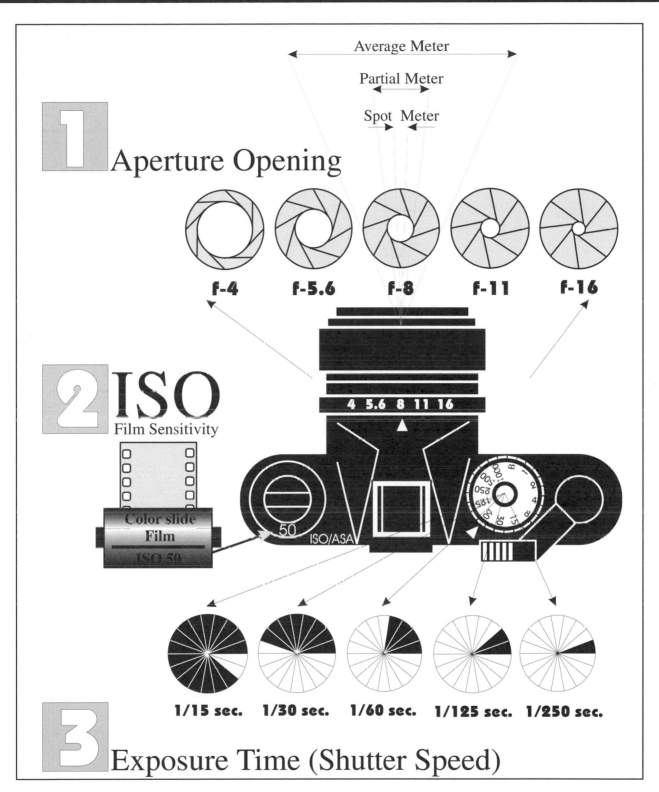

Average Meter

Partial Meter

Spot Meter

1 Aperture Opening

f-4 f-5.6 f-8 f-11 f-16

4 5.6 8 11 16

2 ISO
Film Sensitivity

Color slide
Film
ISO 50

50
ISO/ASA

1/15 sec. 1/30 sec. 1/60 sec. 1/125 sec. 1/250 sec.

3 Exposure Time (Shutter Speed)

Diagram 1.8.0

Diagram illustrating the three main components of a camera which effect the exposure.

1.9 The aperture opening

The aperture opening determines how much light gets into the camera. The larger the opening, the more light enters the camera. To indicate the degree to which the lens is open, numbers such as 1.4, 2, 2.8, 4, 5.6, 8, 11, 16, and 22 can be seen on many older lenses.

In the newer cameras, these numbers can be found in the viewfinder (what you look through) of your camera. In this book, these numbers are prefixed by [f-]. For example an aperture opening of 5.6 is referred to as f-5.6. The only thing that a beginner should be aware of is that the _larger_ the number, the _smaller_ the aperture opening. Simply stated, the _numbers_ and the _aperture opening_ have an _inverse_ (reverse) relationship.

In our illustration, f-4 (smallest number) has the largest opening and f-16 (largest number) has the smallest opening. Please make sure you understand this (see diagram 1.9.0).

The most important thing about these numbers is that they are one STOP away from one another, i.e., f-5.6 is one STOP away from its two neighboring aperture openings of f-8 and f-4. Another piece of information that may interest you is that for each STOP the area of the aperture opening doubles or halves, depending on the direction in which it is moved. For example closing the aperture down from f-1.4 to f-2 reduces the area of the aperture by one half (the amount of light entering the camera is halved). By the same token, if you open the aperture from f-8 to f-5.6, the area of the aperture opening doubles; so does the amount of light passing through the lens.

In newer electronic cameras (and some older cameras) one may see 1/2 stop divisions. These are half-way between the standard aperture openings. For our examples above, these include 1.7, 2.3, 3.4, 4.7, 6.7, 9.5, 13.5 and 19. To simplify the illustrations and accommodate photographers with older cameras, we will be using full aperture numbers like f-5.6, f-8 and f-11.

Section 1.9 Summary:

Aperture openings are usually indicated by numbers such as 1.4, 2, 2.8, 4, 5.6, 8, 11, 16 and 22 on many lenses. Each of these numbers is separated by ONE STOP from its neighboring number. Each stop, depending on how you look at these numbers, doubles or halves the amount of light that enters the camera. For example f-11 lets in twice as much as f-16 but half as much light as f-8. With some of the newer cameras, these numbers are not located on the lens and are shown internally in the viewfinder or externally on the camera's main LCD panel.

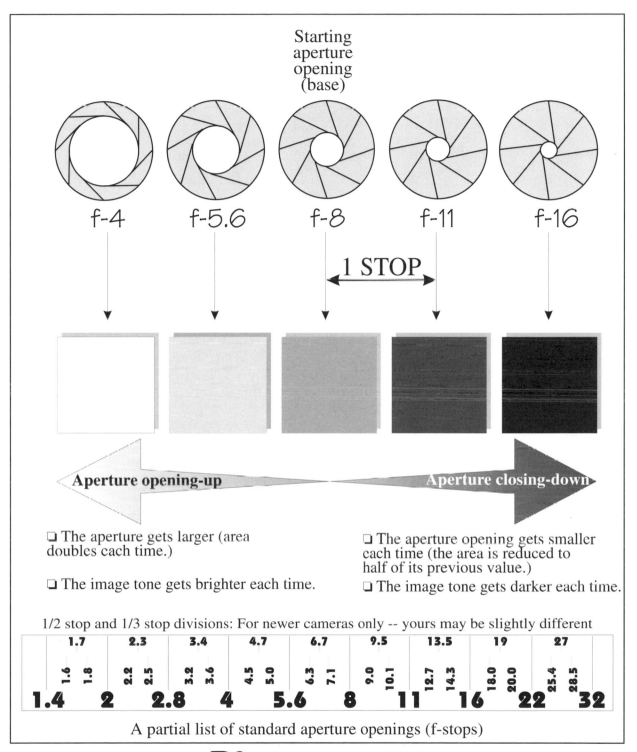

Starting aperture opening (base)

f-4 f-5.6 f-8 f-11 f-16

1 STOP

Aperture opening-up

Aperture closing-down

❑ The aperture gets larger (area doubles each time.)

❑ The image tone gets brighter each time.

❑ The aperture opening gets smaller each time (the area is reduced to half of its previous value.)

❑ The image tone gets darker each time.

1/2 stop and 1/3 stop divisions: For newer cameras only -- yours may be slightly different

| 1.4 | | 2 | 2.8 | | 4 | 5.6 | | 8 | 11 | | 16 | | 22 | | 32 |

1.7 2.3 3.4 4.7 6.7 9.5 13.5 19 27

1.6 1.8 2.2 2.5 3.2 3.6 4.5 5.0 6.3 7.1 9.0 10.1 12.7 14.3 18.0 20.0 25.4 28.5

A partial list of standard aperture openings (f-stops)

Diagram 1.9.0

Diagram illustrating the effects of opening-up and closing-down the aperture by 1 stop on the final image tone for a slide film *given that the shutter speed remains constant.*

1.10 The exposure time (Shutter speed)

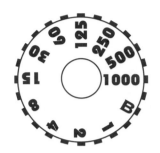

Exposure time is the measure of time, usually in fractions of a second, that the shutter stays open and exposes the film. Standard shutter speeds are 1, 1/2, 1/4, 1/8, 1/15, 1/30, 1/60, 1/125, 1/250, 1/500, and 1/1000 second. For some cameras, this range extends from 30 sec. [30"] to 1/8000 sec. In many books including this one, these notations are sometimes simplified by eliminating the "1/" portion. ***In this book I will be using both notations***. Chances are that on your camera the same speeds are indicated as 1, 2, 4, 8, 15, 30, and so on. As with the aperture opening, the only thing that a beginner should be aware of is that with this kind of notation, the *larger the number, the smaller the amount of light reaching the film*. These numbers and the exposure times have inverse (reverse) relationships.

In our examples, **1000** (1/1000th of a second) has the shortest and **1** (1 second) has the longest exposure time. Make sure you understand this. Like aperture openings, each of these numbers is one STOP away from its neighboring numbers: i.e., 500 is one STOP away from 1000 as well as being one STOP away from 250. Another piece of information that may interest you is that for each STOP, the exposure time doubles or halves, depending on the direction in which the settings are changed. For example, when changing the exposure time from 1/500 sec. to 1/1000 sec., the exposure time is halved and so is the amount of light entering the camera. By the same token, changing the exposure time from 1/500 sec. to 1/250 sec. doubles the exposure time (so it doubles the amount of light entering the camera). On many newer electronic cameras you will see numbers such as 45, 90, 180, 360, 720, and so on. These numbers are 1/2 stop exposure times. For example, 1/90 is half a stop between 1/60 and 1/125 sec. In order to support many millions of older cameras and to keep things simple, we will stick with standard exposure times (shutter speeds) such as 1/15, 1/30, 1/60 etc.

1.10.1 Bulb Setting "B"

For many cameras a "B" on a shutter speed dial indicates "Bulb" and signifies the longer than standard exposure time that can be controlled by the photographer. Subjects requiring long exposure times (from a minute to several hours) include moonlit scenes, tracing stars, lightening and fireworks. To keep the shutter open for an extended period one can use a cable release which can be locked in position.

Section 1.10 Summary:

Shutter speed (exposure time) of a camera is represented by series of numbers signifying the amounts of time (generally in fractions of a second) that the shutter remains open. Typical practical exposure times in seconds are 1, 1/2, 1/4, 1/8, 1/15, 1/30, 1/60, 1/125, 1/250, 1/500 and 1/1000. The exposure time for some of the professional cameras extends from 30 seconds [30"] to 1/8000th of a second.

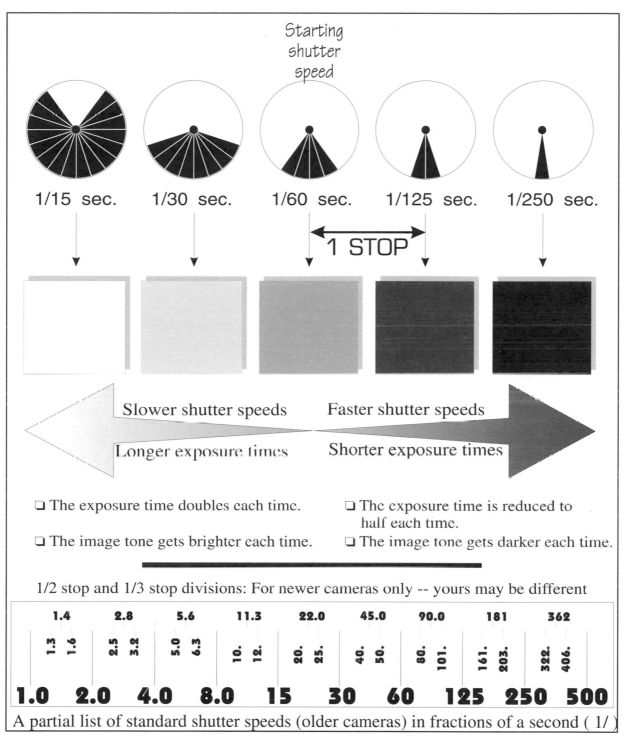

Starting shutter speed

1/15 sec. 1/30 sec. 1/60 sec. 1/125 sec. 1/250 sec.

◄──► 1 STOP

Slower shutter speeds Faster shutter speeds

Longer exposure times Shorter exposure times

❏ The exposure time doubles each time.

❏ The image tone gets brighter each time.

❏ The exposure time is reduced to half each time.

❏ The image tone gets darker each time.

1/2 stop and 1/3 stop divisions: For newer cameras only -- yours may be different

1.4	2.8	5.6	11.3	22.0	45.0	90.0	181	362

1.3 1.6 2.5 3.2 5.0 6.3 10. 12. 20. 25. 40. 50. 80. 101. 161. 203. 322. 406.

1.0 2.0 4.0 8.0 15 30 60 125 250 500

A partial list of standard shutter speeds (older cameras) in fractions of a second (1/)

Diagram 1.10.0

Diagram illustrating the effects of exposure time on image tone production for slide film. *If the aperture remains constant,* the longer the exposure, the lighter the image tone. The shorter the exposure, the darker the image tone. In the above illustration, the **black** areas of the wheel represent the exposure time. Please note that each time slice is 1/250 sec.

1.11 The ISO dial

ISO stands for International Organization for Standards and is the measure of film's sensitivity. Like other numbers (shutter speed and aperture opening), there is a reverse relationship between the ISO number and the amount of light needed to expose the subject. ***This means the higher the ISO, the less light is needed to expose the image***. Films with an ISO of 25 are considered low-speed or "slow" films. Films with an ISO of 50 to 100 considered to be medium speed. Films with ISO's of 400 or greater are considered high-speed. Films with an ISO of 800 to 3200 or higher are labeled ultra high-speed. Generally, low to medium speed films provide the best color and detail. High speed films tend to be grainy and generally have poor color. Low-speed black and white films have minimal grain and produce the best detail. High-speed black and white films, very much like color films, are more grainy. As was mentioned, in order to simplify the teaching process, we will be using 100 ISO color slide film in our examples.

DIGITAL FOOTNOTE:

ISO of a digital camera very much like the standard camera can be set to different values. The ISO of Pentax *ist-D can be set to 200, 400, 800, and 1600.

Section 1.11 Summary:

The ISO is the measure of the sensitivity of a film to light. The higher the ISO of the film, the less light it needs to capture the image. The lower the number, the more light it needs to record the image. An ISO 25 film is considered low-speed film, an ISO 100 film is considered to be a medium speed film. Films with ISOs of more than 200 are considered high speed. A film with an ISO of 3200 is considered to be an ultra high speed film. The ISO of many of today's newer and more advanced digital cameras (D-SLRs) can be set to 50, 100, 200, 400, 800, and 1600.

A partial list of ISOs in 1/3 stop increments

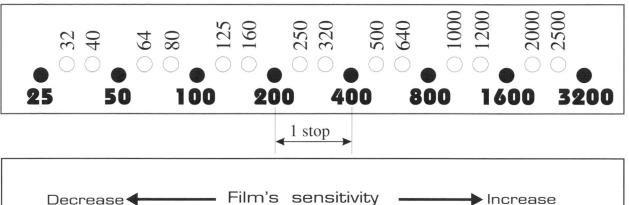

1 stop

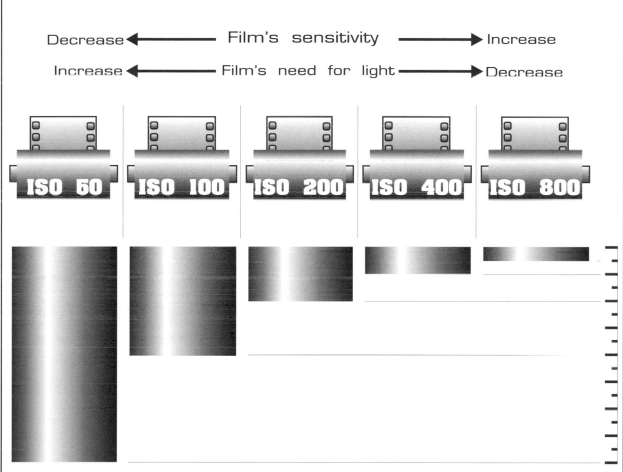

Diagram 1.11.0

ISO (film sensitivity or film speed)

A film's ISO can be graphically represented by water tanks that are of different capacities. The volume of the container that is proportional to the ISO of the film represents the film's need for light. In this illustration, as the film's ISO is halved (say from 200 to 100), its need for light (the volume of the tank) is doubled.

1.12 The Reference Tone (Visual Handle)

1.12.1 Handle for visually grabbing the subject

Let's pretend that when you release the shutter, you grab the subject and carry it through the lens to the back of the camera and record its image on the film. Picking up a subject and moving it from one medium (subject tones) to another (image tones) is similar to picking up a stool with one hand and moving it from one room to another. To pick up a stool, one must look for a handle.

Let's define a handle as a section of the stool that can be grasped in order to move it to another location. Let's also refer to this part as the reference point of the stool. If an object (like a stool) has more than one handle, it has more than one reference point. The same applies to a complex subject. When photographing a complex subject (very much like picking up a stool), you must first select a simple tone that you can use as a handle. Let's call this a Reference Tone or the Visual Handle. By definition, this is a simple tone that is "visually grabbed" by the photographer's eye. Once this is done, he or she uses this tone as a handle to pull the entire subject through the lens to the back of the camera and record its proper image on film. Since the simple subject has only one tone, this tone will also become its only Reference Tone. Therefore, the tone of the simple subject is the only "handle" that we can use to pick up the subject.

To choose a Reference Tone (Visual Handle) for a complex subject, we must visually break the subject down into two or more simple subjects (tones). Once this is done, then theoretically any one of these simple tones can become a Reference Tone that can be used as a Visual Handle.

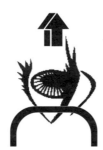

As is shown, the symbol for the Reference Tone is an eye with a handle. <u>Consequently, when you see this or just the eye symbol, the attached tone will be the complex subject's Reference Tone.</u>

Section 1.12 Summary:

If you ask three of your friends to pick up a small chair ***with one hand*** and carry it to the next room, chances are that every one of them will grasp the same point of the chair. As any chair has its natural handle, so does any subject. The natural subject tone can be referred to as a "Visual Handle" or a "Reference Tone." A "Reference Tone" by definition is a tone that can be visually grabbed in order to transfer itself (as well as the rest of the subject) to the back of the camera and be recorded on film. In this book, the symbol used to signify a "Visual Handle" is an eye with a handle.

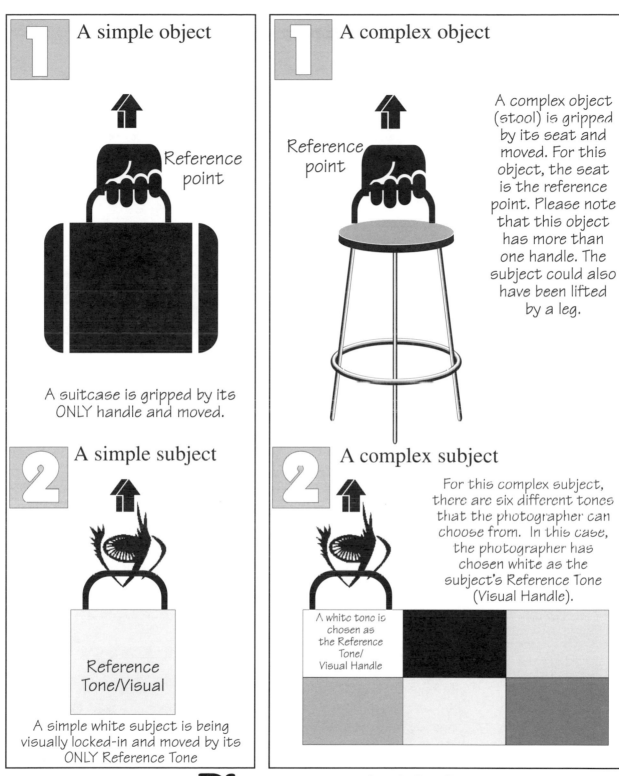

1 A simple object

Reference point

A suitcase is gripped by its ONLY handle and moved.

1 A complex object

Reference point

A complex object (stool) is gripped by its seat and moved. For this object, the seat is the reference point. Please note that this object has more than one handle. The subject could also have been lifted by a leg.

2 A simple subject

Reference Tone/Visual

A simple white subject is being visually locked-in and moved by its ONLY Reference Tone

2 A complex subject

For this complex subject, there are six different tones that the photographer can choose from. In this case, the photographer has chosen white as the subject's Reference Tone (Visual Handle).

A white tone is chosen as the Reference Tone/ Visual Handle

Diagram 1.12.0

Diagram illustrating Reference Tones for simple and complex subjects.

1.13 How does one choose a Reference Tone?

When photographing a subject, choosing a Reference Tone is very much like choosing a part of a stool that you can grab in order to pick up the stool with it. As a stool can be picked up by its seat, or legs, any complex subject can be picked up by any of the simple tones that makes up the subject. In practice, any complex subject has handles that are more logical. When using slide film, these are usually chosen from the medium or brighter tones of the subject. These tones are easier to handle than darker tones.

The only exception to this rule is that the Reference Tone <u>can not</u> be a source of light like the sun, a candle flame, or a lamp that is illuminating your subject.

Another factor to consider is that the ***<u>Reference Tone should be selected from an important part of your subject</u>***. For example, in portrait photography the most logical tone to be used as the Reference Tone is the skin tone of the subject.

1.13.1 How to choose a Reference Tone

1) Choose the Reference Tone from the most important area of the subject.

2) If your subject does not have a "most important area," and you are using slide film, choose tones that are medium gray or brighter — if possible, avoid areas whose tones are darker than medium gray.

3) Although the sun, a lamp, or the flame of a candle can be photographed in a scene, *<u>you MUST avoid using them as a "Reference Tone."</u>* Please remember, <u>choose a "Reference Tone" that is lit by one of these light sources and not the light source itself</u>. In cases like these, the Reference Tone is simply too hot to handle!

Portrait on the opposite page:

When taking a portrait, the most important tone is the flesh tone. The most common "Reference Tone" for this type of photography is the forehead.

Section 1.13 Summary:

Reference Tone (a simple tone/subject) is a convenient visual handle chosen from the most important part of your subject. It is no different than locating the handle of a briefcase or a section of a stool that you choose to pick up the subject with.

Subjects that ***<u>should not</u>*** be used as Reference Tones include a flame of a candle, an electric lamp, or the sun. These are simply to hot to handle!

What can be used as the Reference Tone is a face or a surface that is lit by a candle, electric lamp, or the sun.

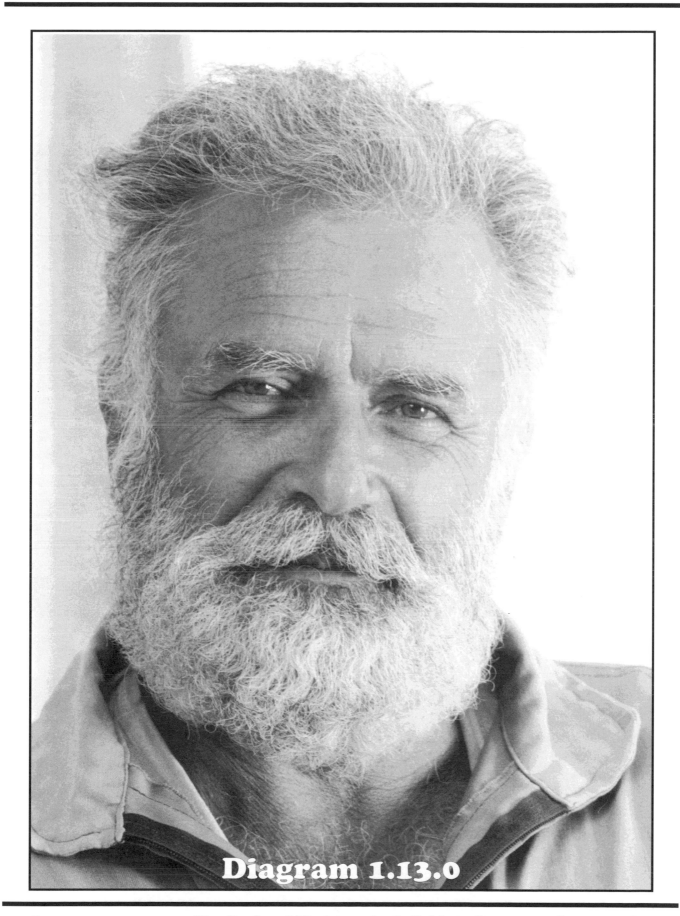

Diagram 1.13.0

1.14 Viewing the world through five shades of gray

1.14.1 The Tone Ruler concept

When we talked about the 18% gray card, I mentioned that one of its most important properties is that *its tone is exactly in the middle of our black and white tones*. Now we have reached a point where we need to be more specific. Although the term "middle" means different things to different people, the term "photographic middle" has a specific meaning. If you look at the exposure time (shutter speed) readings on your camera, 1/500 is one stop (full click) away from 1/1000 and one stop (full click) away from 1/250 sec. By this definition the exposure time of 1/500 is in the *middle* of 1/250 and 1/1000 sec. If we expand our scale, 1/500 sec. is also in the *middle* of 1/2000 and 1/125 sec. Each of these exposure times are two stops (full clicks) away from 1/500 sec. As much as I hate to ask you to do multiplication and division, it is necessary for you to understand the concept of the Tone Ruler. By starting with an 18% gray card and dividing it by 2, we get 9%. By multiplying 18% by 2, we will get 36%. Therefore 18% gray is the middle of 9% dark gray and 36% light gray. Now let's divide 9% by 2 and we get 4.5%. If we multiply 36% by 2 we get 72%.

If you do not care about mathematics (I sympathize with you) you can ignore what I said. The only thing that I would like you to remember is that *by starting with the standard 18% gray tone, we created four other standard shades of gray around it.* Very much like the middle finger, 18% gray is the middle of each pair of these tones. Therefore, the 18% tone is the *middle* of the 9% (dark gray) and 36% (light gray) tones *as well as* the 4.5% (black) and 72% (white) tones.

To simplify the book, if I am referring to black, I am talking about 4.5% black. If I am referring to white, I am referring to 72% white and so on. Please look at the illustration on the next page for the different shades of gray represented by the Tone Ruler. *If you do not understand anything that I talked about on this page, you must understand the following important points:*

Very Important Points:

Medium (18%) gray is the <u>middle</u> of <u>9% dark gray</u> and <u>36% light gray</u>. In photographic terms, the <u>18% medium gray</u> is ONE STOP away from <u>9% dark gray</u> and <u>36% light gray</u>.

Medium (18%) gray is also the <u>middle</u> of <u>4.5% black</u> and <u>72% white</u>, or in photographic terms, <u>18% medium gray</u> is TWO STOPS away from <u>4.5% black</u> and <u>72% white</u>.

This is similar to the North American Time Zones that are away from one another by one hour, with the Central Time Zone in the middle. Please study the following illustrations and make sure that you understand the concept.

The Five-Stop Tone-Ruler

| Extra Dark Gray (Black) | Dark Gray | Medium Gray | Light Gray | Extra Light Gray (White) |

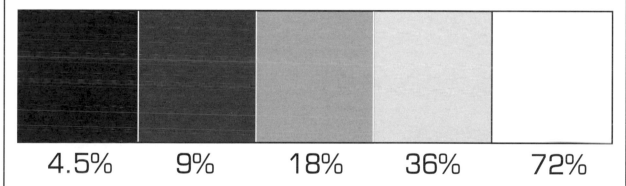

| 4.5% | 9% | 18% | 36% | 72% |

Diagram 1.14.0

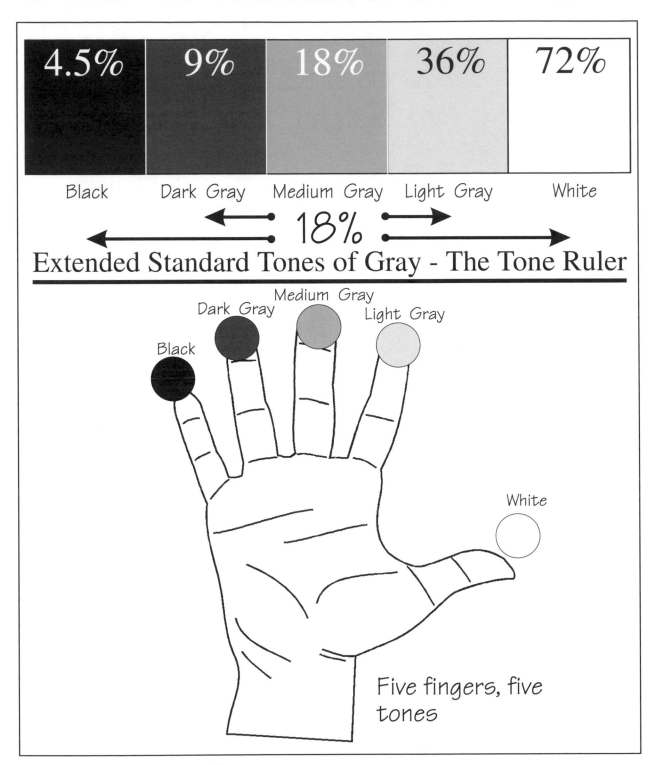

4.5%	9%	18%	36%	72%
Black	Dark Gray	Medium Gray	Light Gray	White

18%

Extended Standard Tones of Gray - The Tone Ruler

Black

Dark Gray

Medium Gray

Light Gray

White

Five fingers, five tones

Diagram 1.14.1

By dividing and multiplying the number "18" by 2, we created four more **_Standard Tones_**. As you can see, the 18% gray tone is the middle of Standard Dark Gray and Standard Light Gray tones as well as the Standard Black and Standard White tones.

An Example of Extended Standard Subject Tones

4.5% Black	9% Dark Gray	18% MEDIUM GRAY	36% LIGHT GRAY	72% WHITE
A 4.5% reflective surface is an extra dark gray and for all practical purposes is black. This is not the darkest black we can get, but it is convenient for our purposes. In this book we refer to this also as 4.5% black. Examples: Dark, new blue jeans, black cloth.	A 9% reflective surface is considered dark gray. Examples: Moist earth, clean asphalt, ultra blue sky.	A 18% reflective surface is called "medium gray" or "standard 18% gray." Examples: A beach of wet brown sand, medium blue sky.	A 36% reflective surface is considered light gray and has a tone whose value is close to the Caucasian skin tone. Other examples include: A beach of dry brown sand, concrete.	A 72% reflective surface can be called extra light gray and for all practical purposes is white. To distinguish it from other whites, we also refer to this as 72% white. The paper that this text is printed on has an approximate reflectivity of 72%.

Diagram 1.14.2

Diagram 1.14.3

Diagram illustrating five North American Time Zones
(Approximate. For illustration purposes only!)

1.14.2 Verifying that standard tones are one stop away from one another

Each of the following five pages represents subject tones with ***approximate*** reflectivities of 4.5%, 9%, 18%, 36% and 72%. Set your camera to manual mode with the aperture set to f-8.

Place this book with the 18% gray page in a shadowed area and by changing the shutter speed find its normal exposure.

Your camera could be ten or twenty inches away from this medium gray page. Please make sure that you do not shadow the subject and that all you see in the spotmetering circle (frame) of your viewfinder is the center of the gray page (no white borders)! If you have a camera with a Partial Metering feature without a partial metering frame, please make sure the center of viewfinder is pointing at the center of the card.

Let's assume your normal exposure from the 18% gray page is 60@f-8.

Now under the same lighting situation, by ***keeping the aperture setting at f-8*** and changing the shutter speed, find the normal exposure for other four pages.

❑ If you take a normal exposure reading from the 4.5% black page, your normal exposure would be approximately 1/15@f-8.

❑ If you take a normal exposure reading from the 9% dark gray page, your normal exposure would be approximately 1/30@f-8.

❑ If you take a normal exposure reading from the 18% dark gray page, your normal exposure would be 60@f-8 (this is what you started with).

❑ If you take a normal exposure reading from the 36% light gray page, your normal exposure would be approximately 1/125@f-8.

❑ If you take a normal exposure reading from the 72% white page, your normal exposure would be approximately 1/250@f-8.

You can see for yourself that the normal exposure for each page is ***approximately*** one stop away from the next. You could have also obtained the same results if you had changed the aperture instead of the shutter speed. In this specific example, your apertures would have been 1/60@f-4 for the 4.5% page, 1/60@f-5.6 for the 9% page, 1/60@f-11 for the 36% page, and 1/60@f-16 for the 72% page.

An important Note:

Due to variations in mechanical reproduction (i.e., the way this book is printed), you may not get all the expected results. Hopefully these shades of gray will be close enough so that they help you to understand the idea behind this exercise.

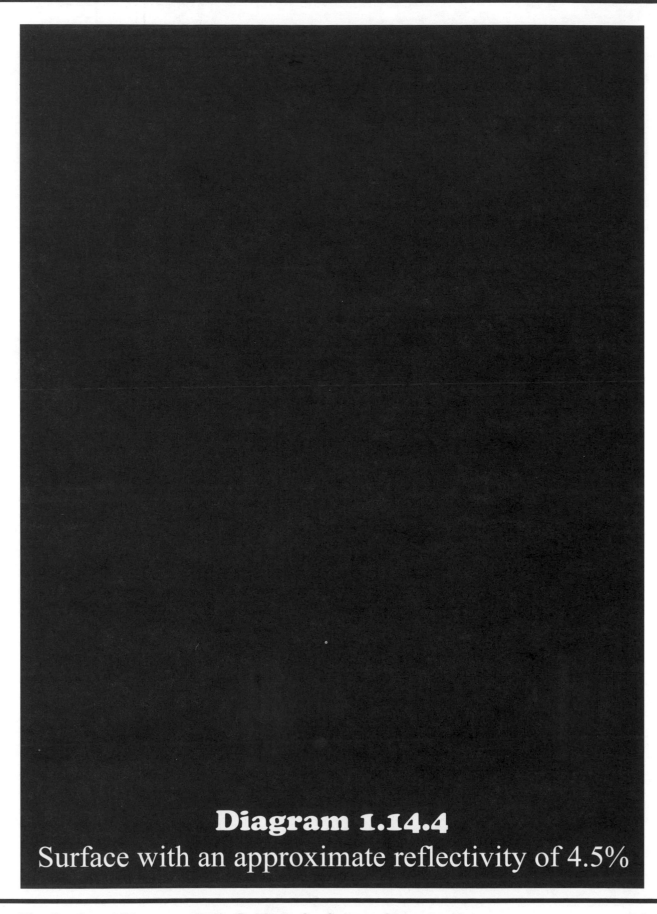

Diagram 1.14.4
Surface with an approximate reflectivity of 4.5%

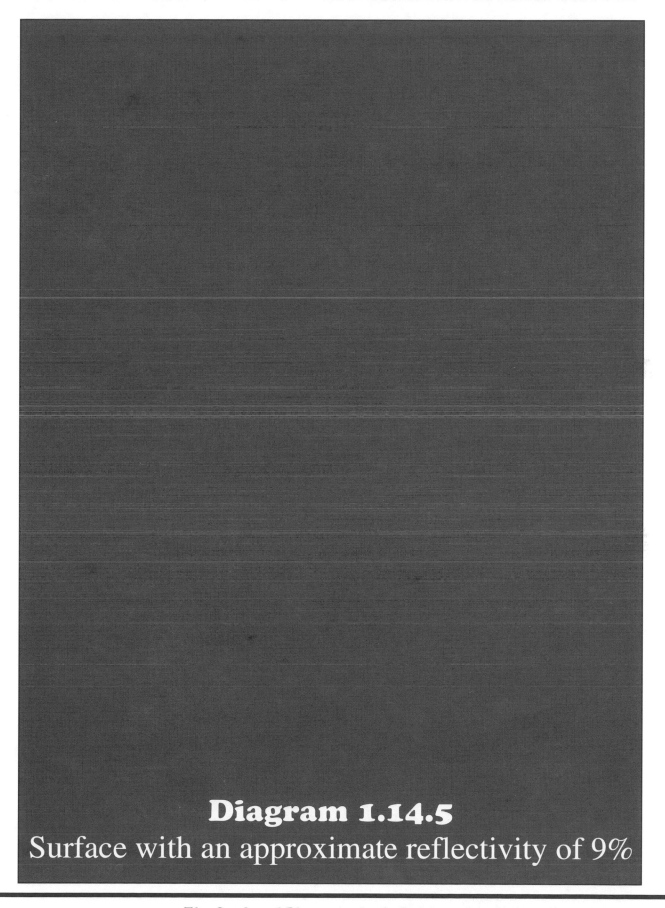

Diagram 1.14.5
Surface with an approximate reflectivity of 9%

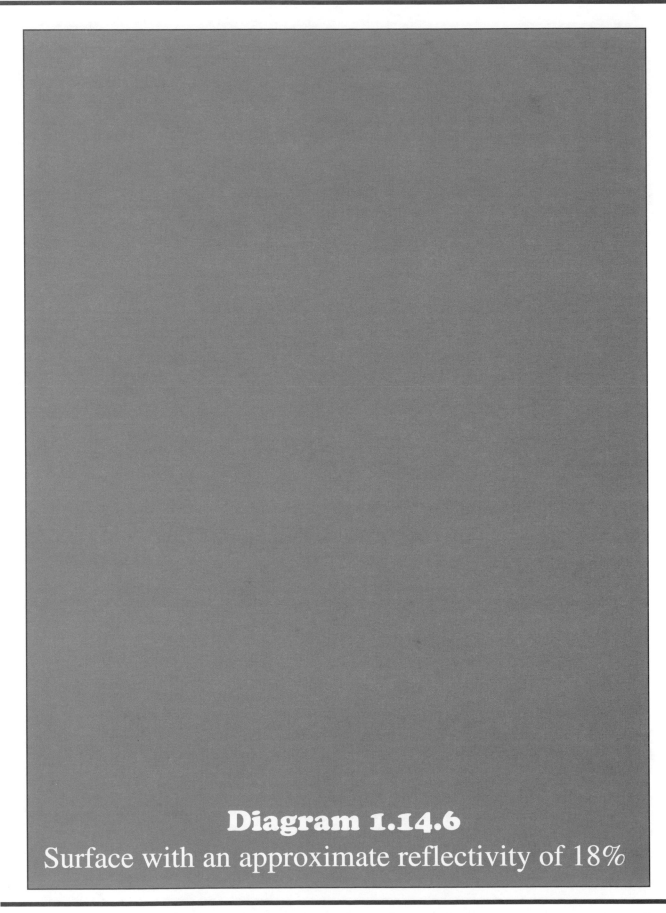

Diagram 1.14.6
Surface with an approximate reflectivity of 18%

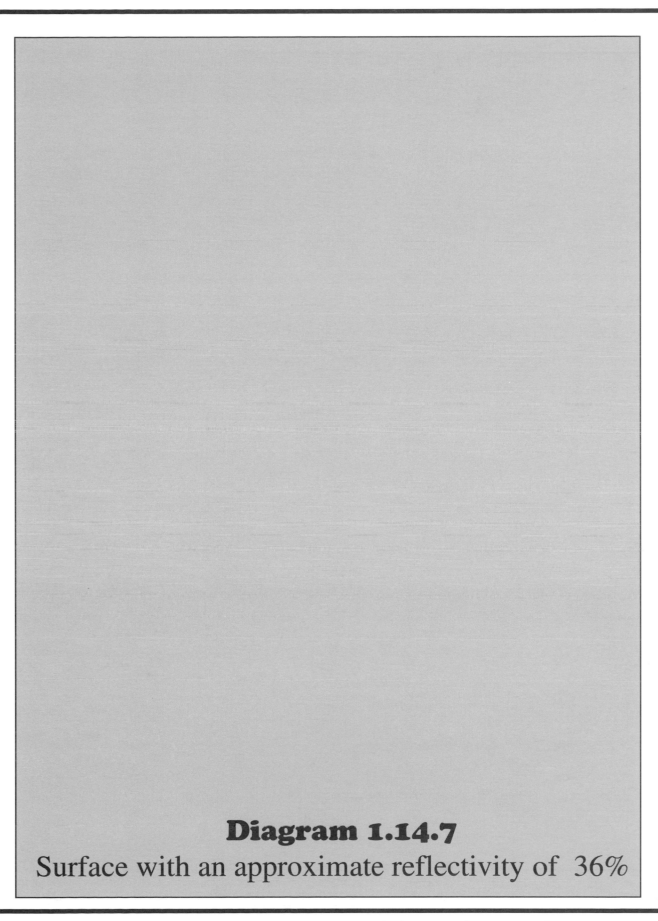

Diagram 1.14.7
Surface with an approximate reflectivity of 36%

Diagram 1.14.8
Surface with an approximate reflectivity of 72%

1.15 Equivalent exposures and the Law of Reciprocity in films

Let's assume that an exposure for a scene is 1/1000@f-2.8. This could be a "correct exposure," "normal exposure," or the "desired exposure."

Once you have found an exposure for a subject, you must realize that there are many equivalent exposures that expose the film with exactly the same amount of light and that the exposure you found is NOT the ONLY exposure.

The following table illustrates exposure pairs (shutter speed/aperture opening combinations) that expose the film with *exactly the same amount of light*.

Shutter speed/aperture pairs producing identical exposures							
The following row illustrates eight consecutive exposure times in increasing order							
1/1000	1/500	1/250	1/125	1/60	1/30	1/15	1/8
f-2.8	f-4	f-5.6	f-8	f-11	f-16	f-22	f-32
The above row illustrates eight consecutive aperture openings in decreasing order							

As you notice, for every STOP decrease in the aperture opening (the aperture opening gets smaller), the exposure time increases by one STOP (the exposure time gets longer). Equivalent exposures are possible since every full click on the aperture is equivalent to a full click of the shutter speed dial, and a full click on each dial is also equivalent to one stop.

If a photographer is interested in freezing the action, perhaps he uses 1/1000@f-2.8. However, if he requires the maximum depth of field (keeping most or all of the subject in focus) then he might use 1/30@f-16. The law that governs equivalent exposures is known as the law of reciprocity.

Section 1.15 Summary:

Exposing a film correctly means we have to allow the "correct" amount of light to enter the camera so that we can create a "correctly exposed" image. To illustrate, assume a swimming pool can be filled with water in 4 hours if we use a small pipe, in 2 hours if we use a medium sized pipe, in one hour if we use a large sized pipe. Please remember that each of these pipes will discharge exactly the same amount of water to fill-up the pool.

In photography, an aperture opening of 1/60@f-11, 1/30@f-16, and 1/15@f-22 will expose the film with exactly the same amount of light. Exposure settings that expose the film with exactly the same amount of light are called "Equivalent Exposures."

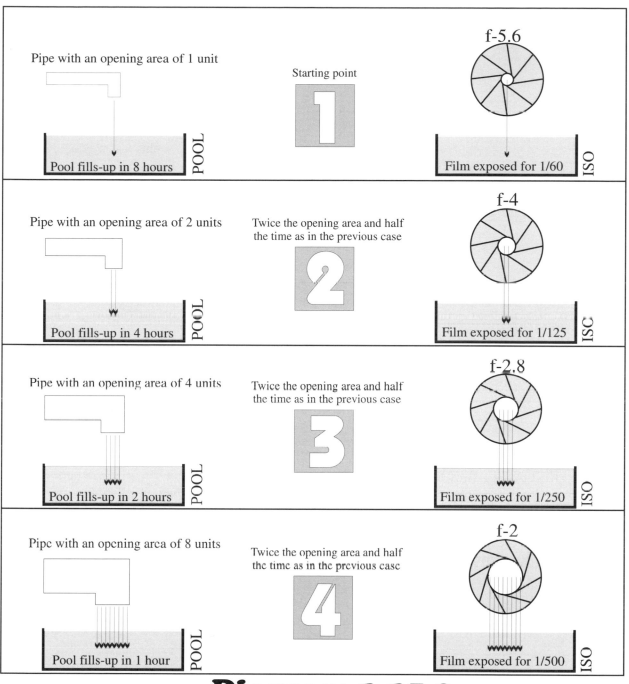

Diagram 1.15.0

An illustration of equivalent exposures

In this example, the pipe in illustration #2 discharges twice as much water as in illustration #1. The pipe in illustration #2 also discharges half as much water as in illustration #3 and so on. The same logic applies to the aperture opening. The aperture opening of f-4 lets in half as much light as f-2.8 and twice as much light as aperture opening of f-5.6.

In the water example, *in each case*, the pipe discharges *exactly* the same amount of *water in a given time* to *fill up the pool*. In the camera example, *each exposure (shutter speed/aperture opening combination)* will allow *exactly* the *same amount* of *light* to *expose the film*.

1.16 The Built-in Spotmeter/Partial Meter

We are just about ready to put together all that we have learned and make some sense out of our on-camera spotmeter. Now we have the basic knowledge to understand how the spotmeter works and how to find the normal exposure of a subject. What we have learned so far has been mechanical and does not involve much thinking and interpretation on our part. By definition, spotmeter is a ***narrow angled*** light measuring device capable of providing the photographer with a normal exposure reading from a ***simple subject.***

Please note that the word "simple" is the key word. If the subject that you are photographing is not uniform and does not have a uniform tone, the normal exposure reading of your spotmeter is totally meaningless, i.e., the reading of the spotmeter can not be interpreted correctly and accurately.

Before using your camera's spotmeter, *please make sure that your camera comes with one!* If your camera has this feature (in less expensive Canon cameras such as Rebel and Elan series this feature is called partial metering) pick up your camera, turn it on, and enable its manual and spotmetering/partial metering modes. For many cameras, the spotmetering option is turned on if a small dot is showing in the center of a rectangle [⊡], or on the external LCD screen. For outside shots, you can set the shutter speed for your ISO 100 film to 125 (1/125 sec.) and leave it there. Now look through the viewfinder and point the spot frame/circle (located at the center of the viewfinder) at a subject with a uniform tone. This tone that we call a simple tone could be a portion of blue sky, a white wall, a person's forehead, or a gray card. By changing the aperture opening, you can determine the normal exposure settings. For most Nikon and Canon cameras, a pointer appears in the viewfinder exactly under the digit [0]. If you are not sure of your camera's dials, please refer to Appendix C. You may find a cheat sheet for your camera's exposure functions.

❏ With the center of your camera pointed at a piece of ***white paper placed in the shade,*** your camera may provide you with a normal exposure setting of 125@f-16. *What your spotmeter is actually doing, by design, is creating a medium gray image tone from this white surface.* It does not take much thinking to conclude that our "normal exposure" as indicated by the camera is creating a wrong image tone from a white surface. In this case, the "normal exposure" is not the same as the "correct exposure." Did I lose you? Let's try again.

❏ With the center of your camera pointed at a piece of ***black paper placed in the shade,*** your camera may provide you with a normal exposure setting of 125@f-4. What your spotmeter is actually doing is creating a medium gray image tone from a black surface. It does not take much thinking to conclude that our "normal exposure" as indicated by the spotmeter is creating a wrong image tone. In this case, the "normal exposure" is not the same as the "correct exposure." Did I lose you again? Let's try one more time.

❏ With the center of your camera pointed at a standard ***18% gray card placed in the shade,*** your camera may provide you with a normal exposure setting of 125@f-8. Again, your spotmeter is providing you with a normal exposure and by design, the tone of the image is medium (18%) gray. What your spotmeter is actually doing is creating a medium gray image tone from a medium gray surface.

It does not take much thinking to conclude that _in this situation our "normal exposure" as indicated by the spotmeter is creating a correct image tone on film. This means that for a gray card, the normal exposure and correct exposure are identical._

Extremely important conclusions:

From these three experiments you can conclude that when your camera's spotmeter is showing you a normal exposure from a simple subject, regardless of the tone of the subject, the image tone will always be 18% gray or medium gray. This is the hardest concept for my students to understand. Believe it or not, the spotmeter is designed to do just that! *That is why this is the most important page in this book*.

Please make sure that you review the next section (1.17). The Federal Express (FedEX) illustration has a lot to do with the system used in your spotmeter. Once you have grasped the concept, we are on our way to expose our first complex subject.

A very important summary for Section 1.16:

When you point your spotmeter at a simple surface (simple tone) and your camera indicates a "normal exposure," your spotmeter is simply creating an 18% gray image tone from this simple subject. ***This medium gray image tone is independent of its original subject tone***. This is the most important foundation of spotmetering. If you want something to remember this, please memorize the following:

There are three things that are for sure:

1) Death

2) Taxes

3) An 18% gray image tone from a normally exposed simple subject.

As cliché as it sounds, this saying can help you to remember this important property. Just make sure you do not leave out a single word. Without the unconditional understanding of this point, one can not learn proper application of a spotmeter.

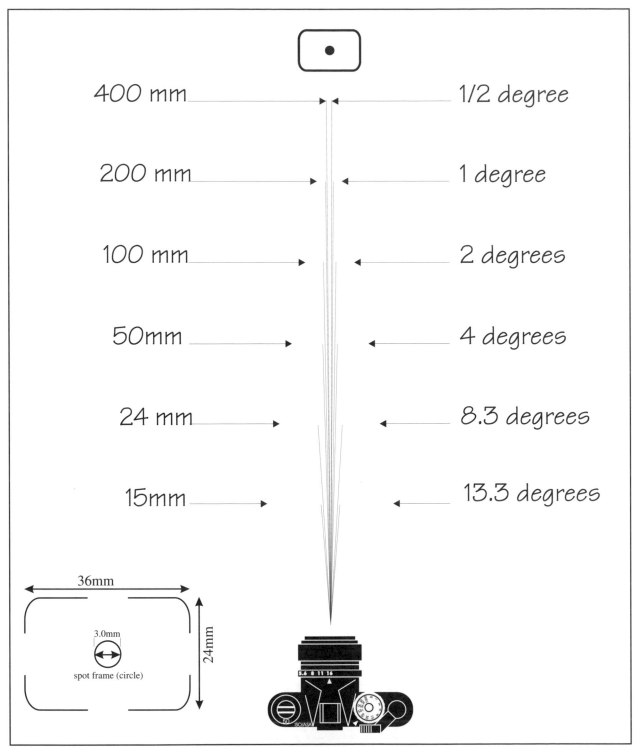

400 mm		1/2 degree
200 mm		1 degree
100 mm		2 degrees
50mm		4 degrees
24 mm		8.3 degrees
15mm		13.3 degrees

36mm

3.0mm

24mm

spot frame (circle)

Diagram 1.16.0

This generic diagram shows the approximate angle of measure for a 35mm camera with spotmetering capability. These specifications modeled after the Nikon N90/N70 cameras with a spotmetering diameter of 3.0mm, and an angle of measure of about 4 degrees with a 50 mm normal lens.

The spot circle (spot frame) is positioned correctly to determine the normal exposure of the white surface.

The spot circle (spot frame) is positioned correctly to determine the normal exposure of the black surface.

The spot circle (spot frame) is positioned **_incorrectly_**. When the measuring circle does not fall within the boundaries of a simple tone, its normal exposure reading is **_meaningless_** and **_cannot_** be interpreted correctly.

Diagram 1.16.1

These diagrams illustrate the correct use of the spot circle (spot frame).
When using an on-camera spotmeter, the measuring circle must fall within the boundaries of the simple subject whose normal exposure is being determined. Otherwise the "normal exposure" reading is meaningless and can not be interpreted correctly.

When spotmetering, the measuring circle (or frame) must fall within the boundaries of the _**simple**_ tone that is being measured.

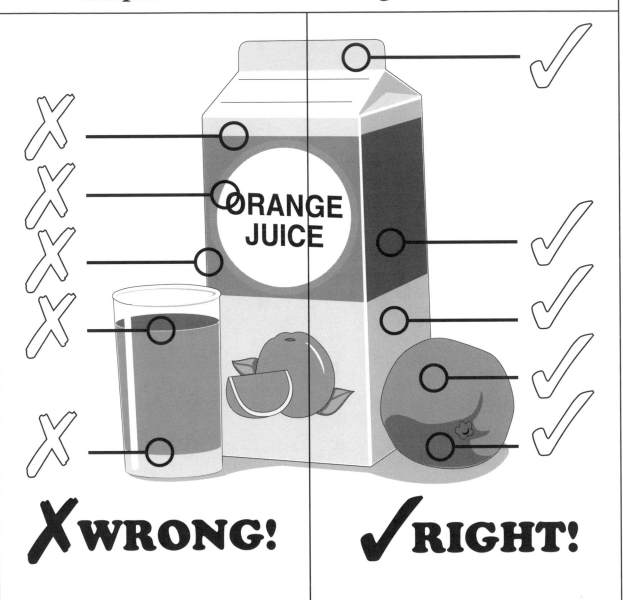

X WRONG!

✓ RIGHT!

Diagram 1.16.2

In this illustration, the circle illustrates the measuring circle (frame) of your spotmeter. For the normal exposure to be meaningful and consistent, the circle (or in some cameras the rectangle's) boundaries MUST fall WITHIN the boundaries of the _**simple**_ subject that is being evaluated. In other words what is inside of the frame MUST be a SIMPLE tone.

1.17 The Federal Express (FedEx) Story

The Federal Express Company (FedEx) is the world's largest express transportation company and carries more than two million packages daily. Many of these packages are delivered overnight to hundreds of destinations in the USA. For many years, until the volume became overwhelming, all packages from different cities, regardless of their final destination, were flown to Memphis, Tennessee to the FedEx base. From there the packages were sorted and placed on a plane and flown to their appropriate destinations (except all packages whose final destination were Memphis!) The two diagrams (1.17.1 and 1.17.2) illustrate similarities between your spotmeter's operation and that of the FedEx original operations.

1.17.1 Let's relate the FedEx's process to the function of your spotmeter

When sending a package from one city to another, the package always ended up in Memphis before it was shipped to its final destination. For many years Memphis was the base for the FedEx operations in the same way that the 18% gray image tone is the base for your spotmeter's operation. When you point the spotmeter in your camera at any simple subject and the meter in your camera shows a normal exposure, it is simply creating an 18% gray image tone. For the original FedEx, Memphis was considered to be the city where all packages had to change planes to reach their final destination. For your camera, 18% gray base can be considered as a point through which all **_simple_** image tones must pass before reaching their final destination. The only difference is that **_your camera does not know where these tones are coming from and where they are going_**. The final destination of any gray tone at the gray base must be determined by you, the photographer. Photographers, having the knowledge of spotmeter applications, know what the original tone looks like. They use this "normal exposure" as the base to determine the subjects "correct exposure."

Section 1.17 Summary:

During their early days, the Federal Express Company (FedEx) used a centralized method of package distribution. Using this method, all packages from anywhere in the US regardless of their final destination, were flown to Memphis every night before they were flown to their city of destination.

Your spotmeter uses a similar centralized technique. This means that the image tone of any normally exposed simple subject will **always go to the 18% gray image base** before it is sent to the correct destination tone by the skilled photographer.

Please remember: The 18% gray image tone to a meter is what Memphis was to the Federal Express operation.

1 The original operation of the FedEx Company

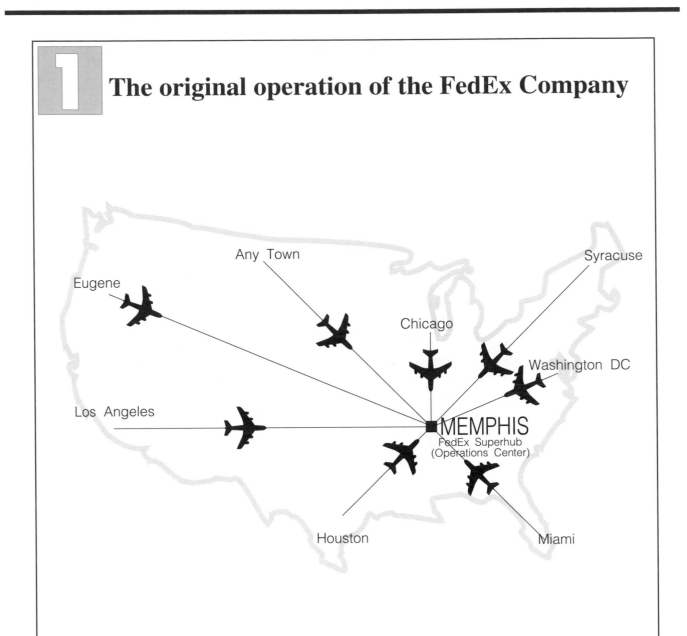

Diagram 1.17.1

Similarities between two operations:
The FedEx versus your camera's meter

Regardless of the city of origin, all packages ended up in Memphis each night before they were shipped to their final destination.

The operation of your camera's meter

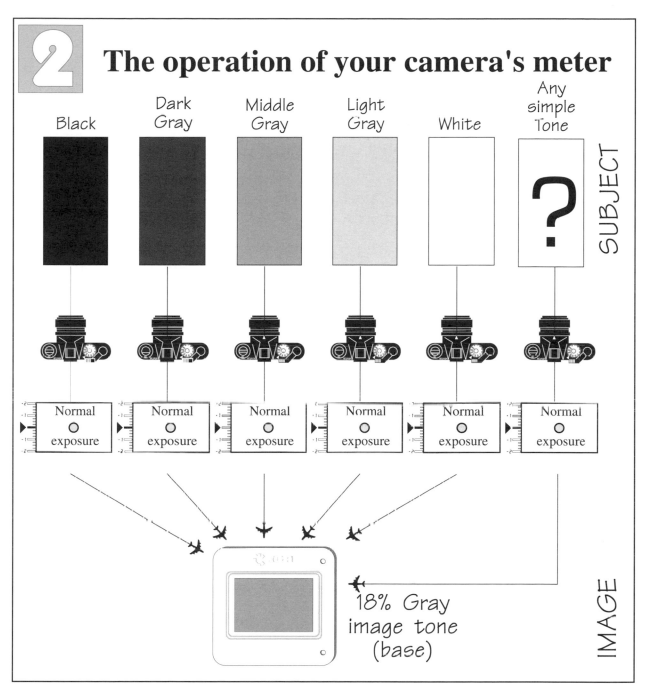

Black	Dark Gray	Middle Gray	Light Gray	White	Any simple Tone

SUBJECT

IMAGE

18% Gray image tone (base)

Diagram 1.17.2

Similarities between two operations: The FedEx versus your camera's meter

For these simple subjects, when your meter indicates a normal exposure, it is simply creating an image whose tone is 18% gray. **When a simple subject is normally exposed, the tone of the image will always be independent of the original tone of the subject.**

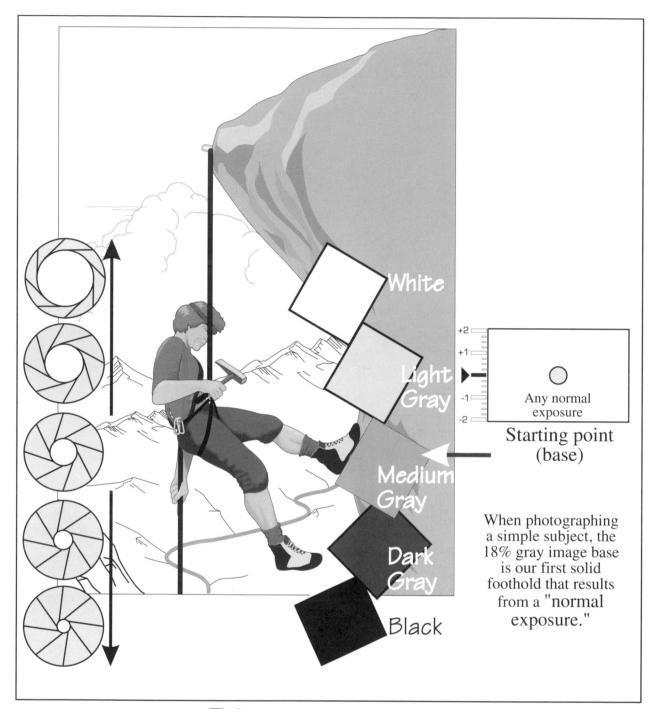

White

Light Gray

Medium Gray

Dark Gray

Black

+2
+1
-1
-2

Any normal exposure

Starting point (base)

When photographing a simple subject, the 18% gray image base is our first solid foothold that results from a "normal exposure."

Diagram 1.17.3

A climber can climb up and down the mountain, as a photographer can create brighter or darker image tones from the 18% gray image base. This 18% gray image base was generated when you exposed a simple subject using the spotmeter's normal exposure settings. To go up (brighten the image tone) a photographer can open-up the aperture, say, from f-5.6 to f-4. To go down (darken the image tone), a photographer can close-down the aperture, say, from f-5.6 to f-8. Where to go from this 18% gray image base would entirely depend on the tone of the original subject, your taste, your judgment, your objective, and skill as a photographer.

When photographing any simple surface such as mat board, white wall, portions of the blue sky, or snow

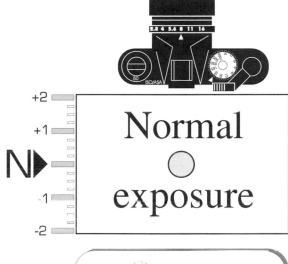

and your on-camera spotmeter indicates a normal exposure,

then the final image (regardless of the tone of the subject) will always have an 18% gray image tone.

Image of an 18% gray card or the 18% gray image tone

Chapter 1.17.4

Conclusions

When you use a spotmeter to find the normal exposure of a simple subject such as a white piece of paper, portions of the blue sky, or a snow-covered landscape, this reading creates an image whose tone is equivalent to that of a normally exposed 18% gray card. This image is generally called the 18% or standard gray image tone.

The "normally exposed" tone of the image is always independent of the original tone of the subject.

1.18 Exposure Determination of a complex subject

1.18.1 Using a Gray card *and* a spotmeter

We discussed how you can determine a gray card's correct exposure by simply determining its "normal exposure." As you remember, the gray card's "normal exposure" was also its "correct exposure." To determine a complex subject's "correct exposure," I assume that you and your subject are under the same lighting situation and the subject's tone is not extreme (snow or black velvet). For example, if your subject is sunlit, the sun is also shining on you and your gray card. If it is cloudy and the mountain that you are photographing is lit by the same light as your gray card.

One of the easiest techniques of exposure determination is to place an 18% gray card with your subject (or under the same light as your subject). Then point the spotmeter at the center of the gray card and determine the gray card's "normal exposure." In this case, as we learned before, the gray card's "normal exposure" is also the "correct exposure" for that lighting situation. The advantage of this method is that it is simple, accurate, and mechanical: i.e., you do not need to interpret the meter (and think too hard!) and find the "correct exposure" of the subject. One of the most frequently asked questions is "How do I hold my gray card?" The answer is that if the source of light is the sun, hold the gray card so that its gray surface is directly pointed towards the sun. This means the rays of sun strike the gray card in a right (90 degree) angle.

If you are still not sure, hold the gray card so that it points towards the sun and makes a 45 degree angle with the ground. If in doing so, you see glare on the surface of the card, tilt it slightly until the glare disappears. If it is cloudy and there is no distinct source of light, you can use the same 45 degree technique. Please remember: you must avoid glare at all costs! The major advantage of this method is that it is simple and does not involve much thinking. The major disadvantages of this technique are: a) You may not have a gray card (people do not like carrying them) b) You may not be able to place a card close to a subject; or you are not lit by the same light that is illuminating your subject. An example of this is that if you are in a tunnel and what you want to photograph is the scene that you see at the end of the tunnel or you are on a plane and you would like to photograph the clouds and the sky. Since you do not have access to the light that is illuminating your subject, you can not use the gray card to get a meaningful exposure.

1.18.2 How do you expect me to find the normal exposure with one hand while holding the gray card with the other?

This is another valid question that I am asked every time when I try to explain the exposure determination using the 18% Gray card. Fortunately, with the newer cameras it is very easy.

In order to determine the gray card exposure with one hand, you need to get help from two of your modern (and some older) camera functions, namely the shutter priority or the aperture priority.

1.18.3 One Handed Normal Exposure Technique: Using Shutter priority

If your camera has a Shutter Priority feature and you have a hard time finding the normal exposure of your gray card with one hand, you can try this:
Set your Shutter Speed to a desired value (say 1/250) and then change the camera's "Exposure Mode" setting from "M" to Shutter Priority ("S" or "Tv" (Time Value) on many of the newer cameras).

Now point the camera towards the center of your gray card with one hand.
With some cameras you must activate the meter by gently pushing down the shutter release button halfway. The camera will automatically give you the aperture opening for the "normal exposure" of your gray card (say f-16).
Now set your camera back to the "M"anual mode, set the exposure to 1/250@f-16, remove the card and shoot.

1.18.4 One Handed Normal Exposure Technique: Using Aperture priority

If your camera has an Aperture Priority feature and you have a hard time finding the normal exposure of your gray card with one hand, you can try this:
Set your aperture opening to a desired value (say f-8) and then change the camera's "Exposure Mode" setting from "M" to Aperture priority ("A" or "Av" (Aperture Value) on many of the newer cameras).
Now point the camera towards the center of your gray card with one hand.
With some cameras you must activate the meter by gently pushing down the shutter release button halfway.
The camera will automatically give you the shutter speed (exposure time) for the "normal exposure" of your gray card (say 1/125 sec.). Now set your camera back to the "M"anual mode, set the exposure to 1/125@f-8, remove the card and shoot.

Section 1.18 Summary:

When the light that falls on a subject also falls on you, and you have a gray card, you can determine the correct exposure of the subject quickly and accurately. Simply place the card in the same lighting situation as your subject. If in doubt, for outside shots place it at a 45 degree angle *facing the sky* (glare from the gray card must always be avoided). Then by using your spotmeter, find the card's "normal exposure." You can shoot using this setting since this exposure is also the "correct exposure."

How you can be sure that your exposure is correct? Simply turn the gray card upwards by a few degrees and point the camera at its center then tilt the card slightly downwards and then point the spot circle at its center. In both cases, the needle should not move and should stay in the middle confirming your original "correct exposure."

Please avoid this technique (using a gray card) for subjects that are too bright (snow) or too dark (black velvet).

1.19 Exposure Determination of a complex subject

1.19.1 Using a spotmeter *without* a gray card

To photograph a complex subject using a spotmeter, set your camera to the "Manual" mode and activate its spotmetering function. Then you need to follow these steps.

1) Observe the subject (don't just look at it!) This simple but obvious step is usually overlooked by many photographers.

2) Find a simple tone that you can use as a Reference Tone. Remember, with slide film you need to choose the brightest tone in the subject.

3) Once you have determined the normal exposure for this Reference Tone, you know one thing for sure: *__Regardless of what your subject tone is, this exposure setting will always create an 18% gray image tone on film.__*

4) *__At this point the function of your spotmeter is over.__* This is where your skill begins to kick in. Simply ask yourself if this 18% gray image tone truly represents your Reference Tone (subject tone). If your answer is yes, simply use the same "normal exposure" setting and shoot the picture.

5) If not (if your Reference Tone *is not* medium gray) simply look at this book's Tone Ruler and ask yourself the following question:

Which one of these other tones (Black, Dark gray, Light gray or White) closely resembles your Reference Tone? *__Remember, you have only four choices and you must choose one of them! If you are in doubt, choose one of these tones anyway. Once you have made the choice, simply follow the logic for determining the "correct Exposure."__*

❏ If you chose **Black,** close-down the aperture by two stops and shoot.

❏ If you chose **Dark Gray**, close-down the aperture by one stop and shoot .

❏ If you chose **Light Gray,** open-up the aperture up by one stop and shoot.

❏ If you chose **White,** open-up the aperture up by two stops and shoot.

1.19.2 Example 1:

Assume that you chose a Reference Tone that is white and that your camera indicated a normal exposure of 125@f-16. With this normal exposure, the image tone will be 18% gray. Now you have to choose a tone from the Tone Ruler to match the subject tone. The tone to choose is white; hence you have to open-up from the normal exposure by two stops to brighten the gray image tone and make it white. Therefore, the "correct exposure" is 125@f-8.

1.19.3 Example 2:

Assume that you chose a Reference Tone that was Light Gray and that your camera indicated a normal exposure of 125@f-11. With this normal exposure, like always, the image tone will be 18% gray. Now you have to choose a tone from the Tone

Ruler to match the subject tone. The tone to choose is Light Gray; hence you have to open-up the normal exposure's aperture by one stop to brighten the gray image tone and make it Light Gray. Therefore the "correct exposure" is 125@f-8.

1.19.4 Example 3:

Assume that you chose a Reference Tone that was Black and that your camera indicated a normal exposure of 125@f-4. With this normal exposure, like always, the image tone will be 18% gray. Now you have to choose a tone from the Tone Ruler to match this Reference Tone. The tone to choose is Black; hence you have to close-down from the normal exposure by two stops to darken the gray image tone and make it Black. Therefore the "correct exposure" is 125@f-8.

1.19.5 Exposure determination exercise:

Assume that you chose a Reference Tone that was Dark Gray and that your camera indicated a normal exposure of 125@f-5.6. With this normal exposure, like always, the image tone will be 18% gray. Now you have to choose a tone from the Tone Ruler to match this Reference tone. The tone to choose is ____ ____; hence you have to _____ from the normal exposure by ____ stop(s) to _____ the gray image tone and make it _____. Therefore the "correct exposure" is 125@___.

Section 1.19 Summary:

To determine the correct exposure of your complex subject, choose an important simple tone within your complex subject and find its "normal exposure." Once you have done this, the function of your spotmeter is over. Now decide which of the five tones (Black, Dark Gray, Medium Gray, Light Gray, White) represents your subject tone. As hard as it sounds you must make this decision. Once you determined this, use the following logic to determine the "correct exposure" of your subject:

If you chose Black, close-down by two stops and shoot.

If you chose Dark Gray, close-down by one stop and shoot.

If you chose Medium Gray, leave the settings as they are and shoot.

If you chose Light Gray, open-up by one stop and shoot.

If you chose White, open-up by two stops and shoot.

1.20 Let's photograph our first complex subject

The snow covered cottage on the next page will be our first complex subject to analyze and photograph. In this specific subject, we have three distinct tones: the snow, the walls, and the door. *__For illustration purposes__*, every one of these three subjects (surfaces) can be considered a simple subject and therefore can be used as the Reference Tone.

*We must choose **one** of these tones (snow, wall or the door) as the Reference Tone.* Then by determining the correct exposure for this tone, we will have determined the correct exposure for the entire subject.

To do this you need to match the Reference Tone with one of the five tones of the Tone-Ruler. It is up to you to select the "wall," the "door," or the "snow" as your Reference Tone. Once you have matched the Reference Tone with a tone on the Tone-Ruler, the rest is easy.

For some people (myself included), the hardest part of this process is to match the Reference Tone with one of the tones on the Tone-Ruler. If you have a hard time with this technique, try the negative logic that I use. To illustrate, let's use the wall as our Reference Tone. When using this technique, we always start with 5 tones and by *eliminating tones that **do not** resemble the subject*, we will end up with the tone that would. The reasoning goes something like this:

Since the wall is not black, we are left with 4 other choices.

Since the wall is not white, we are left with 3 other choices.

Since the wall is not dark gray, we are left with 2 other choices.

Since the wall is not 18% gray, we are left with 1 other choice.

By default, our only remaining choice is the 36% gray tone. Therefore, we will assign the 36% reflectivity to the wall.

To expose the complex subject properly, we simply measure the normal exposure for the wall and open-up one stop (brighten-up the 18% gray image tone to 36% light gray).

You can use this "reverse" logic to any simple tone that you see around you to determine its approximate exposure. Please remember that you will make mistakes in the beginning. It will always help to keep notes! *Actually, you'll learn nothing if you don't keep notes.*

As you practice, you will become increasingly skilled at placing tones into their appropriate reflectivity on the Tone-Ruler.

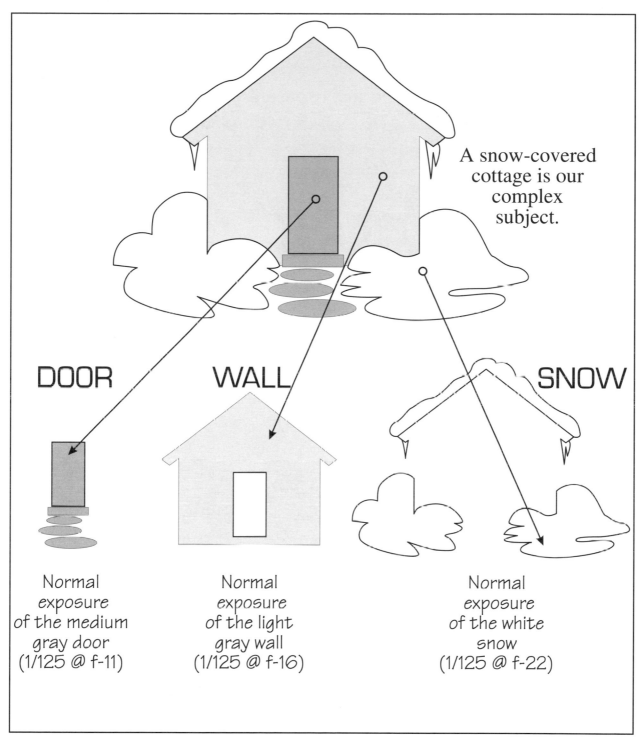

A snow-covered cottage is our complex subject.

DOOR

WALL

SNOW

Normal exposure of the medium gray door (1/125 @ f-11)

Normal exposure of the light gray wall (1/125 @ f-16)

Normal exposure of the white snow (1/125 @ f-22)

Diagram 1.20.0

The tones of a complex subject can always be broken down to its simple tone components. In this case, our simple subject tones are: DOOR, WALL, and SNOW.

1 Using the SNOW as the Reference Tone

Find the snow's normal exposure.

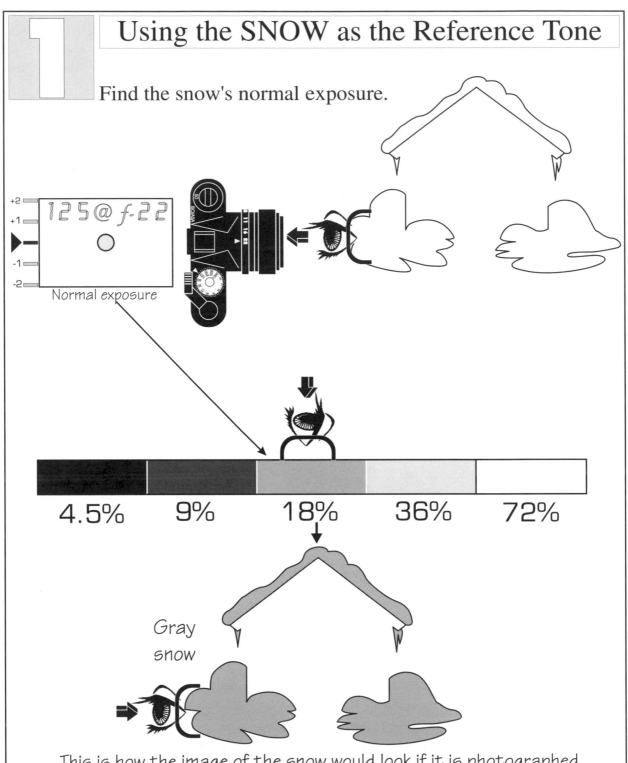

Normal exposure

4.5% 9% 18% 36% 72%

Gray snow

This is how the image of the snow would look if it is photographed with the normal exposure setting of 1/125 @ f-22.

Diagram 1.20.1

Using the SNOW as the Reference Tone

2

To change the image tone of the SNOW from 18% gray to 72% white, we need to open-up the aperture by two stops from this setting. This results in a final exposure of 1/125 @ f-11.

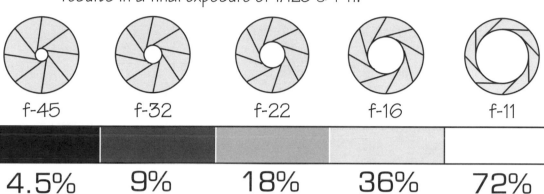

| f-45 | f-32 | f-22 | f-16 | f-11 |

| 4.5% | 9% | 18% | 36% | 72% |

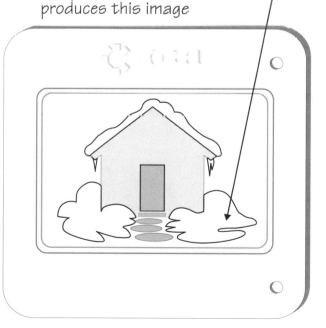

72% white

A final exposure of 1/125 @ f-11 produces this image

Once the image of the snow has a 72% white tone, the image of the DOOR will have an 18% gray tone, and the image of the WALL will have a 36% gray tone. Remember, the DOOR and the WALL fall into 18% and 36% image tones because of our original assumptions about this subject. If these two tones had different reflectivities, they would have still fallen into their appropriate places and would be correctly exposed.

Diagram 1.20.2

Using the WALL as the Reference Tone

1 Find the wall's normal exposure.

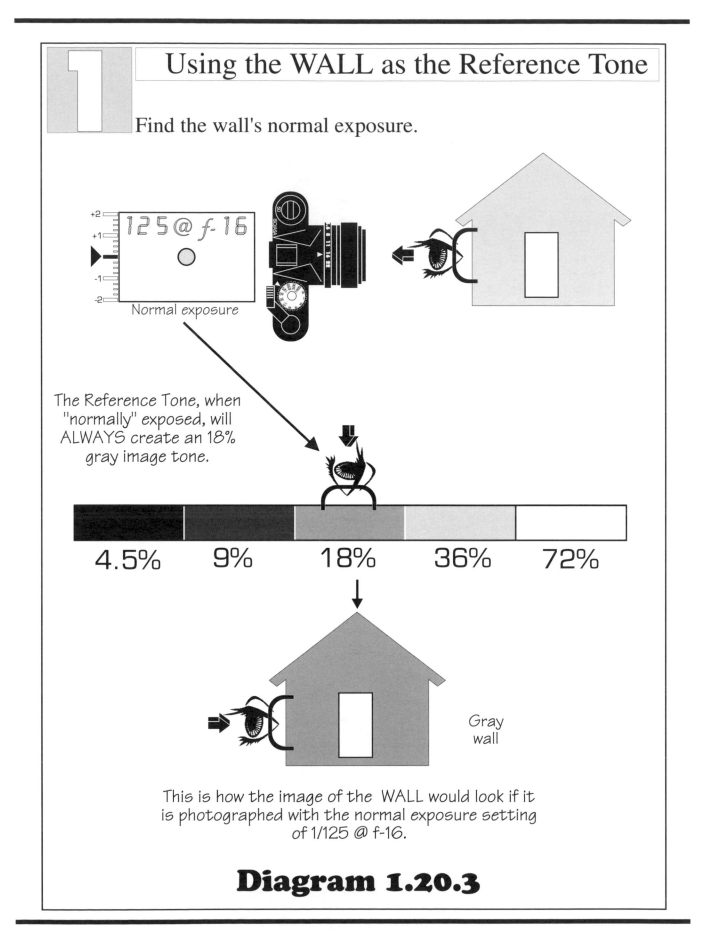

+2
+1
-1
-2

125 @ f-16

Normal exposure

The Reference Tone, when "normally" exposed, will ALWAYS create an 18% gray image tone.

4.5% 9% 18% 36% 72%

Gray wall

This is how the image of the WALL would look if it is photographed with the normal exposure setting of 1/125 @ f-16.

Diagram 1.20.3

Using the WALL as the Reference Tone

To change the image tone of the WALL from 18% gray to 36% gray, we need to open-up the aperture by one stop from this setting. This results in a final (correct) exposure of 1/125 @ f-11.

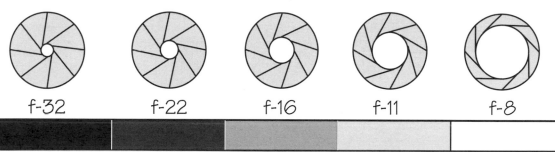

f-32	f-22	f-16	f-11	f-8
4.5%	9%	18%	36%	72%

18% gray image

36% gray image

A final exposure of 1/125 @ f-11 produces this image.

Once the image of the WALL has a 36% gray tone, the image of the DOOR will have an 18% gray tone and the image of the SNOW will have a 72% white tone. Remember, the DOOR and the SNOW fall into 18% and 72% image tones because of our original assumptions about this subject. If these two tones had different reflectivities, they would have still fallen into their appropriate places and would have been correctly exposed.

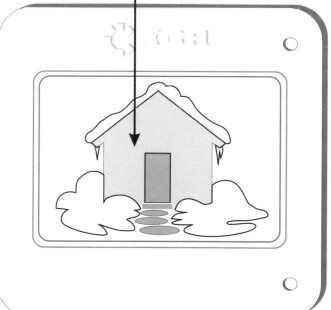

Diagram 1.20.4

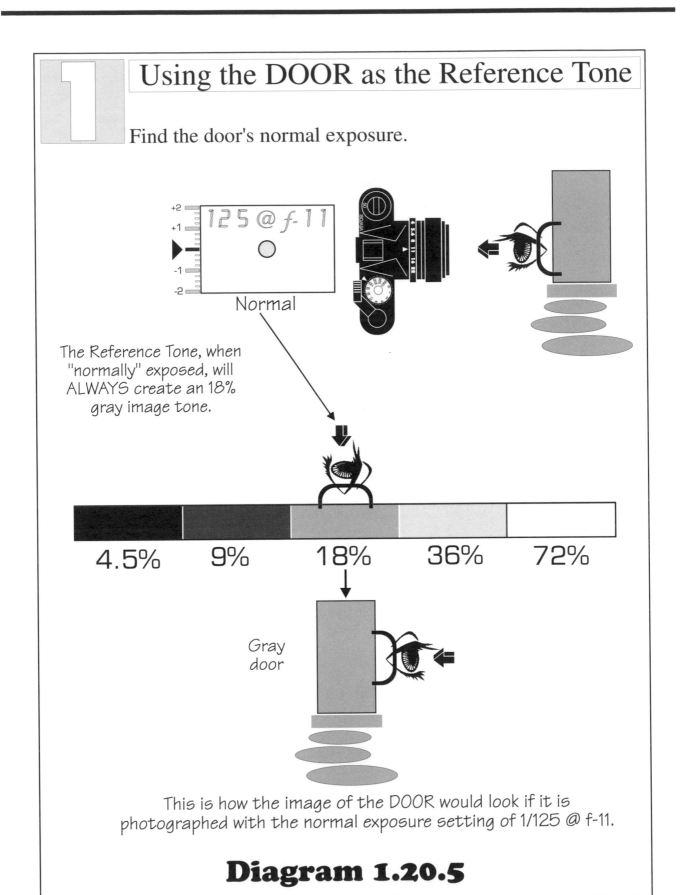

Using the DOOR as the Reference Tone

Find the door's normal exposure.

$125 @ f-11$

Normal

The Reference Tone, when "normally" exposed, will ALWAYS create an 18% gray image tone.

| 4.5% | 9% | 18% | 36% | 72% |

Gray door

This is how the image of the DOOR would look if it is photographed with the normal exposure setting of 1/125 @ f-11.

Diagram 1.20.5

Using the DOOR as the Reference Tone

Since the door's tone approximates a medium gray, by keeping the exposure at 1/125 @ f-11, its image will have an 18% gray tone.

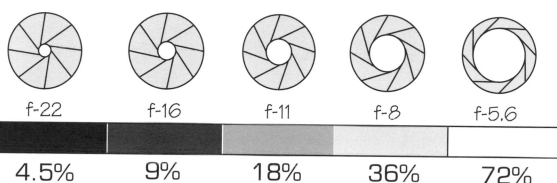

f-22	f-16	f-11	f-8	f-5.6
4.5%	9%	18%	36%	72%

18% gray image

A final exposure of 1/125 @ f-11 produces this image.

Once the image of the DOOR has an 18% gray tone, the image of the SNOW will have a 72% white tone and the image of the WALL will have a 36% gray tone. Remember, the WALL and the SNOW fall into 36% and 72% tones because of our original assumptions about this subject. If these two tones had different reflectivities, they would have still fallen into their appropriate places and would be correctly exposed.

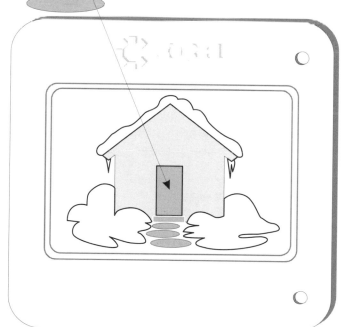

Diagram 1.20.6

1.21 Tone Train Technique applied to the snow-covered cottage

The following three pages illustrate the Tone Train Technique to determine the exposure for each of the three tones of the snow-covered cottage. Please take a few minutes to familiarize yourself with its application.

In this illustration, there are two railroad tracks. The top one is the SUBJECT track and the lower one is the IMAGE track.

Moving the train to the right (brightening its image tone):

As can be seen, as the subject tone is moved to the right, its image becomes brighter. This is done by opening-up the aperture by one or two stops. The objective is to move the subject to the right so that the subject tone aligns itself with its corresponding bright image tone.

Moving the train to the left (darkening its image tone):

Inversely, as the subject train moves to the left, its image gets darker. This is done by closing-down the aperture by one or two stops. The objective is to move the subject to the left so that it aligns with its corresponding dark image tone.

Please study the next three pages carefully!

The concept is very simple and by moving the subject train (DOOR, WALL, and SNOW) alongside the image train, we can park the train in a location where its tones are represented by the image train. As you would notice in each example, we have chosen a different tone. Once we selected the Reference Tone, we find its normal exposure. By finding its normal exposure, *__the Reference Tone will always align itself with the medium gray (18%) image tone in the middle__*. The following are three scenarios for these illustrations:

❏ By choosing the SNOW to be White, at the normal exposure, its image will be aligned with the 18% gray tank car. Since we want the wall to have a White tone, we open-up the aperture by two stops (moving the subject train to the right by two car lengths), the subject train will be correctly aligned with the image train. We now can shoot the picture.

❏ By choosing the WALL to be Light Gray, at the normal exposure, its image will be aligned with the 18% gray tank car. Since we want the wall to have a light gray tone, we open-up the aperture by one stop (moving the subject train to the right by one car length), the subject train will be correctly aligned with the image train. We now can shoot the picture.

❏ By choosing the DOOR to be Medium Gray, at the normal exposure, its image will be aligned with the 18% gray tank car. Since the subject's image matches the subject tone, we leave the settings as they are and shoot.

Please note that if you want to understand the more advanced concepts of spotmetering, you must study and understand these illustrations.

The loaded tank car represents the tone of a simple subject. Movement of the tank car to the left or right is controlled by opening-up or closing-down the aperture.

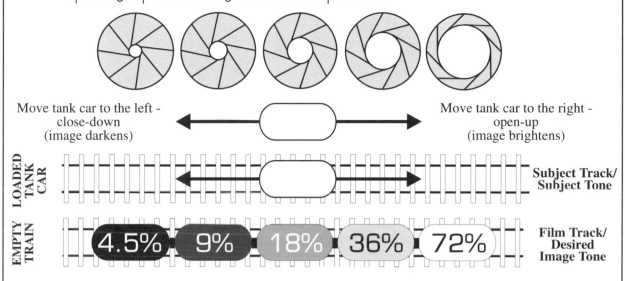

Move tank car to the left -
close-down
(image darkens)

Move tank car to the right -
open-up
(image brightens)

LOADED TANK CAR

Subject Track/
Subject Tone

EMPTY TRAIN

| 4.5% | 9% | 18% | 36% | 72% |

Film Track/
Desired
Image Tone

An empty five-car train representing the Standard Tones that can be captured by slide film. Each tank represents the image tones of our Standard Tone Ruler.

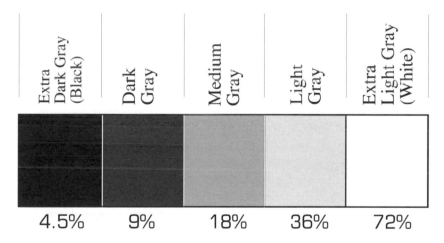

Extra Dark Gray (Black)	Dark Gray	Medium Gray	Light Gray	Extra Light Gray (White)
4.5%	9%	18%	36%	72%

The Five-Stop Tone Ruler

Diagram 1.21.0

Graphic illustrations for a loaded tank car representing a simple subject and an empty five-car train representing the film image tones. For this example, the loaded car (subject) has a white tone.

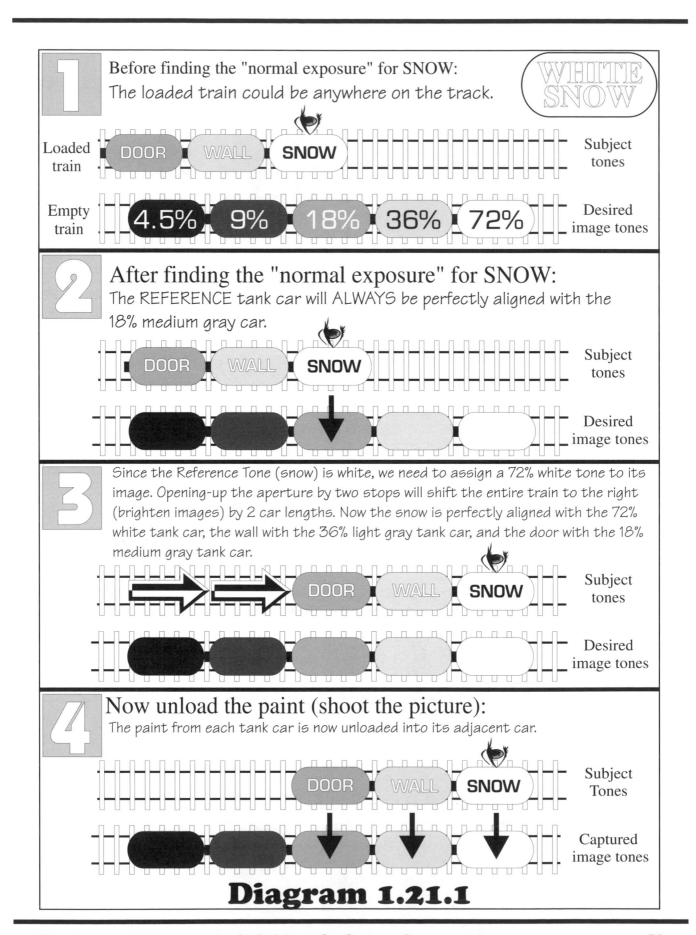

1 Before finding the "normal exposure" for SNOW:
The loaded train could be anywhere on the track.

WHITE SNOW

Loaded train — DOOR WALL **SNOW** — Subject tones

Empty train — **4.5%** **9%** **18%** **36%** **72%** — Desired image tones

2 After finding the "normal exposure" for SNOW:
The REFERENCE tank car will ALWAYS be perfectly aligned with the 18% medium gray car.

DOOR WALL **SNOW** — Subject tones

Desired image tones

3 Since the Reference Tone (snow) is white, we need to assign a 72% white tone to its image. Opening-up the aperture by two stops will shift the entire train to the right (brighten images) by 2 car lengths. Now the snow is perfectly aligned with the 72% white tank car, the wall with the 36% light gray tank car, and the door with the 18% medium gray tank car.

DOOR WALL **SNOW** — Subject tones

Desired image tones

4 Now unload the paint (shoot the picture):
The paint from each tank car is now unloaded into its adjacent car.

DOOR WALL **SNOW** — Subject Tones

Captured image tones

Diagram 1.21.1

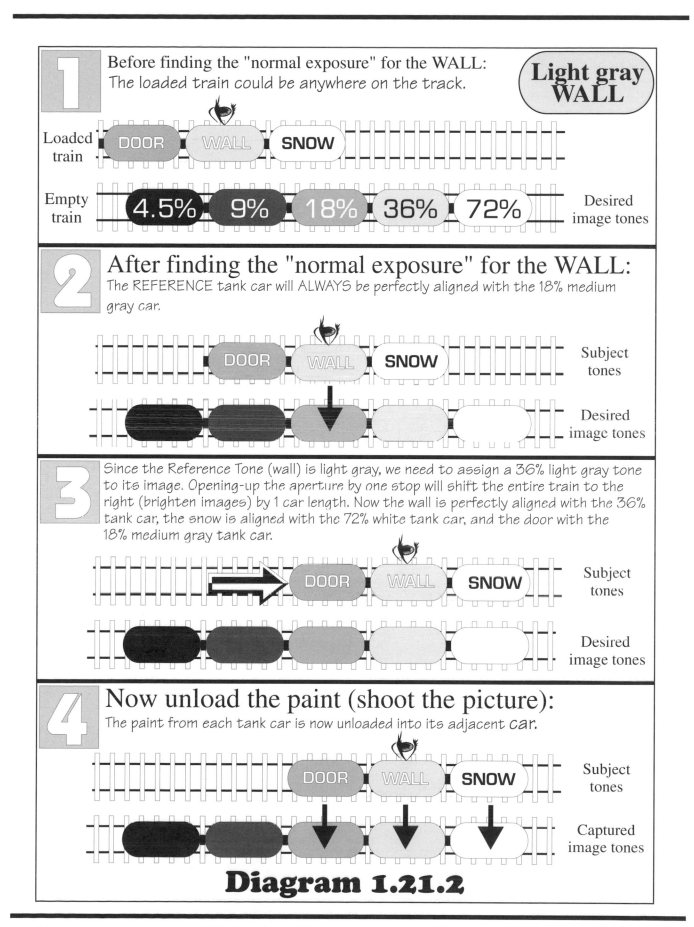

1 Before finding the "normal exposure" for the WALL:
The loaded train could be anywhere on the track.

Light gray WALL

Loaded train: DOOR WALL SNOW

Empty train: 4.5% 9% 18% 36% 72% — Desired image tones

2 After finding the "normal exposure" for the WALL:
The REFERENCE tank car will ALWAYS be perfectly aligned with the 18% medium gray car.

DOOR WALL SNOW — Subject tones

— Desired image tones

3 Since the Reference Tone (wall) is light gray, we need to assign a 36% light gray tone to its image. Opening-up the aperture by one stop will shift the entire train to the right (brighten images) by 1 car length. Now the wall is perfectly aligned with the 36% tank car, the snow is aligned with the 72% white tank car, and the door with the 18% medium gray tank car.

DOOR WALL SNOW — Subject tones

— Desired image tones

4 Now unload the paint (shoot the picture):
The paint from each tank car is now unloaded into its adjacent car.

DOOR WALL SNOW — Subject tones

— Captured image tones

Diagram 1.21.2

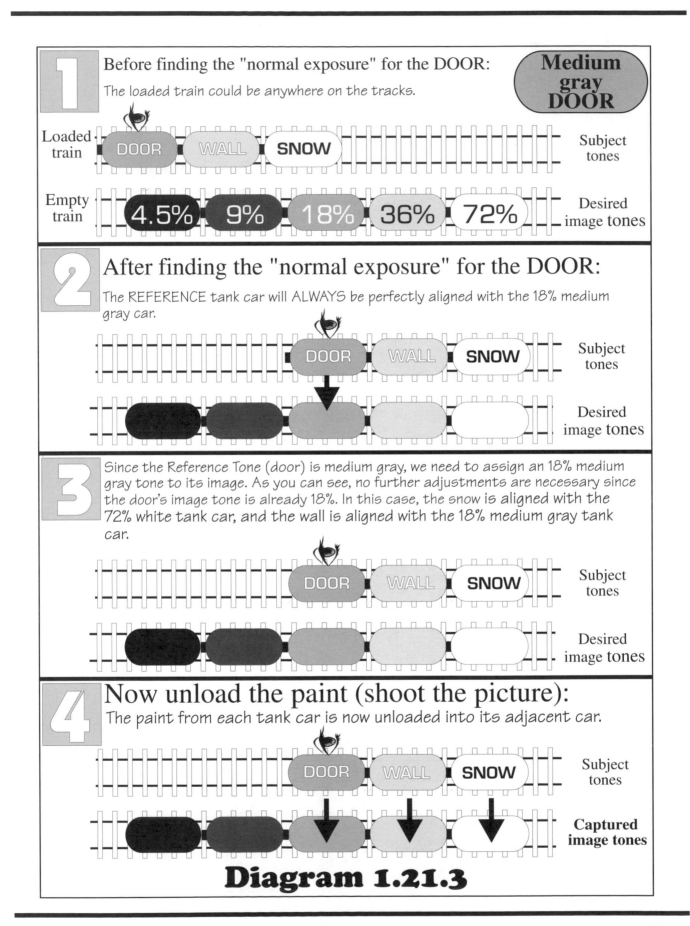

1 Before finding the "normal exposure" for the DOOR:

The loaded train could be anywhere on the tracks.

Medium gray DOOR

Loaded train — DOOR | WALL | SNOW — Subject tones

Empty train — 4.5% | 9% | 18% | 36% | 72% — Desired image tones

2 After finding the "normal exposure" for the DOOR:

The REFERENCE tank car will ALWAYS be perfectly aligned with the 18% medium gray car.

DOOR | WALL | SNOW — Subject tones

Desired image tones

3 *Since the Reference Tone (door) is medium gray, we need to assign an 18% medium gray tone to its image. As you can see, no further adjustments are necessary since the door's image tone is already 18%. In this case, the snow is aligned with the 72% white tank car, and the wall is aligned with the 18% medium gray tank car.*

DOOR | WALL | SNOW — Subject tones

Desired image tones

4 Now unload the paint (shoot the picture):

The paint from each tank car is now unloaded into its adjacent car.

DOOR | WALL | SNOW — Subject tones

Captured image tones

Diagram 1.21.3

On-camera spotmetering - More advanced concepts

What will you learn in this chapter?
In this chapter we will explain the meaning of the Subject Brightness Range (SBR) and the Film Contrast Range (FCR) and how to fit a subject onto a specific type of film.

If previous chapters have confused you, please stop right here.

2.1 A review of Chapter 1

What you learned in the last chapter, whether you know it or not, was the ***single tone metering of a complex subject***. This involved selecting a tone, preferably the subject's most important tone or the brightest tone, and finding its normal exposure. Once this was determined, you equated this tone with one of the five standard tones on the Tone Ruler. You may have done this by looking at the tone ruler or by using your own judgment. Depending on which tone you choose, you left the settings as they were, opened-up the aperture by 1 or two stops, or you closed-down the aperture by 1 of 2 stops. Remember, we could have achieved the same thing changing the shutter speed, however, in this book to keep things simple, we keep the shutter speed constant! Then you shot the picture. What you did was called overriding your camera to create a correctly exposed image. ***The idea behind this simplified system was that once you have exposed one tone correctly, the rest of the tones follow and they would be exposed correctly.***

For many of you, including myself, this technique is all you need. The drawback of this simplified technique, as some could claim, is that the exposure is determined without any concern about the Subject's Brightness Range (SBR) or the Film's Contrast Range (FCR). If these two new buzzwords caught you totally off guard, don't worry. These terms are used in determining the range of tones in a subject and whether these tones can be successfully recorded on a specific film. It is a way of recording a subject's image (or fitting the subject's image into a film). Here is a brief explanation. We will cover these in detail later on.

Like everything else in photography, SBR and FCR are both measured in STOPs. FCR is very much like the number of seats on a plane. As the number of seats on a plane limits the number of passengers that can be carried, the FCR of a film limits how much of the subject can be successfully recorded on film. The SBR of a subject in STOPs is determined by the subject's lightest and darkest tones. A subject with a short tonal range may have an SBR of 2 to 3 stops. A typical subject has an SBR of 5 stops and a subject with a long tonal range has an SBR of about seven stops. In real life, SBRs of more than 7 are rare and one has to look very hard to find them.

In general, the FCR of a film for factory recommended development is fixed. For example, the FCR of 35mm slide film is about five stops, for 35mm black and white negative film it is about 7 stops, for color negative film it is about six stops, and for Polaroid Instant film it is about 3 stops. Since the FCR of a film is fixed, as the number of seats on a plane is fixed, then we can use our on-camera spotmeter to determine the subject's SBR that we are planning to photograph. After determining this, we can decide whether the film can accommodate (record) the entire subject tones or not. If it can, we can use the same techniques that we used in the last chapter to expose the film. If the subject's SBR is greater than what the film can accommodate, then we have to choose on how we can compromise to get the film to produce the desired image. Before we can do this, we need to explain in full what we mean by "Highlights," "Lowlights (shadows)," Subject Brightness Range (SBR), and Film Contrast Range (FCR).

2.2 Subject Highlights

The areas or portions of a subject that are the brightest and that you wish to control and capture are defined as "Highlights."

Let's start with a classic example of a sunlit, snow-covered mountain top. In your scene, chances are that the sunlit snow will be the brightest tone. This example, although extreme, illustrates the concept. The term "Highlight" is generally used to indicate the brightest part of the subject.

In brief, highlights are considered to be the brightest (or the most reflective) part of the subject that you have an interest in capturing its tone and controlling its detail (Please see Appendix A).

2.2.1 When in doubt, use your spotmeter to determine subject's highlight

Sometimes, you may not be able to visually determine the subject's highlight. In cases like this, you can use the on-camera spotmeter to determine which one of the two surfaces are brighter. As before, set your mode to "Manual" and activate the spotmetering function. Now pick your first highlight and by pointing the spot frame of the spotmeter at this tone, find its "normal exposure."

Keeping the shutter speed and aperture opening the same, now point the spotmeter at the second tone. If the little indicator in your viewfinder moves towards [+], this tone is brighter than the previous tone and can be used as your new highlight. If the indicator moves towards the [-], the new tone is darker than the first tone and you can use the first tone as your subject's highlight. If the indicator stays the same, both highlights have the same tone.

2.3 Subject Lowlights (Shadows)

Lowlights are the opposite of highlights. By definition, the darkest area of the subject that you have an interest in capturing is called the subject's lowlight. In many older books on exposure, lowlights are referred to as shadows. The term "shadows" is misleading, since you may have a piece of black velvet in the sun creating your sunlit subject's lowlight. However, it is not shadowed. Remember, shadows generally represent the lowlight areas of an outdoor scene, but every lowlight is not necessarily shadowed.

In brief, lowlights are considered to be the darkest (or the least reflective) part of the subject that you have an interest in capturing its tone and controlling its detail (Please see Appendix A).

2.3.1 When in doubt, use your spotmeter to determine subject's lowlight

Sometimes, you may not be able to visually determine the subject's lowlight. In cases like this, you can use the on-camera spotmeter to determine which one of the two surfaces are darker. As before, set your mode to "Manual" and activate the spotmetering function. Now pick out the first lowlight tone and by pointing the measuring circle of the spotmeter at this surface, find its "normal exposure."

Keeping the shutter speed and aperture opening the same; now point the spotmeter at the second tone. If the little indicator in your viewfinder moves towards [-], this tone is darker than the previous tone and can be used as your new lowlight. If the indicator moves towards the [+], the new tone is brighter than the first tone and you can use the first tone as your subject's lowlight. If the indicator stays the same, both lowlights have the same tone.

2.4 Examples illustrating SBR and FCR

The definition of "Subject Brightness Range" and "Film Contrast Range" somehow scares people off. Since these two concepts are new to you, let's discuss them in terms that are easy to understand.

2.4.1 Example:

Let's assume we have a bus with 32 seats. Let's also assume that all passengers must sit beside one another (very much like a chain).

1) In the first scenario we have 20 passengers:

As you can imagine, the passengers have three main seating choices. First, they can sit in the front of the bus. Second, they can sit in the middle of the bus (in this case the front and back seats will remain empty). Third, they can sit in the back. In this case, the front row seats will remain empty. Having 20 passengers represents the case where SBR is less than the FCR. In this case the photographer has different choices of fitting (recording) the subject onto the film.

2) In the second scenario we have 32 passengers:

In this case, since the number of passengers and seats are the same, it is a perfect fit. This represents the case where SBR was the same as FCR; a perfect subject/image fit.

3) In the third scenario we have 40 passengers:

Since the number of passengers exceeds the number of seats, eight passengers will be left behind. This illustrates the case where the SBR of the subject is greater than the FCR of the film. Since the film can not accommodate all tonal values of the subject, parts of the subject will not be recorded on film.

2.5 How to determine the SBR of a subject

Let's illustrate the SBR through the following procedures and scenarios:

2.5.1 SBR Determination procedure:

1) Observe the subject.

2) Visually locate the highlights and the lowlights of the subject that are important to you and that you wish to photograph. You must make this decision!

3) Set your aperture to f-22 or the smallest aperture opening on your lens.

4) Set your camera's metering to "Manual" mode and activate its spotmetering function.

5) Point the spotmeter at the brightest section of the subject. Keep the aperture opening at 22 or the smallest on your lens, and by changing the shutter speed determine the highlight's "normal exposure."

6) Assume the normal exposure from this bright simple tone (highlight) is **125@f-22** (remember, the aperture must be kept on f-22 or the smallest aperture opening of your lens).

7) Now point the spotmeter at the darkest part of your subject (the subject's lowlight) and determine its "normal exposure." *This must be done by changing the **Aperture** opening only, i.e., do not touch the shutter speed dial!*

Now let's learn the SBR determination for ***three different subjects***. To keep things simple, we'll ***consider three different complex subjects whose highlights have the same brightness (normal exposure of 125@f-22)*** but whose lowlights have different reflectivities.

2.5.2 Scenario 1 — SBR the same as FCR:

As was described in the previous section, the normal exposure of the highlights was 1/125@f-22. By keeping the shutter speed the same, *let's assume that our lowlight's normal exposure is 1/125@5.6.*

In this case, the SBR is determined by counting the f-stops from f-22 to f-5.6. Let's count: f-22, f-16, f-11, f-8, f-5.6. Five f-numbers represent an SBR of 5 stops. Remember: Very much like a Yardstick, you must count <u>ALL</u> aperture openings, including f-22 as well as f-5.6. A subject with an SBR of 5 stops is considered to be a subject with medium tonal range.

2.5.3 Scenario 2 — SBR less than FCR:

In this case, we have a highlight "normal exposure" of 1/125@f-22. By keeping the shutter speed the same, *let's assume that our lowlight's normal exposure is 1/125@f-11.*

To determine the SBR of this new subject, we count the aperture openings, i.e., f-22, f-16, and f-11. Therefore the SBR of the subject is 3 stops. A subject with an SBR of 3 stops is considered to be a subject with a short tonal range.

2.5.4 Scenario 3 — SBR greater than FCR:

Let's assume that the normal exposure from the lowlight tone of the third subject is 1/125@f-2.8. Please remember that the subject's highlight, as in the previous examples has a normal exposure of 125@f-22.

To determine the SBR of this new subject, we will count *all* the aperture openings, i.e., f-22, f-16, f-11, f-8, f-5.6, f-4, and f-2.8. Therefore by our definition, the SBR of this subject is 7 stops. A subject with an SBR of 7 stops is considered to be a subject with a long tonal range.

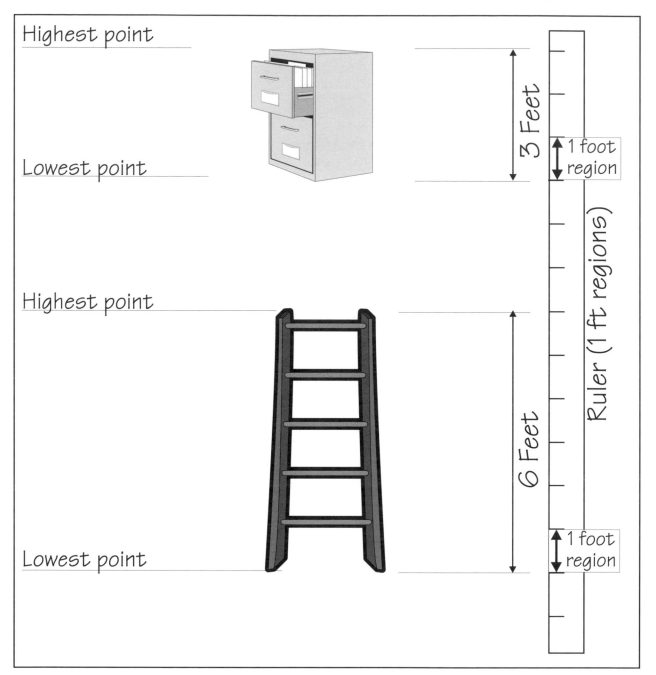

Diagram 2.5.1

Subject's height measurement illustration

Height measurement is made from the lowest point to the highest. In this illustration, the file cabinet is 3 feet high and the ladder is 6 feet high. Please remember that to find the height, you count the number of 1-foot regions between the markings.

Another important feature of this method of measurement is that the number of notches on the ruler is always one more than the height of the subject.

In the case of the file cabinet, it is four (one more than three).

In the case of the ladder, it is seven (one more than six).

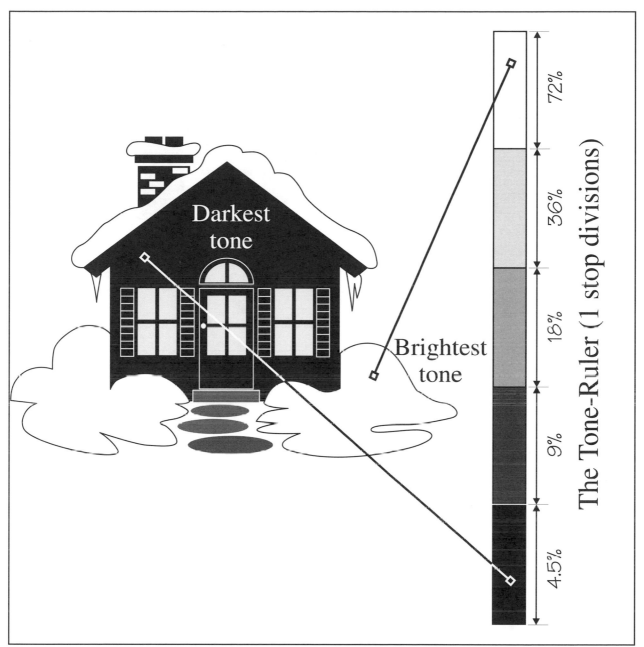

Diagram 2.5.2

Subject Brightness Range illustration

In Diagram 2.5.1, we used a ruler to measure the height by counting the number of 1-ft regions along the length of the subject. In this example, we simply count the number of STOPs from the darkest to brightest region.

In Diagram 2.5.1, the unit of height was FEET. In this diagram, the unit of range is STOP. The SBR of this subject is 5 STOPs.

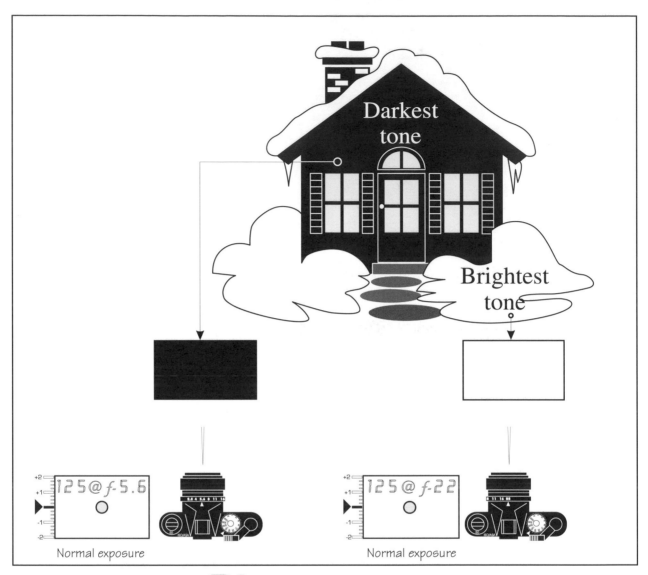

Normal exposure Normal exposure

Diagram 2.5.3

Subject Brightness Range illustration

As illustrated, your on-camera spotmeter indicates a normal exposure of f-5.6 from the darkest and f-22 from the brightest part of the subject. (Remember, the shutter speed is kept constant at 1/125 sec.) Since the aperture sequence is 22, 16, 11, 8, and 5.6, then by counting the number of these aperture openings, the SBR of this subject is 5 stops.

Please remember, with the method that is used in this book, counting all the aperture readings is all you need to determine SBR. If you are confused, simply think of each aperture (f-stop) reading as a yardstick and not as a notch of a ruler. When using a yardstick, one counts the number of times that the stick is placed along the subject. If this count is 4, then the length is 4 yards and if it is 1, then the length is 1 yard. The same applies to the on-camera spotmeter.

2.6 Film Contrast Range (FCR)

As previously stated, the FCR of the film stands for **F**ilm **C**ontrast **R**ange and is generally fixed for a given film when the film's standard development procedures are followed. The FCR of a film, very much like the number of seats on an airplane, is fixed. If you want to compare the recording ability of your film to what your eye sees, your eye sees approximately 10 to 11 stops. Slide film records about 5 stops and most 35mm black and white films have an FCR of about 7 stops. As you can see, no film can "see" and "record" as your eye sees. Generally, this gives the image, regardless of the film that you use, more contrast than is seen by your eyes. The following is a list of some typical films with their FCR values. If you want to pursue this further, you must be prepared to analyze your film and by creating its practical characteristics curve, determine its true FCR. The subject of sensitometry deals with these topics and experiments can become a little mathematical and out of the scope of a photographer's interest and knowledge. For this reason I will not be discussing it in this introductory book. The following is a list of films with approximate contrast ranges in STOPs. Please note that these values are approximate and are for illustrative and comparative purposes only:

Film Type	Approximate Film Contrast Range (STOPS)
Black and White Negative	7
Color Negative	6
Digital Camera/Film Combination	5
Color Slide (Transparency)	5
Polaroid Film	3
Litho High Contrast Film	2

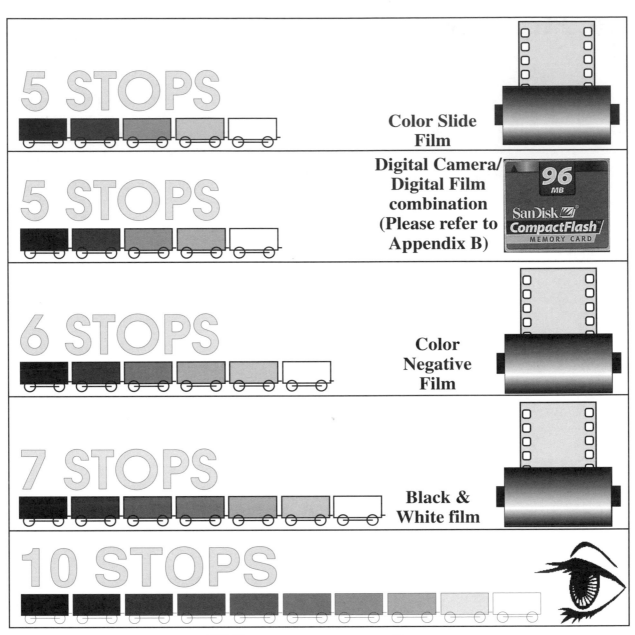

Diagram 2.6.1

Practical Contrast Range for some popular films
(Approximate -- for illustration purposes only)

A simplified diagram showing the average contrast range for some popular films. As can be seen in this illustration, the contrast range of the eye is much greater than the contrast range of any film. In this chapter, you will learn how to best accommodate a subject's image into the appropriate film.

Please also note that with standard film, the film *senses* and *records* the image, whereas with digital photography the camera *senses* the light and then *records* the digitized information onto the film.

2.7 Discussing different relationships between SBR and FCR

2.7.1 When the SBR is the same as the FCR and both are equal to 5 stops.

In this case you have one logical method of fitting the subject onto the film. If you understood the reasoning behind last chapter's example of the snow-covered house with an SBR of three, you should be able to work this one out easily. You can get the same result if you choose a medium tone, the darkest tone, or the brightest tones as Reference Tone.

❏ If you choose the medium tone, your "normal exposure" also becomes the "correct exposure."

❏ If you choose the darkest tone, find the normal exposure, and decrease this exposure (close-down) by two stops. For example, if the "normal exposure" from the darkest tone is 1/60@f-2.8, then the correct exposure would be 1/60@f-5.6.

❏ If you choose the brightest tone, find its normal exposure, and increase the exposure (open-up) from this setting by two stops, giving it a 72% white image tone. For example, if the brightest tone has a "normal exposure" of 1/60@f-11, then the correct exposure would be 1/60@f-5.6. Please note that the final "correct exposures" for both cases are identical.

2.7.2 When the subject's SBR is less than the film's FCR.

Here we have more than one choice of accommodating the subject tones. Please note that technically you can fit the subject in three ways:

1) In →4.5% Black →9% Dark Gray→18% Medium Gray image tones.

2) In →9% Dark Gray →18% Medium Gray →36% Light Gray image tones.

3) In →18% Medium Gray →36% Light Gray and →72% White image tones.

Each one of these three exposures will produce a technically correct image, but only one of them will look closer to the original subject than the other two.

2.7.3 When the SBR is greater than the FCR.

This is common with subjects with a long tonal range: for example, sunlit snow and dark lowlights (shadows). Different ways of capturing this subject's image will be discussed. Since this case requires new reasoning, I will explain it in detail.

2.8 When Subject Brightness Range exceeds the Film Contrast Range

Here the subject does not fit onto our slide film. Therefore, an educated compromise is the best solution. For cases like this, you need to use your best judgment (logical and/or artistic) to fit the image onto the film. This is typical of sunny days when you have bright subjects such as snow or a brightly painted building (highlights), as well as deep shadows (lowlights). This is similar to a situation where there are 7 people and only 5 bicycles. Two of the people will be left out. As before, set your camera to "M"anual and activate the spotmetering function. Assume that the spotmeter reading shows a normal exposure of 1/125@f-22 from the highlights and a normal exposure of 1/125@f-2.8 from the lowlights (\rightarrow22, \rightarrow16, \rightarrow11, \rightarrow8, \rightarrow5.6, \rightarrow4, \rightarrow2.8) has an SBR of 7 stops. In this case, the outcome will be different if different tones are used as a Reference Tone. If one chooses the highlights as the Reference Tone, darker areas of the subject will be blacked-out. If one chooses the lowlights as the Reference Tone, the highlights will be overexposed and will be washed-out. If the medium tones are favored and are chosen as the Reference Tone, the highlights as well as lowlights will be compromised. For a better understanding of this method, please carefully follow the Tone Train illustrations. With the Tone Train example, the loaded train has 7 cars. As you can see, there are many ways that the subject train can park alongside the empty film (image) train for a partial cargo transfer. I will examine three of these.

PLEASE NOTE: When reading this section and studying its illustrations, you will see reflectivities that are referred to as 2.25% or 144%. These reflectivities simply are extensions of our 5-stop Tone System and are obtained by multiplying 72% by 2 and dividing 4.5 by 2.

Super Black	Black	Dark Gray	Medium Gray	Light Gray	White	Super White
2.25%	4.5%	9%	18%	36%	72%	144%
Reflects 1/8 of the amount of light reflected by the 18% Gray tone	Reflects 1/4 of the amount of light reflected by the 18% Gray surface	Reflects 1/2 the amount of light reflected by the 18% Gray surface	Base	Reflects twice as much light as the 18% Gray surface	Reflects four times as much as the 18% Gray surface	Reflects eight times as much as the 18% Gray surface

If reflectivity of 144% does not make sense to you, remember that 144% reflects twice as much light as a 72% (or eight times as much as the 18% gray tone) surface. For our purposes, any reflectivity that is greater than 100 is simply an index and it does not represent the actual reflectivity of a subject. If you would like a further explanation of these, please read Appendix A or for more information refer to my book on simplified Zone System titled "The Confused Photographer's Guide to Photographic Exposure and the Simplified Zone System" ISBN:0-966-0817-1-4.

SPECIAL NOTE: If this section confuses you, simply skip it! You can produce beautifully exposed images without knowing all this!

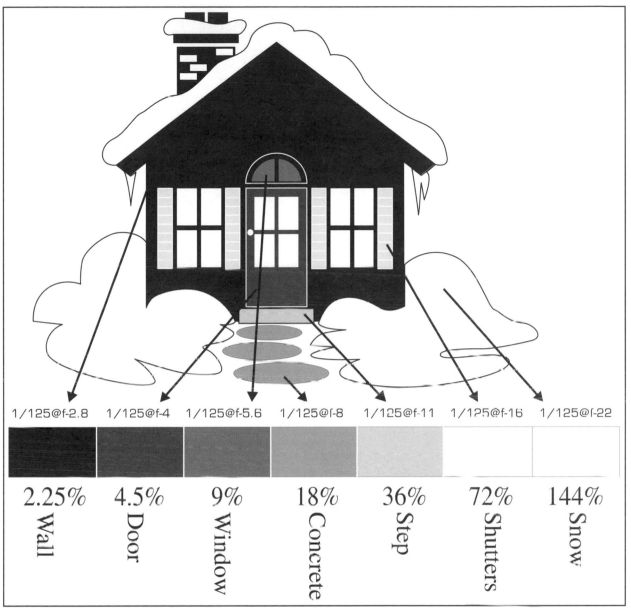

1/125@f-2.8	1/125@f-4	1/125@f-5.6	1/125@f-8	1/125@f-11	1/125@f-16	1/125@f-22
2.25%	4.5%	9%	18%	36%	72%	144%
Wall	Door	Window	Concrete	Step	Shutters	Snow

Diagram 2.8.0

When the Subject Brightness Range (SBR) is greater than the Film Contrast Range (FCR). In this case the SBR is 7 and the FCR (as always in this book) is 5.

AN EXTREMELY IMPORTANT NOTE: A reflectivity of 144% means that the surface is 8 times (3 STOPs) more reflective than 18% gray. For example, if the normal exposure of the snow is 1/125@f-22, then the normal exposure of what we chose to be gray is 1/125@f-8. In this book, any surface whose reflectivity is indicated to be more than 100%, is simply more than 2.5 stops (about 6 times) brighter than the middle gray tone of that subject. In all of these cases, the reflectivity becomes a reference number (index) and is relative to the amount of light reflected from the surface of an 18% gray card and not the actual reflectivity of the subject. *If SBR of more than 7 confuses you, please ignore this example. Chances of coming across a situation like this are rare. If you would like further explanation of this, please refer to Appendix A.*

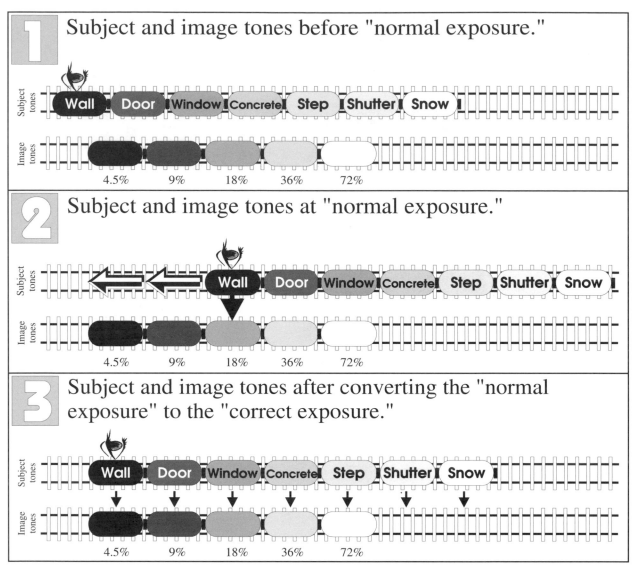

1 Subject and image tones before "normal exposure."

Subject tones

Wall | Door | Window | Concrete | Step | Shutter | Snow

Image tones

4.5% 9% 18% 36% 72%

2 Subject and image tones at "normal exposure."

Subject tones

Wall | Door | Window | Concrete | Step | Shutter | Snow

Image tones

4.5% 9% 18% 36% 72%

3 Subject and image tones after converting the "normal exposure" to the "correct exposure."

Subject tones

Wall | Door | Window | Concrete | Step | Shutter | Snow

Image tones

4.5% 9% 18% 36% 72%

Diagram 2.8.1

Option 1: Choosing the black wall as the Reference Tone when SBR = 7 and FCR = 5.

When the lowlights (dark or shaded areas) are important, simply measure the normal exposure from the darkest tone. This aligns the black wall with the 18% gray image tone. Now close-down (move train to the left) by 2 stops to place the wall at the 4.5% image tone. In this case, the two brightest tones (the shutters and the snow) will be placed outside our 72% white scale and their image will be washed out and overexposed.

Detailed example: Assume that the normal exposure reading indicates 1/125@f-2.8 from the darkest part of the subject (wall). This exposure will generate an 18% image tone from the wall. To make this image tone 4.5% black, we need to close-down from our "normal exposure" by 2 stops, i.e., change the aperture from f-2.8 to f-5.6. The correct exposure will then be 1/125@f-5.6.

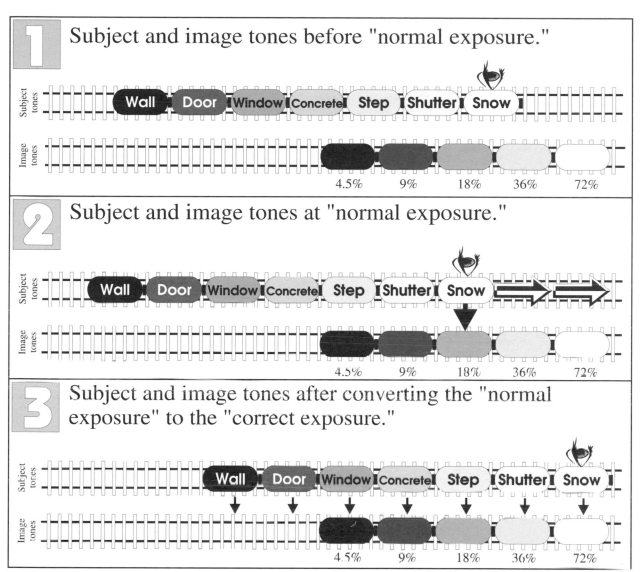

1 Subject and image tones before "normal exposure."

Subject tones: Wall | Door | Window | Concrete | Step | Shutter | Snow

Image tones: 4.5% 9% 18% 36% 72%

2 Subject and image tones at "normal exposure."

Subject tones: Wall | Door | Window | Concrete | Step | Shutter | Snow

Image tones: 4.5% 9% 18% 36% 72%

3 Subject and image tones after converting the "normal exposure" to the "correct exposure."

Subject tones: Wall | Door | Window | Concrete | Step | Shutter | Snow

Image tones: 4.5% 9% 18% 36% 72%

Diagram 2.8.2

Option 2: Choosing snow as the Reference Tone when SBR = 7 and FCR = 5.

When highlights (bright areas) are important, simply measure the normal exposure from the brightest area. This aligns the bright and sunlit snow with the 18% gray image tone. Now open-up 2 stops to place the snow at the 72% image tone. In this case, the two darkest tones (the door and the wall) will be placed outside our 4.5% black scale and will be recorded as black with no detail.

Detailed example: Assume that the normal exposure reading indicates 1/125 @ f-22 from the brightest part of the subject (snow). This exposure will generate an 18% image tone from snow. To make this image tone 72% white, we need to open-up from our "normal exposure" by 2 stops, i.e., open-up from f-22 to f-11. The correct exposure will then be 1/125 @ f-11.

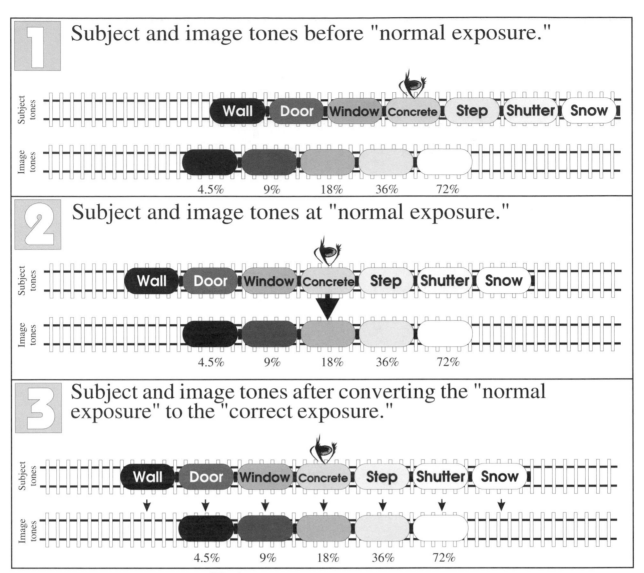

1 Subject and image tones before "normal exposure."

Subject tones: Wall | Door | Window | Concrete | Step | Shutter | Snow

Image tones: 4.5% | 9% | 18% | 36% | 72%

2 Subject and image tones at "normal exposure."

Subject tones: Wall | Door | Window | Concrete | Step | Shutter | Snow

Image tones: 4.5% | 9% | 18% | 36% | 72%

3 Subject and image tones after converting the "normal exposure" to the "correct exposure."

Subject tones: Wall | Door | Window | Concrete | Step | Shutter | Snow

Image tones: 4.5% | 9% | 18% | 36% | 72%

Diagram 2.8.3

Option 3: Choosing concrete as the Reference Tone when SBR = 7 and FCR = 5.

When medium tones are important, simply measure the normal exposure from the average or medium toned subject (concrete). This aligns the medium-toned surface (concrete) with the 18% gray image tone. Since in this case the normal exposure and the correct exposures are identical, leave the dials as they are and shoot the subject.

Detailed example: Assume that the normal exposure reading indicates 1/125 @f-8 from the medium gray part of the subject (concrete). This exposure will generate an 18% image tone from this surface. Since in this case the "normal exposure" and "correct exposure" are identical, we leave the dials as they are, i.e., at 1/125 @f-8 and shoot. In this case, the wall will have a black image tone with no detail and snow will have a white and washed-out image tone with no detail.

Miscellaneous Exposure Techniques

What will you learn in this chapter?
The more advanced photographer will learn different exposure techniques with or without a spotmeter.

3.1 Spotmeter limitations

On-camera spotmetering, in my opinion, is the most powerful light measurement tool available to the skilled photographer. Its only drawback is that it takes time to read the meter and interpret those readings. Therefore, for those times when you do not have time to analyze your subject, it is possible to pre-set your exposure so that when the opportunity comes along you simply point, shoot, and correctly expose! The following are some guidelines:

3.2 Outdoor Photography

3.2.1 Sunny-16 and its equivalent exposures

If it is sunny, your subject is sunlit, and it is between 9:00 a.m. to 3:00 p.m., you can safely use the SUNNY-16 exposure technique. With this technique: set the camera's shutter speed as close as possible to the ISO of your film and set the aperture opening to f-16. This means that if you have an ISO 400 film in your camera, set the shutter speed to 1/500 sec. and keep the aperture at f-16 for every sunlit subject. Other shutter speed combinations for different ISO films include: 1/1000@f-16 for 1000 ISO film, 1/250@f-16 for ISO 200 film, 1/125@f-16 for ISO 100-125 film and 1/60@f-16 for ISO 50-64 films. If you have one of the newer cameras where you can set your shutter speed to a value closer to the ISO, please do so. The following is a table of Equivalent Exposures for Sunny-16 for an ISO 100 film:

Sunny-16 Equivalent Exposure table for ISO 100 film					
1/1000	1/500	1/250	1/125	1/60	1/30
f-5.6	f-8	f-11	f-16	f-22	f-32

Note:

Please note that the Sunny-16 exposure is only **_one of many_** equivalent exposures. For example, 1/125@f-16 is equivalent to 1/60@f-22 or 1/250@f-11 or 1/500@f-8. If the subject is moving fast and you are using a medium or low-speed film, like ISO 25 or 50, the equivalent exposures of 1/500@f-5.6 or 1/1000@f-4 may be more desirable. Please note that the sunlit subject is any subject that is lit by direct sunlight. This includes photographing the full moon in the middle of the night!

The only exception to the Sunny-16 rule:

The only exception to this rule is that if your subject is very light toned (like snow). In cases like this, the Sunny-16 becomes Sunny-22. This means for an ISO 100 film, the exposure of a sunlit snow will become 1/125@f-22 (instead of f-16). If the smallest aperture on your camera is f-16, you can simply decrease exposure by reducing the exposure time by one stop. In the case of an ISO 100 film, the Sunny-22 exposure would be equivalent to 1/250@f-16.

3.2.2 Hazy-11 Exposure

If it is hazy, you can use the Hazy-11 technique. As with Sunny-16, the shutter speed is 1/ISO (one over ISO) and the aperture is set at f-11. Hazy-11 exposure for an ISO 100 film is 1/125@f-11 and for an ISO 400 film is 1/500@f-11. Please also note that this technique is slightly less accurate than Sunny-16.

3.2.3 Cloudy-8 Exposure

If it is cloudy, you can use the Cloudy-8 technique. As with Sunny-16, the shutter speed is 1/ISO and the aperture is set at f-8. Cloudy-8 exposure for an ISO 100 film is 1/125 sec.@f-8 and for an ISO 400 film it is 1/500@f-8. Please also note that this technique is slightly less accurate than Hazy-11.

3.2.4 Overcast-5.6 Exposure

If it is overcast, you can use the Overcast-5.6 technique. With this technique, the shutter speed remains on 1/ISO and aperture is set at f-5.6. Overcast-5.6 exposure for an ISO 100 film is 1/125@f-5.6 and for an ISO 400 film it is 1/500@f-5.6. Please also note that this technique is slightly less accurate than cloudy-8.

3.3 Freezing-5.6 to freeze the action

Freezing-5.6 is a derivation of the Sunny-16 (or to be exact an equivalent exposure of sunny-16) rule when you are *using a low-to-medium speed film such as ISO 25, 50, 64, or 100*. If you look at the table in section 3.2, one of the equivalent exposures uses an aperture setting of f-5.6. This setting can be used to freeze the action with shutter speeds higher (shorter exposure times) than Sunny-16. Although Sunny-16 can be used successfully to photograph sunlit subjects, when using 25 to 100 ISO films, you may need a faster shutter speed to freeze the action. The action could be outdoor soccer, tennis, or baseball.

Assume that you are using ISO 64 film. With Sunny-16 your speed would be 1/60@f-16. To freeze action, you need to use shutter speeds of 1/250 to 1/1000 sec. With Freezing-5.6 your aperture will *always* stay at 5.6 and the shutter speed *will always be 10 times the film's ISO*. For example, using ISO 64 film set your aperture at 5.6 and your shutter speed to $10 \times 64 = 640$. Since you have no 640 on your shutter speed dial, set your shutter speed to its closest number, i.e., 500.

Let's try another example. Using ISO 100 film, to freeze the action simply set the aperture to 5.6 and the shutter speed to $100 \times 10 = 1000$ (1/1000 sec.) For ISO 25 film, set the aperture at 5.6 and the speed to $10 \times 25 = 250$ (or 1/250 sec.)

3.4 Moony-64 to capture moonlit scenes

Since the moonlight cannot be measured by most meters that are in common use, I came up with the idea of Moony-64. This exposure is for moonlit scenes without the moon included in the image. Since I never carry my books with me, with this technique I can remember how to expose my average moonlit landscapes (not too dark and not too bright). The foundation of this technique is ISO 64 film. All you

have to remember is that 64 = 60 + 4, where 64 is the ISO of the film, 60 is the exposure time in minutes, and 4 is the aperture opening.

For long exposures like this, you will need to use a tripod and a cable release that can be locked with the shutter speed of your camera set to "B" and the distance set to infinity (∞).

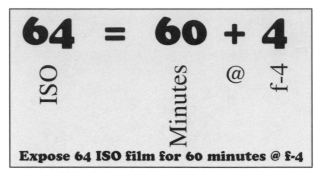

**Moony-64 Rule
for full moon landscape photography**

Equivalent exposures for Moony-64 for an ISO 50/64 film would be 30 min.@f-2.8, 15 min.@f-2 or 7.5 min.@f-1.4. (Please note: these times are minutes and not seconds!) For this assignment, choose a clear night. Before you choose the scene, examine the movement of the moon to make sure that it will not sneak into the frame of your picture. The moon moves the length of its diameter every 2 minutes or so. Other considerations that will help your pictures are a wide angle lens (16, 24 or 28mm) and the position of the North (pole) star. All the stars in the sky draw a circle around the Pole Star. This star is an important element in your picture's composition. Remember, the Moony-64 is only a starting point and a method of remembering the starting exposure. It is highly recommended that you take alternative exposures. Moony-64 usually gives you a slightly overexposed image. Your alternative exposures could be 1/2 or 1 stop less than this exposure. Exposures such as 45 min.@f-4, or 30 min.@f-4 for ISO 64 film should cover the majority of your moonlit subjects. Although ISO 50-64 films seem to work out best for long exposures, you can use the following if you are ***not using*** ISO 50/64 film:

ISO	Approximate Equivalent Exposures		
25	60 min.@f-2.8	30 min.@f-2	15 min.@f-1.4
100	60 min.@f-5.6	30 min.@f-4	15 min.@f-2.8
200	60 min.@f-8	30 min.@f-5.6	15 min.@f-4
400	60 min.@f-11	30 min.@f-8	15 min.@f-5.6

PLEASE NOTE: Moony-64 exposure is for the full moon. If you do not have a full moon, you must increase the exposure by 1 stop for each 1/4 moon. This means 1 stop of overexposure for 3/4 moon (60 min.@f-2.8), 2 stops for 1/2 moon (60 min. @f-2), and 3 stops for 1/4 moon (60 min.@f-1.4) or equivalent.

For those of you who are really interested, sunlight is approximately 500,000 times brighter than the full moonlight. 500,000 times translates to 19 stops (divide 524,288 by 2 nineteen times and you get 1). Adding 3 stops for reciprocity failure of the film makes Moony-64 approximately 22 stops dimmer than Sunny-16. Therefore, for a given film, if you open-up 22 stops from the Sunny-16 exposure, you will get down to Moony-64!

3.4.1 Tracing stars during moonless nights

During moonless, dark, clear nights and miles away from the big cities and light pollution, you can set your camera on a tripod and point the camera at the sky. Using ISO 64 film, set the aperture to f-4 (like Moony-64) and leave the shutter open for minutes or hours (please realize that the 60 minute time limit of the Moony-64 does *not* apply here). This will trace the stars in the sky. Of course the longer the exposure time, the longer the trace of the stars. If you know where the pole star is (North star in North America), you can point your camera toward it and use it as an element of your composition. As I mentioned before, this star works as the center of the sky and other stars will trace circles around it.

3.5 Photographing backlit subjects: leaves, flags, stained glass, etc.

A) If the sun is strong, the easiest method is the Sunny-16 method. For example, if you are using ISO 1000 film, set your shutter speed to 1/1000@f-16. If you are using 100 ISO film set your shutter speed to 1/125@f-16 and shoot.

B) For early morning or late afternoon sun, or any other light source with an unknown intensity, go to the opposite side of the backlighted subject and use a gray card (or interpret your spotmeter's normal exposure) to determine the correct exposure for the sunlit side. Now set your camera to the indicated setting, return to your original position, and shoot the backlit subject.

3.5.1 Special note on backlighted materials

If the above technique produces images that are too dark for your taste, you may open-up the aperture by 1/2 stop to 1 stop over the recommended exposure. Please remember, these techniques are designed to give you a logical and practical starting point. What you do with this exposure depends entirely on your objective and personal taste as a photographer.

3.6 Silhouette photography

The objective of silhouette photography is to make the face or the subject black. In our case, let's assume that we want to create a 4.5% black image tone from a person's face.

1) Use a spotmeter or another reflective meter to determine the normal exposure of the model's face (flesh tone). Assume it is 1/60@f-2.8.

2) This normal exposure indicated by the reflective meter will produce an 18% tone from the side of the face.

3) To convert this 18% gray skin to 4.5% black image tone, simply close down the aperture by 2 stops from this normal exposure setting. The face now has a 4.5% image tone and is black. Therefore, the final exposure would be 1/60@f-5.6.

3.7 Photographing translucent subjects on the surface of a light box

A light-box, as its name implies, consists of a light inside of a box with its top covered by a sheet of white translucent plastic. To illustrate this, drop a processed color slide on top of a light box. The objective is to take a picture of the surface of the light box (with the slide covering a little part of it) so that you see the image slide the way your eye sees it. Remove the slide and determine the normal exposure of the white surface of the light box. This indicated exposure will produce an 18% gray image tone from the surface. Since the light box emits 100% of the light, open-up 2-1/2 stops from the normal exposure setting and shoot. It is necessary to open-up 2-1/2 stops from the normal exposure setting because a 100% is about 2-1/2 stops away from an 18% gray surface. For those of you that are interested, 1/2 stop values of our Tone Ruler has reflectivities of 3.18%, 6.36%, 12.72%, 25.45%, 50.91%, and 101.82%.

3.8 Photographing sunrises and sunsets

Although there are no exact methods of exposure determination for sunrises or sunsets, the following are general guidelines:

1) Always use a heavy tripod with a telephoto lens whose focal length is more than 200mm.

2) If you want a high degree of magnification and you cannot afford a long lens, use a 2X teleconverter. In cases like these, they are lifesavers.

3) If the sun is too bright to be looked at, do not try to look at it or photograph it. Sunrises are generally less colorful than sunsets. They are cleaner and more yellow. Sunsets are usually more red since the sun has to travel through the expanded atmosphere. The redness of the sunset is magnified if you live in areas with polluted air.

4) Clouds are extremely important reference points in a sunrise or a sunset scene. Find a patch of clouds whose tones fall somewhere in the middle (not too dark and

not too bright), take the spotmeter or telephoto reading from that area, set your camera to this normal exposure and shoot. If you use a spotmeter, do not let the sun in its view. Even though the sun is not in the spotmetering frame (circle), the stray light will cause erroneous readings and your pictures will be underexposed.

5) If you cannot find a medium toned Reference Tone and you do not have time to find the proper exposure (the sun rises and sets rather quickly), use your telephoto lens and obtain a ***normal exposure*** reading adjacent to the sun. Do not include the sun itself in your metering area. Once you have determined the normal exposure, then include the sun in your image area and shoot.

3.9 Photographing fireworks

Fireworks are another unusual subject to expose. Since your spotmeter cannot determine its exposure, you have to rely on previous experience. As a starter you can use the Moony-64 aperture. In this case, when using ISO 64 film, set your aperture to f-4, set your shutter speed to "B" on a tripod, and leave the lens open for two or three bursts. In this case, ignore the 60 minute time factor.

If you use ISO 100 film, set the aperture to f-5.6, for ISO 200 film to f-8, for ISO 400 to f-11, and so on. Please realize that these are starting exposures and depending on your taste, you may close down by one, two, even three stops from these aperture openings.

For example, with ISO 64 film you can start with f-4 and take alternative exposures at 5.6, f-8, or f-11 (all of them will come out!) Once you have determined the aperture opening that you liked, record it and stick with it.

3.9.1 Special note on fireworks

Avoid street lights as they will cause light pollution and ruin your picture. Do not leave the camera open for more than a couple of bursts. Fireworks will lighten the smoke-filled air that is left from previous bursts. Hence, long exposures of more than two or three bursts can overexpose your picture!

3.10 Photographing lightning at night

Lightning is another unusual subject to photograph since you have absolutely no control over its exact exposure or its composition. In situations like these, luck is your best friend! If you have forgotten your notes, simply remember the ISO 64 and f-4 aperture that we used in Moony-64. If you are not using ISO 64 film, you can estimate the correct aperture with other films accordingly. For ISO 100 it is f-5.6, for ISO 200 it is f-8 and for ISO 400 it is f-11, and so on. Set up your equipment in a dark and dry place away from a major light source.

Remember, if you are getting wet, or the hair on your body begins to rise, you are too close and the picture can cost you your life, especially when using a metallic tripod!!!

Using ISO 50/64 film, set your aperture to f-4 and set your shutter speed to "B" on a tripod with the distance set at infinity. Leave the lens open for one or two lightning bolts. If these images are too bright for your taste, try f-5.6 or f-8. If you are using

ISO 100 film, vary your aperture from f-5.6 to f-11, for ISO 200 film, vary your aperture from f-8 to f-16 and for ISO 400 film, vary your aperture from f-11 to f-22 and so on.

Capturing lightning bolts during the day is much harder than at night. To have long exposures, i.e., exposures of a few seconds or more, you will need a tripod. Simply find the correct exposure from a medium toned area of the scene. Point your camera to the general area of the lightning and shoot. You can also use your camera with a Neutral Density filter to achieve longer exposures.

3.11 Photographing subjects with glare

The best way to photograph subjects with glare is ***to exclude*** the glare from your metering area. The glare can come from ice, water, or metallic objects. Once you have determined the normal exposure for a Reference Tone in the scene, you can determine its correct exposure and use this exposure to shoot the entire scene.

3.12 Photographing with Neutral Density Filters

Neutral density filters can be considered as sunglasses for your camera. These filters are designed to reduce the amount of light reaching the film without changing its original color. When placed on your lens, they can reduce the light entering your camera to 1/2, 1/4, 1/8, 1/16, and 1/32 of its original brightness.

Filter identification numbers corresponding to the above reductions in light are 0.3 (one stop), 0.6 (two stops), 0.9 (three stops), 1.2 (four stops) and 1.5 (five stops). Plastic throw-away glasses that you are given by your eye doctor after he or she dilates your eyes have an ND equivalent of 1.5 (approx.) Therefore, these glasses reduce the light reaching your eye by about 5 stops.

The strongest ND filter manufactured by Tiffen Corporation is rated at 4.0. This filter reduces the amount of light entering your camera to 1/10,000 of its original strength, or by 13 1/3 stops.

3.12.1 ND filters — A detailed example

Assume the exposure for a waterfall is 1/15@F-22 using ISO 25 film. However, for a special effect you want to use a slow shutter speed. To do this we require an exposure of f-22@2 seconds. In order to achieve this, we must reduce the amount of light by 5 stops. Five stops is the ***difference*** between 1/15 sec. and 2 sec. (→1/8, →1/4, →1/2, →1 sec., and →2 sec.) This can be achieved by using a 1.5 ND filter or five 0.3 ND filters (0.3 + 0.3 + 0.3 + 0.3 + 0.3 = 1.5) or by combining a 0.9 and a 0.6 ND filter (0.9 + 0.6 = 1.5) and so on. ***In cases like this, the fewer filters used, the better will be the quality of the final image.***

Table on the next page contains Neutral Density filters and their corresponding light reduction power.

Neutral Density filters and their corresponding reduction power		
ND Filter Number	Light reduction characteristics	Reduction Factor (STOPs)
0.0	Lets 1/1 (100%) of light to pass through (clear)	0
0.3	Lets 1/2 (50%) of light to pass through	1
0.6	Lets 1/4 (25%) of light to pass through	2
0.9	Lets 1/8 (12.5%) of light to pass through	3
1.2	Lets 1/16 (6.25%) of light to pass through	4
1.5	Lets 1/32 (3.12%) of light to pass through	5
1.8	Lets 1/64 (1.56%) of light to pass through	6
2.1	Lets 1/128 (0.78%) of light to pass through	7
2.4	Lets 1/256 (0.39%) of light to pass through	8
2.7	Lets 1/512 (0.19%) of light to pass through	9
3.0	Lets 1/1024 (0.097%) of light to pass through	10
3.3	Lets 1/2048 (0.048%) of light to pass through	11
3.6	Lets 1/4096 (0.024%) of light to pass through	12
3.9	Lets 1/8192 (0.012%) of light to pass through	13
4.0	Lets 1/10000 (0.010%) of light to pass through	13-1/3

3.13 Photographing with Graduated Neutral Density Filters

The Standard ND filters are used to reduce the brightness of an entire scene. Another type of Neutral Density filter is the Graduated Neutral Density known as ND Grads. These filters are usually used in scenic photography to *__reduce the brightness range__* of a subject. This filter is generally used during the early mornings or late afternoons when the brightness range between the shadowed foreground (usually ground and trees) and the sunlit background (usually sky and the tip of a mountain) exceeds the Film Contrast Range (FCR). These graduated Neutral Density filters consist of a partially clear glass (usually the bottom half) with a top part of gray Neutral Density filtration. There is a smooth transition between these two elements. The numbering system is identical with the Neutral Density filters that were discussed before, except that instead of ND 0.6 the filter is labeled CLEAR/ND 0.6 or ND Grad 0.6.

To illustrate the use of these filters, let's use the following illustration: On a sunny day, find an outside scene that is partly in the sun and partly in the shade. Place a white card in the sunny part of the scene (this represents the highlight or the brightest

part of the subject) and place a black card in the shaded portion (this represents the lowlight or the darkest part of the subject). By using a spotmeter, find the "Brightness Range" of this subject. Assume the spotmeter reading from the *white* cardboard shows a normal exposure of 1/125@f-22 and 1/125@f-2.8 from *black* cardboard. From what we've previously learned, this subject has an SBR of 7 (f-22, f-16, f-11, f-8, f-5.6, f-4, f-2.8). Since the Brightness Range of the subject (7) is greater than the FCR of the slide film (5 stops), instead of compromising, we can use a Graduated Neutral Density Filter. In this situation we can use a 0.6 Clear/ND filter to reduce the brightness of the background by 2 stops, hence reducing the SBR to 5. With a correct exposure, we can fit this subject on slide film.

3.13.1 ND Grads - A detailed and practical example

Assume the sunlit tip of a snow-covered mountain at sunrise (background) for an ISO 100 film shows a **normal exposure** of 1/60@f-22. A dark area of the shadowed foreground, in which we care to retain marginal detail (see Appendix A), indicates a **normal exposure** of 1/60@f-2. Using the same method as the previous example, the SBR of the subject can be calculated to be 8 stops.

3.13.2 Finding Sunlit Background's correct exposure

By using the snow as our Reference Tone, the normal exposure of 1/60@f-22 creates an 18% gray image tone on film. Now opening-up the aperture by two stops from f-22 to f-11 we create a 72% image tone for the snow. In this case, the ***correct exposure*** for the background is: ***1/60@f-11.***

3.13.3 Finding the shadowed foreground's correct exposure

As was mentioned, a normal exposure of 1/60@f-2 creates an 18% gray image tone from the lowlight area of the foreground. By ***closing-down the aperture by two stops*** from f-2 to f-4 (f-2.8, f-4), we create a 4.5% image tone for this lowlight (black) surface. In this case, the ***correct exposure*** for the background is: ***1/60@f-4.***

3.13.4 Foreground/Background exposure analysis

We now seem to have a slight problem! For the highlights (and the top portion of our subject) we have a ***correct exposure*** of ***1/60 sec.@f-11*** and for the lowlights (the bottom portion of our subject) we have a ***correct exposure*** of ***1/60 sec@f-4***. ***This means that for the same subject we have two correct exposures!***

By comparing these exposures, we notice that we have a ***difference*** of 3 stops between these two "correct exposure" settings. Our ultimate objective in cases like this is to make these two "correct exposures" the same! Now by using an ND Grad of 0.9 (three stops) we can increase the highlight exposure of 1/60@f-11 to 1/60@f-4 (8, 5.6, 4). Now with the use of this filter, we have made the background exposure (mountain) to be the same as that of the foreground, i.e., 1/60 sec.@f-4. With the use of ND 0.9 filter, we simply reduced the SBR of the subject from 8 to 5 stops. Therefore, the entire subject can now be successfully recorded on slide film.

Using the same reasoning, if the ***difference*** between these exposures was two stops, we would have had to use an ND Grad of 0.6 and if the difference would have been one stop, the filter number would have been an ND Grad of 0.3.

How to control your image detail

This appendix helps you control the desired Image Detail for your photograph.

DIGITAL FOOTNOTE:

Digital cameras (films) closely follow the Tone/Detail characteristics of slide films.

A.1 What is the image detail?

So far in this book what we have learned was how to produce correct image tones. For many photographers, this is all they need to know in order to create beautiful and correctly exposed images. I deliberately excluded the topic of image detail from the book for two reasons: 1) To avoid confusion before the reader can put his or her foot on a solid exposure foundation. 2) To try to separate the science of light measurement from artistic and judgmental values and opinions.

In some photographs, a characteristic called the "image detail" becomes part of the "image tone" equation. This is true when a photograph includes extreme tones. Examples of extreme tones in a picture could include a white wall, sunlit snow, a piece of black velvet, or a deeply shadowed outdoor scene.

If you do not want to read this section, please read the Appendix A.1 Summary at the end of this section. If you want to read the rest of this section, please realize that because of reproduction limitations (the way this book is printed), this section's illustrations will not truly represent the actual details that I have captured in my slides. Therefore you need to take my word for it, or better, you need to experiment and create your own standard of acceptable image detail. Consider this section as a guideline for your exposure experiments. ***Please also realize that the amount of "image detail" that one needs and expects very much depends on the type of film used and the way the film was processed***. With color slide films, one does not have a second chance. In this case, you must make the final decision before you take the picture. Think of the slide film as a checking account. If you write a check that exceeds your balance, the check will bounce. On the other hand, the negative film is very much like having a checking account and a saving account. In this case if your check bounces, with a previous arrangement with your bank, they can deduct the difference from your saving account. If you print your own black and white pictures, since a negative holds more detail than the paper, you can enhance image detail by selectively burning-in the highlight areas or dodging the lowlight areas. Please realize that even if you use a negative film, you must expose it correctly. If a detail in the negative is poor, regardless of how hard you try, you will not be able to produce an acceptable detail.

Appendix A.1 Summary:

The best detail for any ***rough or textured surface*** appears to be when the image tone is at 18% gray. This is when the amount of white and black in the image are approximately the same. Let's call this the base. As we brighten the image from this gray base, the white (brightness) overpowers the detail and the surface looks more and more light and washed-out. As we darken the image from this gray base, the image looks more and more dark and the detail gets lost in the darkness. The question is "What is the best detail for your image?"

This is the million dollar question. It depends entirely on your taste, camera, the type of film, film development, and the printing process. You must perform your own experiments to find the balance between the "image tone" and "image detail" that you like and stick with it.

A.2 Let's expand our number of Standard Tones to Seven

In this book with the exception of section 2.8, we have used 5 standard tones. If you refer to Chapter 1.14, you will remember that 4 of these standard tones (4.5%, 9%, 36%, and 72%) were obtained by dividing and multiplying 18 by 2. As you have guessed by now, theoretically we can divide and multiply forever and get as many standard tones (zones) as we wish. Of course, due to the limited number of standard tones that can be recorded on any film, there is a practical limitation (section 2.6). To illustrate the subject detail, we need to add a standard tone *to each side* of our 5-stop Tone-Ruler. These two new tones are obtained by dividing 4.5% by 2 (2.25%) and multiplying 72% by 2 (144%). Our expanded standard tones are illustrated in the following table. Please note that the *18% gray tone is still in the middle* of this table.

Expanded Standard Image Tones						
2.25%	4.5%	9%	18%	36%	72%	144%
Super Black	Black	Dark Gray	Medium Gray	Light Gray	White	Super White

The 2.25% in the lower end of the scale represents a surface that is half as reflective as a 4.5% tone (black velvet is approximately 1% reflective). As you can see, the next standard tone after 72% white is 144% super white. To the logical person, this reflectivity may not make much sense, since it reflects more light than it takes in. In our application, all this number means is that this surface reflects twice as much light as the 72% tone, four times as much light as the 36% tone, and eight times as much as the *18% gray card that is placed in a scene with a long tonal range*. As far as we are concerned, any reflectivity greater than 100% becomes a reference number or an index. If you are still shaking your head and you don't believe me, try the following experiment:

Pick a simple surface and find its normal exposure. Assume that the normal exposure is 1/60@f-16. This exposure produces an 18% gray image tone.

As you should know by now, an exposure of 1/60@f-11 will create a 36% gray image tone from this surface and an exposure of 1/60@f-8 will create a 72% white image tone. Now by opening the aperture up by 1 stop, the exposure of 1/60@f-5.6 will create a 144% (super white) image tone from the same surface.

Appendix A.2 Summary:

By dividing 4.5% by 2, we get a 2.25% black or super black surface. By multiplying 72 by 2, we get a 144% super white reflective surface. This expanded Tone Ruler will help us to analyze our images and better understand the relationship between the "image tone" and "image detail"

A.3 Relationship between "Image Tone" and "Image Detail"

If you have read books on the subject of photography, perhaps you have heard of terms such as "detail in the highlights" or "shadow detail." Detail is an important element of any photograph and helps to make the image look more real and three dimensional. Subjects without detail appear washed out (very white) or blacked out (very dark). Therefore, a photographer not only needs to expose a subject properly, he or she also needs to know how to control the amount of detail for very bright or very dark (extreme) tones. We will be illustrating this by performing two experiments. One with a rough (textured) black surface and the other with a rough (textured) white surface. Please remember that smooth simple surfaces like a piece of white paper or blue sky have only tones and no texture (detail). The following table illustrates the relationship between the "Image Tone" and the "Image Detail."

Expanded Standard Tones and Image details for textured (rough) simple surfaces						
Super Black	Black	Dark Gray	Medium Gray	Light Gray	White	Super White
2.25%	4.5%	9%	18%	36%	72%	144%
Retains minimal or no image detail	Retains marginal to poor detail	Retains a good to moderate detail	Retains the best detail	Retains a good to moderate detail	Retains marginal to poor detail	Retains minimal or no detail

The image of a 2.25% super black surface retains minimal to no detail and will be blacked out. The image of a 4.5% black surface retains a marginal detail. The image of a 9% dark gray surface retains a good to moderate detail. The image of an 18% medium gray surface retains the ideal detail. The image of a 36% light gray surface retains a good to moderate detail. The image of a 72% white surface retains a marginal to poor detail. The image of a 144% super white surface retains a minimal detail and will be washed out. As can be seen from the above table and illustrations that follow, "TONE" and "DETAIL" generally oppose one another. For this reason, as we will shortly see, a demanding and hard-to-please photographer must compromise between a subject's tone and its corresponding detail.

Appendix A.3 Summary:

The 18% gray image tone retains the best detail. For most films, the three middle image tones (9%, 18%, and 36%) produce the best image detail. The outer image tones (2.25%, 4.5%, 72%, and 144%) will produce marginal to non-existent detail. You must experiment (as in the next section) with your camera, film, and processing to establish *your* desired image tone / image detail relationships.

A.4 The black floor mat -- "Image Tone" versus "Image Detail"

To illustrate tone versus detail, I went to a department store and bought one black and one white floor mat. I then photographed the black mat at different exposures. I used a copy stand, two tungsten lights, and Kodak ISO 64 Ektachrome Tungsten film.

The first thing I did was to find the normal exposure for this subject. As you remember, at this exposure the image tone of the black floor mat would look approximately 18% gray. Now by closing down the aperture from this exposure by three stops the floor mat will be placed at 2.25% image tone. This number (2.25%) was obtained by dividing 18 by 2 three times (9%, 4.5%, and 2.25%). For the next series of exposures, this will be our starting point. To analyze image tone versus detail, we will be increasing the amount of light entering the camera in 1 stop increments:

❏ If we place the image tone at 2.25%, we will have almost no detail in the image. This means that no texture will appear on the slide. For all practical purposes the image will be black.

❏ If the aperture is opened-up by one stop from the previous setting, the image tone will be placed at 4.5%. Here we will see a marginal detail on the final slide film. Due to reproduction limitations in this book, chances are that you could not differentiate between 2.25% and 4.5% images.

❏ By opening-up the aperture from the previous setting by one stop, we get the image tone of the floor mat at 9%. Here we will have a good to moderate detail in the image.

❏ If the aperture is opened-up by another stop, the floor mat's image tone will be placed at 18%. At this point, your image will have the ideal detail. As you remember, this exposure was our normal exposure and our original starting point.

❏ By opening the aperture up by 1 more stop, the image tone will be at 36%. At this stage we have good to moderate image detail.

❏ When the aperture is opened-up by one stop from this point, the image will be placed at 72%. At this tone, we will have marginal to poor detail.

❏ If the aperture is opened-up by another stop, placing the image tone at 144%. At this image tone we will have minimal to non-existent detail.

If you follow the logic, chances are that we had the best detail when the image was somewhere around the 18% gray. The problem is that the floor mat looks gray and the black tone is missing. At 4.5% we got the correct tone, but the details are missing or are not strong. As an old Persian proverb says "You can't have it all!" What are we supposed to do? Well, perhaps compromise is one of the alternatives. If you are not sure, try the surface that you are interested in and photograph it with different exposures. After your slides are processed, choose the one that you like best or the one that best serves your purpose.

Black floor mat -- Tone versus detail

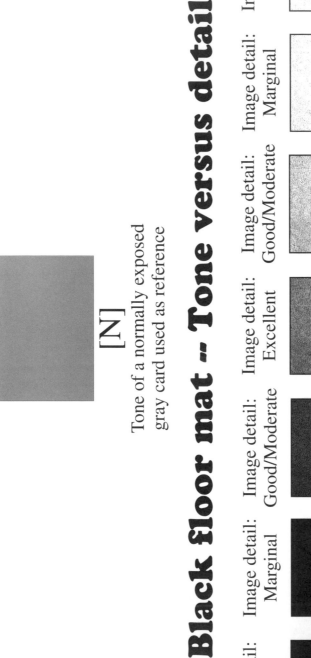

[N]
Tone of a normally exposed
gray card used as reference

Image detail: None	**[N + 3]** Black mat overexposed by 3 stops
Image detail: Marginal	**[N + 2]** Black mat overexposed by 2 stops
Image detail: Good/Moderate	**[N + 1]** Black mat overexposed by 1 stop
Image detail: Excellent	**[N]** Black mat normally exposed
Image detail: Good/Moderate	**[N – 1]** Black mat underexposed by 1 stop
Image detail: Marginal	**[N – 2]** Black mat underexposed by 2 stops
Image detail: None	**[N – 3]** Black mat underexposed by 3 stops

Diagram A.4

A.5 The white floor mat -- "Image Tone" versus "Image Detail"

In this example, I'll be photographing the white floor mat at different exposures. I used a copy stand, two tungsten lights, and Kodak ISO 64 Ektachrome Tungsten film. The first thing I did was to find the normal exposure for the white mat. As you remember, at this exposure the image tone of the white floor mat will look approximately 18% gray. Now by opening-up the aperture from this exposure by three stops the image of the floor mat will be placed at the 144% image tone. 144% was obtained by multiplying 18 by 2 three times (36%, 72%, 144%). For the next series of exposures, this will be our starting point. To analyze image tone versus detail, we will be decreasing the amount of light entering the camera in 1 stop increments:

❏ At 144% image tone, the image detail will be non-existent or at best minimal. At this image tone we will have a clear and washed-out image.

❏ If we close down by 1 stop from the previous setting, the white floor mat will be placed at the 72% image tone. With this image tone, we will have marginal to poor image detail.

❏ By closing down the aperture by 1 more stop from the previous setting, we will be at the 36% image tone. Here, our image tone will be a little gray with good to moderate detail.

❏ If we close down the aperture one more stop from the previous setting, we will be at the 18% gray image tone. Here, the image has the ideal detail. If one places the image of the snow in this medium tone, although one gets a great detail, the snow would look dull and gray.

❏ If we close down by 1 more stop from the previous setting, our image will be placed at the 9% tone. At this tone, we will have a good to moderate detail since we start losing detail to darkness.

❏ If we close down the aperture from the previous setting by 1 more stop, the image tone is at 4.5% and for all practical purposes will look black with marginal detail.

❏ Closing down another stop, we are at the 2.25% image tone. Here, we will lose all detail and the subject will be totally black.

In this book, due to mechanical reproduction limitations, the 2.25% and 4.5% image tones will look totally black and indistinguishable from one another. As in the black floor mat, compromise is the best solution. If you are not sure where you would like to place your white tones, simply experiment with different exposures and take notes until you get the image that pleases you the most. Once you find your favorite tone, write it down and use it for future assignments.

White floor mat -- Tone versus detail

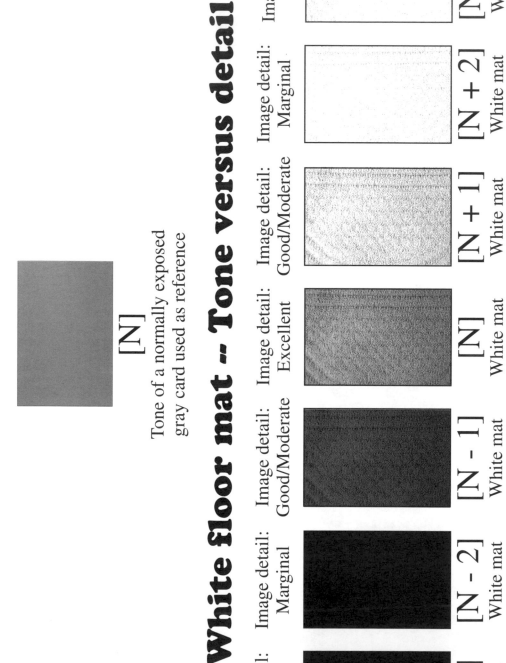

[N]
Tone of a normally exposed
gray card used as reference

Image detail: None	Image detail: Marginal	Image detail: Good/Moderate	Image detail: Excellent	Image detail: Good/Moderate	Image detail: Marginal	Image detail: None
[N − 3] White mat underexposed by 3 stops	[N − 2] White mat underexposed by 2 stops	[N − 1] White mat underexposed by 1 stop	[N] White mat normally exposed	[N + 1] White mat overexposed by 1 stop	[N + 2] White mat overexposed by 2 stops	[N + 3] White mat overexposed by 3 stops

Diagram A.5

A.6 How to control image tones when using B&W negative film?

Although I do not want to get too deep into this subject, the following are the most important differences between slide and black and white film.

A.7 The Film Contrast Range for B&W film

For all practical purposes, the FCR of many black and white films used by 35mm photographers is around _seven_ stops. This is compared to the FCR of five that we used throughout this book with slide film.

A.8 The Reference Tone for B&W film

In this book, with slide (positive) film, we selected the medium to brighter (whiter) portion of the subject to be used as our "Reference Tone." With negative film, as the name implies, the selection is exactly opposite. In this case, we select the medium to darkest area of the subject (lowlight) that has detail we wish to capture.

The logic behind this is simple. By choosing the lowlight portion of the subject as a Reference Tone, depending on the degree of the desired detail, we can place this tone into any of the darker tones of our Tone Ruler. These include 2.25% or 4.5% standard tones. While concentrating on the lowlights of the subject, (for a subject with a long tonal range), there is a good possibility that we will produce overexposed highlights on the negative.

The philosophy with this technique is that *"Overexposed highlights are better than underexposed lowlights"* or simply said *"With overexposed highlights, you have always something to show for where with the underexposed lowlights you have nothing."* The following is a summary:

OVEREXPOSED HIGHLIGHTS:

Although overexposed highlights may go off the film's seven-stop FCR, they will have enough details that they can be forced out of the negative in the darkroom.

OVEREXPOSED LOWLIGHTS:

Lowlights that can be placed in the 2.25% or 4.5% tones of the ruler will record on the film and retain marginal detail, so that they can be printed in the darkroom.

UNDEREXPOSED LOWLIGHTS:

This is perhaps the worst nightmare of a photographer. With underexposed lowlights (underexposing the black and white negative causes this), there is no recorded detail on the negative that a photographer can print. These areas will be totally black and are the least desirable.

Spotmetering with Digital Cameras using Nikon CoolPix 990 as an example

This appendix helps you to apply your spotmetering techniques to digital cameras with spotmetering feature.

Nikon CoolPix 990
Exposure Cheat Sheet

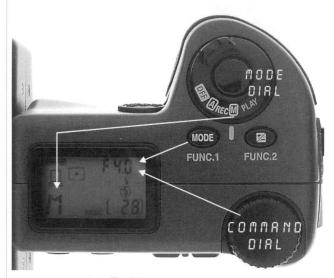

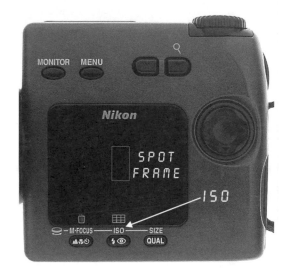

LCD PANEL

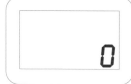

0

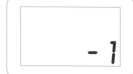

- 1

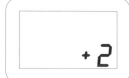

+2

+4

MENU SCREEN

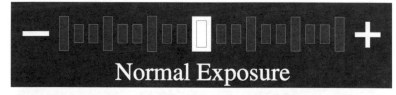

Normal Exposure

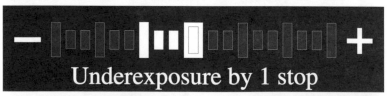

Underexposure by 1 stop

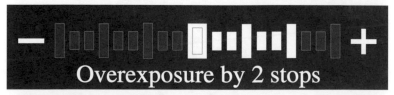

Overexposure by 2 stops

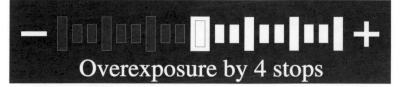

Overexposure by 4 stops

1 How to set the ISO Manually:	**2** How to set the function to Manual Mode:	**3** How to change the aperture Manually:	**4** How to change the Exposure Time (shutter speed) Manually:	**5** How to set the exposure function to SPOT:	**6** How to find the normal exposure of a simple subject:
a) Turn the Mode Dial to the [ON] /M-REC position. b) Push the ISO button and hold-down while rotating the Command Dial. The ISO changes from 100 to 200, 400, and Auto.	a) Turn the Mode Dial to the [ON] /M-REC position. The camera is now in Manual Mode. The letter M will appear at the bottom left of the LCD panel and the Menu screen. Please Note: If any letter other than "M" (such as "A", "P", or "S") appear on your LCD screen, while holding down the "FUNC. 1" button, rotate the Command dial until the letter "M" appears.	a) Turn the Mode Dial to the [ON] /M-REC position. b) Press the "MODE" button until the aperture opening (the F number) such as F-5.0 appears at the top right hand side of the LCD screen or the bottom of the Menu Screen in the back of the camera. Depending on the zoom setting of your camera, the largest opening is F-2.5 and the smallest is about F-11. Please note that since the aperture opening of the CoolPix 990 increases or decreases by 1/3 stop, depending on its zoom/wide settings, you may not see the standard aperture openings such as f-4, f-5.6, or f-8.	a) Turn the Mode Dial to the [ON] /M-REC position. b) Press the MODE button until the letter "F" (aperture opening) disappears from the top right hand side of the LCD screen. Please note that shutter speed and aperture opening occupy the same location on the LCD screen. The number showing is the exposure time (shutter speed). CoolPix 990's exposure times range from bulb to 8" (8 seconds), 4", 2", 1", 2 (1/2 sec.), 4, 8, 15, 30, 60, 125, 250, 500, 1000 (1/1000 sec.)	a) Turn the Mode Dial to the [ON] /M-REC position. b) Press the MENU button on the back of the camera, the option #1/White Balance option will appear c) Down-Click the Multi Selector. Now you are in the METERING option d) Right click the Multi Selector on the back of the camera. All metering options will appear e) Down-click once and the spotmetering option [⊡] will be highlighted in red. f) Right click and your exposure mode is set on SPOT. g) Press the MENU button twice, the screen clears with the spotmetering symbol [⊡] appearing on the LCD and the Menu Screen.	a) Turn the Mode Dial to the [ON] /M-REC position. b) Choose a shutter speed (exposure time). If you are not sure what to set your shutter speed to (for outside shots) set it to a number close to the ISO of the film. For example, if your film's ISO is 100, set it to 1/125 sec. This can be done following directions in step 4. c) Turn your metering to SPOT [⊡]. This can be done by following directions in step 5. Then by pointing the center of the viewfinder (a rectangle) at the desired simple subject and by changing the aperture and/or shutter speed, find the simple subject's normal exposure. This is when the small rectangle at the center of your scale is highlighted and is white-filled (please refer to CoolPix 990's illustration).

Nikon CoolPix 990 Exposure Cheat Sheet

B.1 Digital Photography and Spotmetering:

The same technique that one uses with standard (analog) cameras also applies to digital cameras. When I bought my first digital camera, very quickly I realized that with this miracle of science, I still needed the skill to correctly expose my images. The little viewing screen on the back of the camera was not big enough (or accurate enough) to satisfy me. The only advantage of digital cameras was that the film was cheap and I could quickly correct my compositional errors.

The material covered here is **_not_** intended to be comprehensive. It is for photographers with digital cameras who have realized that even with digital cameras one needs to have exposure skills. In many cases the subject simply does not wait for the photographer to find its exposure by trial and error.

B.2 Gray making property of the Digital Metering:

What you learned about spotmetering in the book also applies to your digital cameras. What this means is that "the image tone (density) of a normally exposed simple subject will **_always_** have an 18% gray image tone!" The great feature of Digital Photography is that you can feed the results into your computer and analyze them quickly.

I assume that you have an image editing/manipulation software such as Adobe's Photoshop (or a less expensive software that does almost the same thing) on your Personal Computer. In my examples I will be using Adobe Photoshop for illustration purposes.

B.3 Digital Experiments:

Set your camera mode to Manual exposure. Please note that many cameras on the market do not have this feature. This includes the Nikon family of CoolPix cameras such as CoolPix 900 and CoolPix 950. If you do not have this feature, you can **_not_** use your camera to apply the spotmetering techniques that we discussed in this book. *With the "M"anual exposure cameras, you can set the aperture opening and the shutter speed to anything that you wish and then take the picture.* When performing the following experiment, please choose a sunny day (no clouds) and place your subjects to be photographed *in the shade.*

1- Photographing an 18% Gray Card:

With your camera set to manual and your exposure mode set to [SPOT] take a photograph of a normally exposed 18% gray card.

2- Photographing a white card (white piece of paper):

With your camera set to manual and your exposure mode set to [SPOT] take a photograph of a normally exposed white card (white piece of paper).

3- Photographing a black card:

With your camera set to manual and your exposure mode set to [SPOT] take a photograph of a normally exposed black card.

B.4 Photoshop Color Picker Option exercise: 256 Grayscale divisions between black and white

Before downloading your images into your PC, start your Image Editing software (In my case Photoshop). Now click on the Foreground Color (a square box at the lower end of the Tool Box). The Color Picker menu will appear. Now type in 128 in Red (R:), 128 in Green (G:), and 128 in Blue (B:). Once you are done, the magic number of 18% will appear at the bottom of your Color Picker Menu/Screen in front of BlacK (K:). The R:128, G:128, and B:128 numbers work very much like the 18% gray card. They are neutral and have no color bias. By definition, the darkest assignment on your monitor has a Grayscale value of "000" and the brightest (whitest) assignment on your monitor has a Grayscale assignment of 255 with 128 being the middle of 256.

B.5 Now download your three images to your computer and analyze their tones

Download your three images to your PC. Please edit each of these images and take away their color, and then save them! In Photoshop, this is done by clicking on Image ➤Mode ➤Grayscale options.

Now bring each image (one at a time), activate the Eyedropper tool and click on the middle of the image. Now click on the foreground color (the rectangular box in the tool bar that has the same tone of gray as your image). Now the Color picker screen/Menu appears. If you have done your experiment correctly, a gray density value of RED:128, GREEN:128, and BLUE:128 will appear on the screen. If you did not get exactly 128, do not worry! Nobody does! Anywhere around 128 should

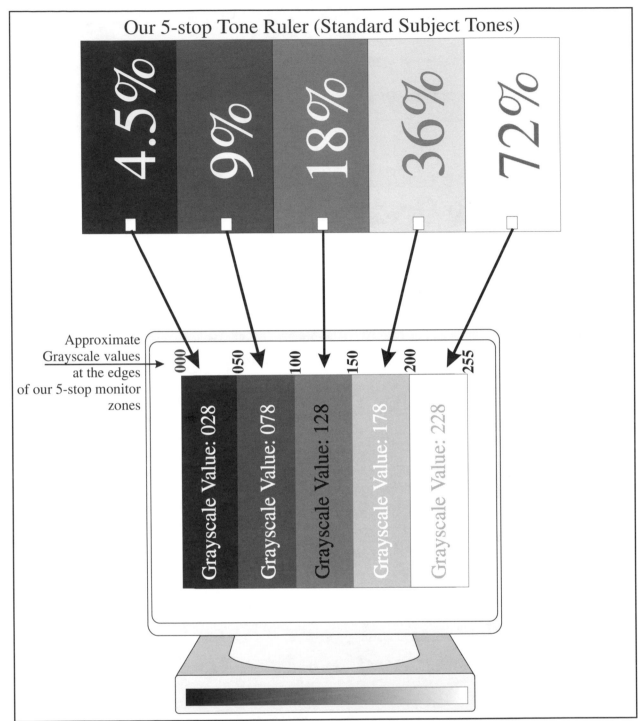

Our 5-stop Tone Ruler (Standard Subject Tones)

4.5% 9% 18% 36% 72%

Approximate Grayscale values at the edges of our 5-stop monitor zones

000 050 100 150 200 255

Grayscale Value: 028
Grayscale Value: 078
Grayscale Value: 128
Grayscale Value: 178
Grayscale Value: 228

Diagram 3 - Appendix B

Illustrating Grayscale Values on your monitor corresponding to our 5-stop Tone Ruler. Please note that to make it easy to remember and understand, the lowlight tone (4.5%) has been oversimplified and approximated to a linear scale, i.e., "028" instead of "038". If you want to understand more about the concept of zones, please read a book titled "The Confused Photographer's Guide to Photographic Exposure and the Simplified Zone System" ISBN: 0-9660817-1-4 by the same author.

be good. Mine was 133. *You should get approximately the same number from each of your three experiments*.

B.6 How Gray Density Values relate to our 5-stop Tone Ruler?

Assume that in your experiment, the Normal Exposure for your gray card was 1/125@f-5.6. Now take five pictures of the gray card with the following exposures: 1/500@f-5.6, 1/250@f-5.6, 1/125@f-5.6, 1/60@f-5.6, and 1/30@f-5.6. If you convert these to Grayscale and measure their Grayscale Density, you will get the following *approximate* numbers:

1/500@f-5.6	1/250@f-5.6	1/125@f-5.6	1/60@f-5.6	1/30@f-5.6
038	078	128	178	228

If you forget this scale, each tone falls *approximately* 50 Grayscale division on each side of medium gray with a value of 128.

Therefore our Tone ruler values will translate into your monitor's brightness (image tones) as follows:

5-Stop Tone Ruler components	Your monitor's Grayscale value (approximate)
4.5% Black	028*
9% Dark Gray	078
18% Medium Gray	128
36% Light Gray	178
72% white	228

* In order to simplify these numbers, the 4.5% image tone has been assigned a Grayscale density of 028.

Now that you know the secret, you can fit any of the tones of your 5-stop tone Ruler into the appropriate brightness of your monitor!

Exposure Cheat Sheets for some popular Film and Digital cameras

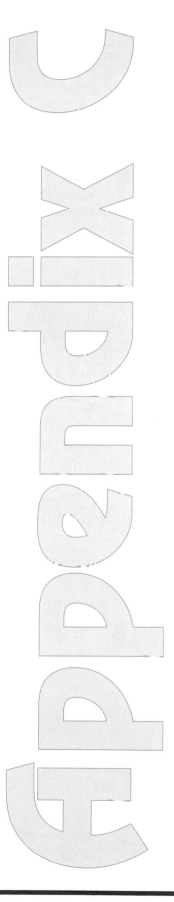

What is covered in this section?

Technical Spotmetering and Partial Metering data for different cameras as well as viewfinder illustrations for different camera models.

1 How to set the ISO Manually	2 How to set the function to Manual mode	3 How to change the aperture Manually	4 How to change the Exposure Time (Shutter Speed) Manually	5 How to set the exposure function to Spot (Partial) Metering	6 Using the SPOT function, how to find the normal exposure of a simple subject?
a) Set the Quick Control *switch* (located on the back of the camera just above the Mode Dial) to [ON]. b) Press and release the DRIVE-ISO button at the top of the LCD screen. The ISO will appear on the LCD screen. c) By rotating the Quick Control Dial (a large notched circular wheel located on the back of the camera), you can set the dial to the desired ISO. d) Press the SET dial at the center of the wheel to register the ISO. The ISO on 10D can be set to 100, 200, 400, 800, and 1600.	a) Turn the Mode Dial to [M]. Your camera is now in the Manual Mode mode. b) Set the Quick Control *switch* (located on the back of the camera just above the Mode Dial) to [ON]. The aperture opening and the shutter will now be displayed on the LCD screen.	a) By following the step 2, set your camera to the Manual Mode. b) By turning the Quick Control Dial on the back of the camera the aperture can be manually changed. The Standard aperture opening values for a typical 50mm lens are: 1.8, 2.8, 4.5, 8, 11, 16, and 22. 1/3 stop values include: 2.0, 2.5, 3.5, 4.0, 4.5 and 1/2 stop values include 6.7, 9.5, 13, and 19.	a) By following the step 2, set the camera to Manual Mode. b) By rotating the Main Dial (located above the shutter release button), the value of the exposure time (shutter speed) can be changed. c) The standard shutter speeds on 10D include Bulb, 30" (seconds), 15", 8", 4", 2", 1", 0"5 (1/2 second), 1/4, 1/8, 1/15, 1/30, 1/60, 1/125, 1/250, 1/500, 1/1000, 1/2000, and 1/4000 second. 10D also offers 1/2 stop as well as 1/3 stop divisions between these standard exposure times.	a) Press the metering mode button so that the shutter speed and the aperture opening dials disappear from the LCD screen and the exposure mode is displayed on the LCD screen (please see diagram). Change the Main Dial until the partial metering symbol (a rectangle with a hollow circle ⊙ inside) appears on the LCD screen. b) Your exposure mode is now set to partial metering. In this mode the camera's meter only reacts to the light that passes through the partial metering circle that is located at the center of the view finder occupying about 9% of the entire viewfinder area	a) Turn on the camera and following step 5, activate the spot metering (partial metering) function. b) Set the Command Dial to [M] and for outside shots turn the main dial to choose a shutter speed that is close to the ISO of the film. c) To determine the normal exposure of a simple subject, point the spot metering/partial metering area of the camera, located at the center of the viewfinder towards the desired *simple tone*. Now change the aperture opening by turning the Quick Control Dial (a large notched wheel located on the *back* of the camera), so that the exposure level indicator in the viewfinder is positioned in the middle of [-2] and [+2]. -2..1..[■]..1..+2

CANON EOS 10D
(D-SLR/Digital)

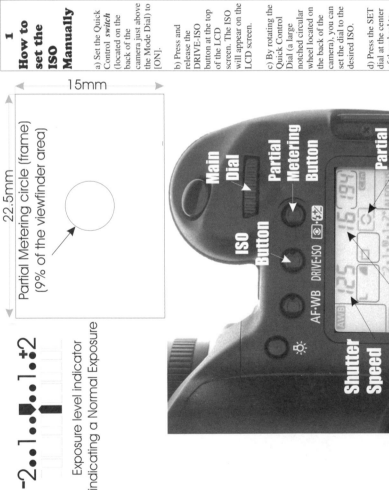

15mm

22.5mm

Partial Metering circle (frame) (9% of the viewfinder area)

-2..1..[■]..1..+2

Exposure level indicator indicating a Normal Exposure

Main Dial · Partial Metering Button · ISO Button · Partial Metering Symbol · Shutter Speed · Aperture Opening · AF-WB · DRIVE-ISO

Aperture Set Dial · QUICK CONTROL DIAL · SET · Canon · ON/OFF

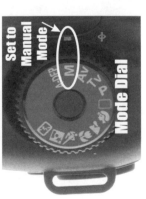

Set to Manual Mode · Mode Dial

CANON EOS 20D
(D-SLR/Digital)

1 How to set the ISO Manually	2 How to set the function to Manual mode	3 How to change the aperture Manually	4 How to change the Exposure Time (Shutter Speed) Manually	5 How to set the exposure function to Spot (Partial) Metering	6 Using the Partial Metering feature of 20D to find the normal exposure of a simple subject?
a) Turn the switch on the back of the camera to the [ON] position. b) Press and release the DRIVE-ISO button at the top of the LCD screen. The ISO will appear on the LCD screen. c) By rotating the Quick Control Dial (a large notched circular wheel located on the back of the camera), you can set the camera to the desired ISO. d) Press the SET dial at the center of the wheel to register the ISO. The ISO on 20D can be set to 100, 200, 400, 800, and 1600. An ISO of 3200 can also be set using the Custom Function feature of the camera.	a) Turn the Mode Dial to [M]. Your camera is now in the Manual mode. The aperture opening and the shutter speed will now be displayed on the LCD screen.	a) By following the step 2, set your camera to the Manual Mode. b) By turning the Power Switch on the back of the camera counterclockwise one notch after the [ON] position, the aperture can be manually changed by turning the Quick Control Dial. The Standard aperture opening values for a typical 28-200mm lens are: 4.0, 5.6, 8, 11, 16, and 22 and ½ stop values for this lens are: 4., 6.7, 9.5, 13, and 19.	a) By following the step 2, set the camera to Manual Mode. b) By rotating the Main Dial (located above the shutter release button), the value of the exposure time (shutter speed) can be changed. c) The standard shutter speeds on 20D include Bulb, 30″ (seconds), 15″, 8″, 4″, 2″, 1″, 0.5″ (1/2 second), 1/4, 1/8, 1/15, 1/30, 1/60, 1/125, 1/250, 1/500, 1/1000, 1/2000, and 1/4000 second. 20D also offers 1/2 stop as well as 1/3 stop divisions between these standard exposure times.	a) Press the Metering Mode button (please see diagram) once. Change the Main Dial until the partial metering symbol (a rectangle with a hollow circle ⌂ inside) appears on the LCD screen. b) Your exposure mode is now set to partial metering. In this mode the camera's meter only reacts to the light that passes through the partial metering circle that is located at the center of the viewfinder. This circle (frame) occupies about 9% of the entire viewfinder area.	a) Turn on the camera and following step 5, activate the spot metering (partial metering) function. b) Set the Command Dial to [M] and for outside shots turn the main dial to choose a shutter speed that is close to the ISO of the film. For an ISO setting of 100, set the shutter speed to 1/100 or 1/125 sec. c) To determine the normal exposure of a simple subject, point the spot/partial metering frame of the camera (at the center of the viewfinder) towards the desired *simple tone*. Now change the aperture opening by turning the Quick Control Dial so that the exposure level indicator in the viewfinder is positioned in the middle of [-2] and [+2]. `-2..1..⚫..1.:+2`

15mm

22.5mm

Partial Metering circle (frame) (9% of the viewfinder area)

`-2..1..⚫..1.:+2`

Exposure level indicator indicating a Normal Exposure

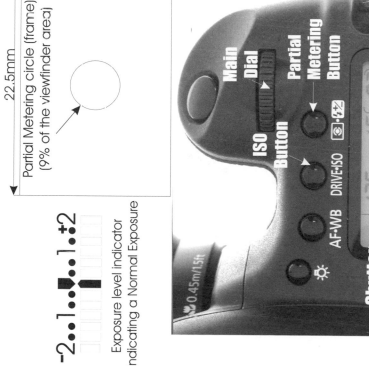

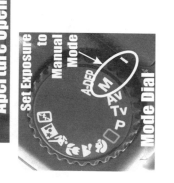

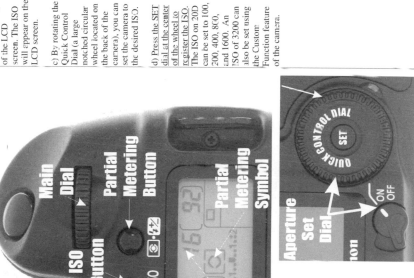

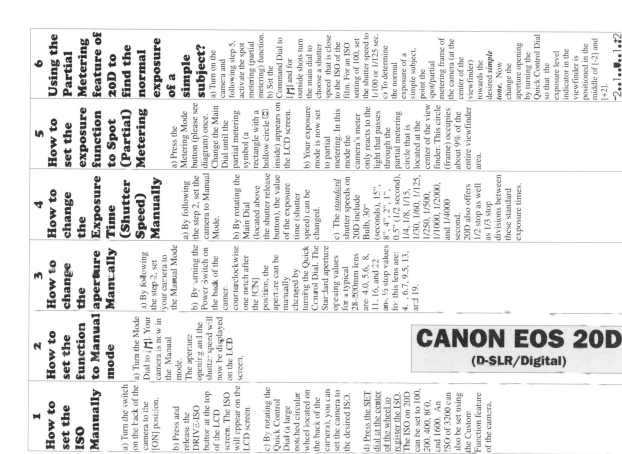

1 How to set the ISO Manually	2 How to set the function to Manual mode	3 How to change the aperture Manually	4 How to change the Exposure Time (Shutter Speed) Manually	5 How to set the exposure function to SPOT	6 Using the Spot function, how to find a simple subject's normal exposure?
If you do not have a DX coded film (i.e., you roll your own film): a) Turn on the camera by turning the main switch on the back of the camera so that the white index mark points to "A" b) While pushing and holding down the two buttons on each side of the word [ISO] and turning the main dial you can set the desired ISO. The value of the ISO will appear on the LCD screen. EOS 3's ISO ranges from 6 to 6400.	a) Turn on the camera by turning the main switch on the back of the camera so that the white index mark points to "A" b) While holding down the [MODE] (Shooting Mode) button turn the [Main Dial] until the letter [M] is displayed at the top left hand side of the LCD panel. Now the Exposure Time (shutter speed) can be seen on the top (middle) of the LCD panel with the aperture opening under it. The shutter speed/aperture opening shown in the photograph is 1/160@f-16.	a) Turn on the camera by turning the main switch on the back of the camera so that the white index mark points to "A" b) Using instructions in step 2, set the exposure mode to [Manual]. The aperture opening will now appear on the LCD panel, under the shutter speed. c) Now turn the Quick Control Dial ON/OFF switch at the back of the camera to "1" c) The aperture opening can now be changed by turning the Quick Control Dial (a large wheel on the back of the camera) Typical full-stop values are 4, 5.6, 8, 11, 16, 22, and 32. Typical ½ stop values are 4.5, 6.7, 9.5, 13, 19, and 27.	a) Turn on the camera by turning the main switch on the back of the camera so that the white index mark points to "A" Using instructions in step 2, set the exposure mode to [Manual]. The Shutter Speed will now appear on the LCD panel, above the aperture opening. c) The shutter speed can now be set by turning the Main Dial located in front of the camera just above the shutter release button. Typical shutter speeds are 30" (30 seconds) to 8000 (1/8000 second). Standard shutter speeds are 30", 15", 8", 4", 2", 1", 2 (1/2 sec.), 4 (1/4 sec.), 8, 15, 30, 60, 125, 250, 500, 1000, 2000, 4000, 8000. Half stop shutter speeds are 20" (20 sec.), 10", 6", 3", 1.5") 0.7, 3, 6, 10, 20, 45, 90, 180, 350, 750, 1500, 3000, 6000.	a) Turn on the camera by turning the main switch on the back of the camera so that the white index mark points to "A" b) Using instructions in step 2, set the exposure mode to [Manual]. c) While holding down the Metering Mode Button (located on the top left hand side of the camera above this ⊡ symbol) turn the Command Dial [●] until the [⊡] symbol appears at the bottom left hand corner of the LCD panel.	a) While pushing down the Shooting Mode button, turn the Command Dial to [M]. By following step 5, set your camera's metering mode to spot [⊡] b) For outside shots, turn the main dial to choose a shutter speed that is close to the ISO of the film. For example for a 100 ISO film, set the shutter speed to 1/90 or 1/125 sec. c) To determine the normal exposure of a simple subject, point the spotmetering area of the camera, located at the center of the viewfinder (a clear circle) towards the desired *simple tone*. Now turn the Aperture set Control Dial (Quick Control Dial located on the *back* of the camera), so that the exposure level indicator in the viewfinder indicates normal exposure. This is when the index mark appears exactly in the middle of the scale on the right hand side of the viewfinder.

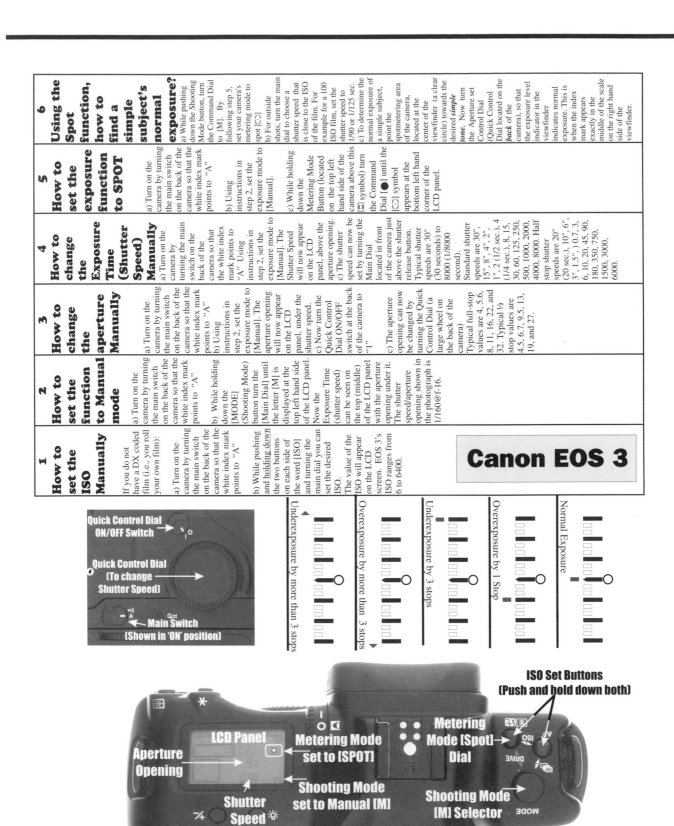

Canon EOS 3

Quick Control Dial ON/OFF Switch

Quick Control Dial (To change Shutter Speed)

Main Switch (Shown in 'ON' position)

Underexposure by more than 3 stops

Overexposure by more than 3 stops

Underexposure by 3 stops

Overexposure by 1 Stop

Normal Exposure

ISO Set Buttons (Push and hold down both)

LCD Panel

Aperture Opening

Metering Mode Set to [SPOT]

Metering Mode [Spot] Dial

Shutter Speed

Shooting Mode set to Manual [M]

Shooting Mode [M] Selector

Main Dial

1 How to set the ISO Manually	2 How to set the function to Manual mode	3 How to change the aperture Manually	4 How to change the Exposure Time (Shutter Speed) Manually	5 How to set the exposure function to SPOT	6 Using the SPOT function, how to find the normal exposure of a simple subject?
If you do not have a DX coded film (i.e., you roll your own film): a) While pushing down the Lock Release Button, turn the Command Dial to "M". b) Push and hold down the ISO Set Button (the function button marked [ISO-AEB] on the back of the camera. The ISO will appear on the LCD Screen. c) The ISO can be changed from 6 to 6400 by turning the Main Dial (a round notched wheel ● above the shutter release button). d) Press the shutter release button halfway to register the new ISO setting.	a) While pushing down the Lock Release Button, turn the Command Dial to "M". Now the Exposure Time (shutter speed) can be seen on the top middle of the LCD panel with the aperture opening to its right. The shutter speed/aperture opening shown in the photograph is 1/125@f-16.	a) Turn the Command Dial to be set to "M" (see step 2) while pushing down the Lock Release Button. b) Set the Quick Control Dial *switch* (a *small* round button located on the back of the camera just above the Aperture Set Control Dial to [1]. c) The aperture opening can now be changed by turning the Aperture Set Control Dial. The value of the aperture opening can be seen at the top right hand side of the LCD panel. Typical full-stop values are 4, 5.6, 8, 11, 16, 22, and 32. Typical ½ stop values are 4.5, 6.7 9.5, 13, 19, and 27.	a) While pushing down the Lock Release Button, turn the Command Dial to "M". The shutter speed will appear at top center of the LCD Panel. b) The shutter speed can now be set by turning the Main Dial (a notched wheel ● located in front of the camera just above the shutter release button. Typical shutter speeds are 30" (30 seconds) to 8000 (1/8000 second). Standard shutter speeds are 30", 15", 8", 4", 2", 1", 2 (1/2 sec.), 4 (1/4 sec.), 8, 15, 30, 64, 125, 250, 500, 1000, 2000, 4000, 8000. Half stop shutter speeds are 20" (20 sec.), 10", 6", 3", 1.5",) 0.7, 3, 6, 10, 20, 45, 90, 180, 350, 750, 1500, 3000, and 6000.	a) While pushing down the Lock Release Button, turn the Command Dial to "M". b) While holding down the Metering Mode Set Button (located on the back of the camera) turn the Command Dial ● until the [·] symbol appears at the bottom left hand corner of the LCD panel.	a) While pushing down the Lock Release Button, turn the Command Dial to "M". By following step 5, set your camera's metering mode to spot [·]. b) For outside shots, turn the main dial to choose a shutter speed that is close to the ISO of the film. For example for a 100 ISO film, set the shutter speed to 1/90 or 1/125 sec. c) To determine the normal exposure of a simple subject, point the spotmetering area of the camera, located at the center of the viewfinder (a clear circle) towards the desired *simple tone*. Now turn the Aperture set Control Dial (Quick Control Dial, a large notched wheel located on the *back* of the camera, so that the exposure level indicator in the viewfinder indicates normal exposure. This is when the [◄►] symbols appear side-by-side in the viewfinder.

CANON EOS A2/A2E

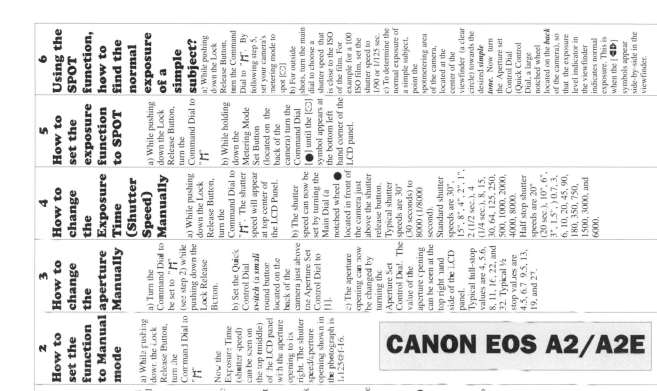

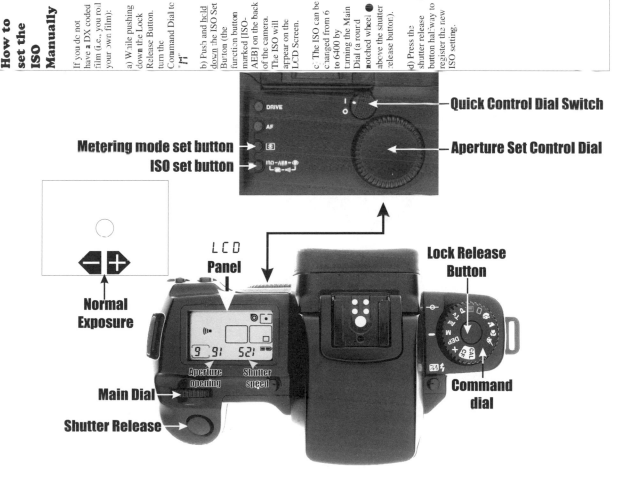

Quick Control Dial Switch

Metering mode set button

ISO set button

Aperture Set Control Dial

LCD Panel

Lock Release Button

Normal Exposure

Aperture opening

Shutter speed

Main Dial

Command dial

Shutter Release

1 How to set the ISO Manually	2 How to set the function to Manual mode	3 How to change the aperture Manually	4 How to change the Exposure Time (Shutter Speed) Manually	5 How to set the exposure function to Spot (partial) Metering	6 Using the Spot function, how to find the normal exposure of a simple subject
If you do not have a DX coded film (i.e., you roll your own film): a) Press the function button until the symbol [ISO] and its corresponding value (say 100) appears on the LCD screen. The function button is a round button, located on the back of the camera, marked with [ISO-AEB].	a) Turn your Command Dial to [M]. Your camera is now in Manual mode. b) Set the Quick Control Dial *switch* (located on the back of the camera just above the Main Dial) to [1].	a) Turn your Command Dial to [M] (see step 2). b) Set the Quick Control Switch (located on the back of the camera just above the main dial) to [1]. c) You can change the aperture opening [M] manually by turning the Quick Control Dial. Typical aperture openings are 4, 5.6, 8, 11 and 16. Typical 1/2 stop aperture openings are 4.7, 6.7, 9.5, 13, and so on.	a) Turn your Command Dial to [M] (see step 2). b) Set the Quick Control Switch (located on the back of the camera just above the main dial) to [1]. c) You can change the shutter speeds Manually by rotating the main dial (a notched wheel, located close to your shutter release button). Typical shutter speeds are 8, 15, 30, 60, 125, 250 and so on. Midpoint (1/2 stop) shutter speeds are 20, 45, 100, 180, 350 and so on.	a) Turn the metering mode lever to partial (a rectangle with a hollow circle ⊙ inside). b) Turn on the camera by turning the Command Dial to CF – Custom Functions. The Custom Function such as C01, C02, etc. appears on the LCD screen. c) Turn the Main Dial (located close to shutter release button) until Special Function 08 (C08) appears.	a) Turn on the camera and following step 5, activate the spotmetering (partial metering) function. b) Set the Command Dial to [M] and for outside shots turn the main dial to choose a shutter speed that is close to the ISO of the film. c) To determine the normal exposure of a simple subject, point the spotmetering area of the camera, located at the center of the viewfinder towards the desired *simple tone.* Now turn the Quick Control Dial located on the *back* of the camera, so that the exposure level indicator in the viewfinder is positioned in the middle of [-2] and [+2] directly under [0].

Canon EOS Elan II E

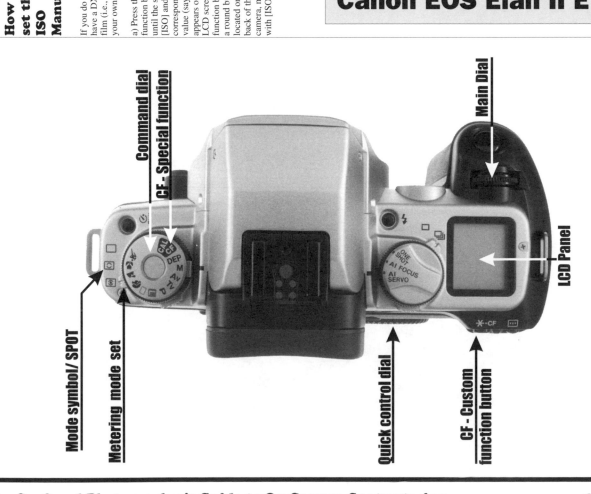

Command dial
CF - Special function
Mode symbol/ SPOT
Metering mode set
Quick control dial
CF - Custom function button
Main Dial
LCD Panel

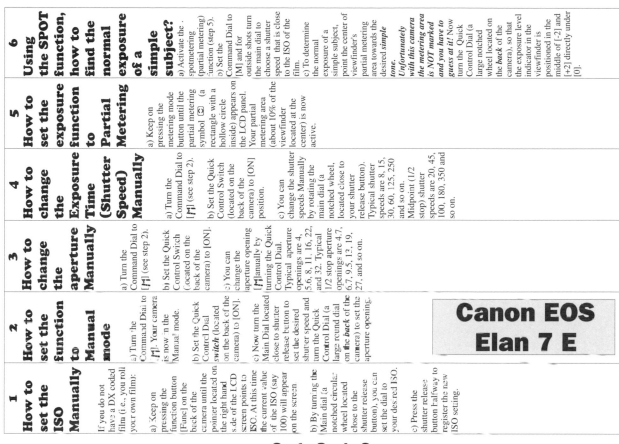

Canon EOS Elan 7 E

1 How to set the ISO Manually	2 How to set the function to Manual mode	3 How to change the aperture Manually	4 How to change the Exposure Time (Shutter Speed) Manually	5 How to set the exposure function to Partial Metering	6 Using the SPOT function, how to find the normal exposure of a simple subject?
If you do not have a DX coded film (i.e., you roll your own film): a) Keep on pressing the function button [Func] on the back of the camera until the pointer located on the right hand side of the LCD screen points to ISO. At this time the current value of the ISO (say 100) will appear on the screen. b) By turning the Main dial (a notched circular wheel located close to the shutter release button), you can set the dial to your desired ISO. c) Press the shutter release button halfway to register the new ISO setting.	a) Turn the Command Dial to [M] (see step 2). Your camera is now in the Manual mode. b) Set the Quick Control Dial switch (located on the back of the camera) to [ON]. c) Now turn the Main Dial located close to shutter release button to set the desired shutter speed and turn the Quick Control Dial (a large round dial on the back of the camera) to set the aperture opening.	a) Turn the Command Dial to [M] (see step 2). b) Set the Quick Control Switch (located on the back of the camera) to [ON]. c) You can change the aperture opening [Manually] by turning the Quick Control Dial. Typical aperture openings are 4, 5.6, 8, 11, 16, 22, and 32. Typical 1/2 stop aperture openings are 4.7, 6.7, 9.5, 13, 19, 27, and so on.	a) Turn the Command Dial to [M] (see step 2). b) Set the Quick Control Switch (located on the back of the camera) to [ON] position. c) You can change the shutter speeds Manually by rotating the main dial (a notched wheel, located close to your shutter release button). Typical shutter speeds are 8, 15, 30, 60, 125, 250 and so on. Midpoint (1/2 stop) shutter speeds are 20, 45, 100, 180, 350 and so on.	a) Keep on pressing the metering mode button until the partial metering symbol (a rectangle with a hollow circle inside) appears on the LCD panel. Your partial metering area (about 10% of the viewfinder located at the center) is now active.	a) Activate the spotmetering (partial metering) function (step 5). b) Set the Command Dial to [M] and for outside shots turn the main dial to choose a shutter speed that is close to the ISO of the film. c) To determine the normal exposure of a simple subject, point the center of viewfinder's partial metering area towards the desired *simple tone. Unfortunately with this camera the metering area is NOT marked and you have to guess at it!* Now turn the Quick Control Dial (a large notched wheel located on the *back* of the camera, so that the exposure level indicator in the viewfinder is positioned in the middle of [-2] and [+2] directly under [0]).

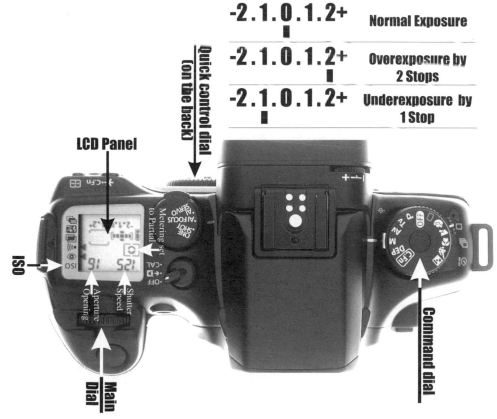

-2.1.0.1.2+ Normal Exposure

-2.1.0.1.2+ Overexposure by 2 Stops

-2.1.0.1.2+ Underexposure by 1 Stop

Quick control dial (on the back)

LCD Panel

ISO

Main Dial

Aperture Opening

Shutter Speed

Meter Set to Partial

Command dial

1 How to set the ISO Manually	2 How to set the function to Manual mode	3 How to change the aperture Manually	4 How to change the Exposure Time (shutter speed) Manually	5 How to set the exposure function to partial Metering	6 How to find the normal exposure of a simple subject?
If you do not have a DX coded film (i.e., you roll your own film): a) Turn the rotary Command Dial to [ISO]. b) By turning the Electronic Input Dial (notched wheel located near the shutter release button), you can set the dial to your desired ISO.	a) Turn the Rotary Command Dial to [M]. Your camera is now in Manual mode.	a) Turn the Command Dial to [M] (see step 2). b) Push and hold down the Manual aperture setting button under the LCD panel marked [AV +/-] while turning the Electronic Input Dial (round notched wheel). Every click of this dial increases or decreases the aperture opening by 1/2 stop. Some typical aperture opening numbers are 4, 5.6, 8, 11, 16 and 22. Their midpoints are 4.5, 6.7, 9.5, 13, and 19.	a) Set the camera mode to Manual [M] (see step 2). b) By rotating the Electronic Input Dial (a notched wheel located near the shutter release button), the shutter speed (exposure time) can be changed by 1/2 stop each time. The new exposure time is indicated on the left hand side of the LCD screen. Some typical shutter speed numbers are 15, 30, 60, 125, 250, 500, and 1000. Some midpoint shutter speeds include 20, 45, 100, 180, 350, and 750. Please remember that the most frequently used shutter speeds are in fractions of a second.	a) Select an aperture opening. If the subject is bright, choose a small opening (like f-11, f-16, or smaller). If the subject is dark, choose a large opening (like f-4, f-2.8, f-2, or larger). b) While pointing the center of the camera at the desired simple surface Reference Tone), press down the spot metering / partial metering button [*] referred to as "AE lock" or "Auto Exposure lock", the camera is in the spot / partial metering mode. As long as the [*] appears at the bottom of the viewfinder, the camera is in the spot / partial metering mode and its exposure is "locked" onto the surface that the *camera was pointing at* when the [*] was pressed.	a) If the subject is bright, the aperture should have a small opening such as f-11, f-16, or smaller. If the subject is dark, the aperture should have a large opening such as f-4, f-2.8, f-2, or larger. b) Now point the center of the camera at the desired simple subject and press the partial metering button marked with an [*]. This symbol will now appear to the left of your display in the viewfinder. b) While [*] is showing and your exposure is locked to that specific surface, turn the Main Dial until the exposure level indicator (index) in the viewfinder is positioned in the middle of [-2] and [+2] directly under [0]. If you change your Reference tone and the [*] is still in your viewfinder, press the [*] one more time to re-expose.

Canon EOS Rebel 2000

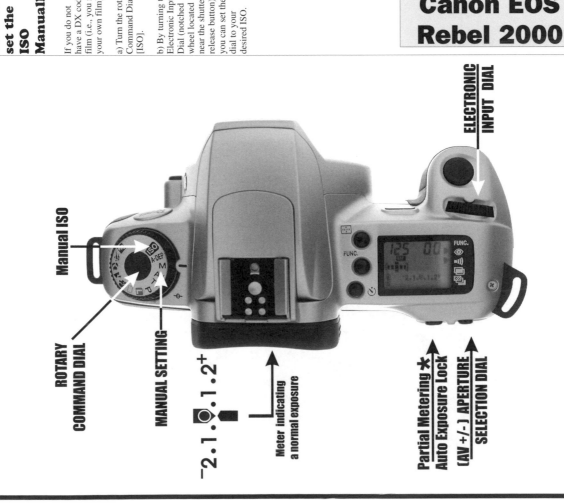

ELECTRONIC INPUT DIAL

Manual ISO

ROTARY COMMAND DIAL

MANUAL SETTING

-2.1.⬚.1.2+

Meter indicating a normal exposure

Partial Metering ✱ Auto Exposure Lock

[AV +/-] APERTURE SELECTION DIAL

1 How to set the ISO Manually	2 How to set the function to Manual mode	3 How to change the aperture Manually	4 How to change the Exposure Time (shutter speed) Manually:	5 How to set the exposure function to Partial Metering	6 How to find the normal exposure of a simple subject?
If you do not have DX coded film (i.e., you roll your own film): a) Press the "FUNC" button on the back of the camera until the arrow ">" points to the ISO icon. The ISO value now appears on the LCD panel. b) By turning the Main Dial (notched wheel located near the shutter release button), you can set the dial to your desired ISO. The ISO values on Rebel Ti can be set to 6, 8, 10, 12, 16, 20, 25, 32, 40, 50, 64, 80, 100, 125, 150, 200, 250, 320, 400, 500, 640, 800, 1000, 1250, 1600, 2000, 2500, 3200, 4000, 5000, and 6400.	a) Turn the Rotary Command Dial to [M]. Your camera is now in Manual mode. b) The shutter speed appears on the left hand side of your LCD panel, the aperture opening appears on the right, and the letter "M" appears at the top of the LCD screen.	a) Turn the Command Dial to [M] (see step 2). b) Push and hold down the "AV+/-" (the top button on the back of the camera) while rotating the "Main Dial". The aperture opening (Value) can now be set to different values. Typical Full-Stop values include 4, 5.6, 8, 11, 16, 22, and 32. Typical 1/2 stop values can include 4.5, 6.7, 9.5, 13, 19, and 27.	a) Set the camera mode to Manual [M] (see step 2). The shutter speed / Exposure Time now appears on the left hand side of the LCD screen and its value can be changed by rotating the Main Dial. b) By rotating the Main Dial (a notched wheel located near the shutter release button), the shutter speed (exposure time) can be changed by 1/2 stop each time from 30" (30 sec.) to 2000 (1/2000 sec.). Some typical shutter speeds are 15, 30, 60, 125, 250, 500, and 1000 and some midpoint shutter speeds include 20, 45, 100, 180, 350, and 750. Please remember that mostly used shutter speeds are in a fractions of a second.	a) Select an aperture opening. If there is a lot of light, choose a small opening (like f-11, f-16, or smaller). If the subject is dark, choose a large opening (like f-4, f-2.8, f-2, or larger). b) While pointing the center of the camera at the desired simple surface Reference Tone), press down the spot metering / partial metering button [*] referred to as "AE lock" or "Auto Exposure lock", the camera is in the spot / partial metering mode. As long as the [*] appears at the bottom of the viewfinder, the camera is in the spot / partial metering mode and its exposure is "locked" onto the surface that the camera was point at when the [*] was pushed down.	a) If the subject is bright, the aperture should have a small opening such as f-11, f-16, or smaller. If the subject is dark, the aperture should have a large opening such as f-4, f-2.8, f-2, or larger. b) Now point the center of the camera at the desired simple subject (Reference Tone) and press the partial metering button located on the back of the camera and marked with an [*]. An [*] will appear to the left of your display in the viewfinder. c) While [*] is showing in the viewfinder your exposure is locked to that specific surface. Now Turn the Main Dial until the exposure level indicator (index) in the viewfinder is positioned in the middle of [-2] and [+2] directly under [0]. If you change your Reference tone and the [*] is still in your viewfinder, press the [*] to reexpose.

CANON EOS Rebel Ti / 300V

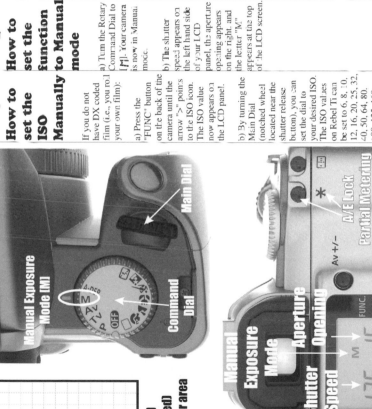

Canon EOS Rebel Ti (300V)
Partial Metering area (shaded)
Occupies 9.5% of the viewfinder area

Manual Exposure Mode (M)
Command Dial
Main Dial

A/E Lock
Partial Metering Mode
Av +/-
FUNC.

Manual Exposure Mode
Aperture Opening
Shutter Speed

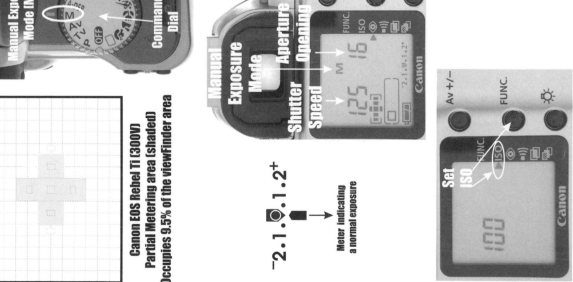

$^-2.1.\odot.1.2^+$

Meter indicating a normal exposure

Set ISO
Av +/-
FUNC.

	1 How to set the ISO Manually	2 How to set the function to Manual mode	3 How to change the aperture Manually	4 How to change the Exposure Time (Shutter Speed) Manually	5 How to set the exposure function to SPOT	6 Using the SPOT function, how to find the normal exposure of a simple subject?
	a) Turn the switch to ON (red camera) position b) Press FUNC, the ISO menu appears c) While ISO is highlighted in red, right-click to highlight the desired ISO value. G3's ISO can be set to 50, 100, 200, and 400. Press FUNC to establish ISO.	a) Turn Mode Dial to "M". The camera is now in Manual Mode. b) The Shutter speed and aperture opening will now appear at the bottom of the screen (as well as the LCD screen).	a) Set the Exposure Mode to "M" (step 2) b) Down-click (not rotate) the rotary main dial until a green arrow appears on the left hand side of the aperture opening at the bottom of the screen. c) Rotate the rotary Main Dial until the desired value is set. G3's aperture opening can be set from f-2 to f-8 in 1/3 stop divisions. Numbers are: 2, 2.2, 2.5, 2.8, 3.2, 3.5, 4, 4.5, 5.0, 5.6, 6.3, 7.1, and 8.	a) Press the rotary (do not rotate!) Main Dial until the green arrow on the back of the camera points to the shutter speed. b) Rotate the Main Dial to set it to the desired value. Standard shutter speeds are 15", 8", 4", 2", 1", 2 (1/2 sec.), 4 (1/4 sec.), 8, 15, 30, 64, 125, 250, 500, 1000, and 1250.	a) Press the Light Metering Button on the back of the camera so that the spot symbol ⊡ appears in the viewfinder and at the top left hand side of the LCD screen. The spot metering area is now within the "[]" symbol at the center of the viewfinder. Please note that the spot metering area is within the Auto Focus Frame (AF Frame). As the AF Frame moves so does the spot frame. For this example we will be using the default position at the center of the viewfinder.	a) Follow instructions in step 5. b) For outside shots, turn the main dial to choose a shutter speed that is close to the ISO of the film. For example for a 100 ISO film, set the shutter speed to 1/125 sec. (step 4). c) Point the spot metering frame of the camera, located at the center of the viewfinder ([]) towards the desired *simple tone*. Now press the shutter release partially (and gently) and wait for a second or so. The scale -2 to +2 appears on the LCD screen. Change the aperture opening or shutter speed to get the index dot in the middle. This WILL correspond to +0 on top left hand side of the monitor.

Canon PowerShot G3

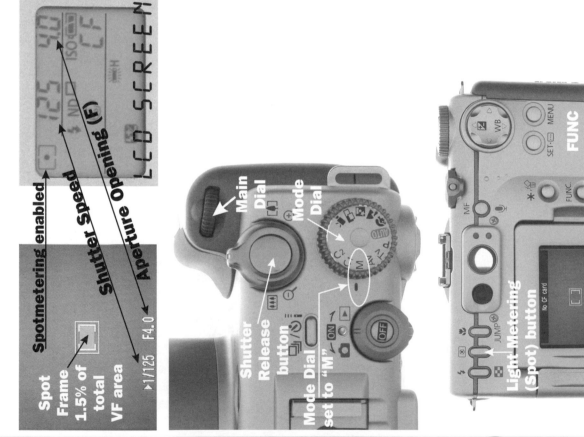

Spotmetering enabled

Spot Frame 1.5% of total VF area

Shutter Speed

Aperture Opening (F)

LCD SCREEN

Main Dial

Mode Dial

Shutter Release button

Mode Dial set to "M"

FUNC button to set ISO

Light Metering (Spot) button

1 How to set the ISO Manually	2 How to set the function to Manual mode	3 How to change the aperture Manually	4 How to change the Exposure Time (Shutter Speed) Manually	5 How to set the exposure function to SPOT	6 Using the SPOT function, how to find the normal exposure of a simple subject?
a) Turn the switch to ON (red camera) position b) Press FUNC, the ISO menu appears c) While ISO is highlighted in red, right-click to highlight the desired ISO value. G5's ISO can be set to 50, 100, 200 and 400. Press FUNC to establish ISO.	a) Turn Mode Dial to "M". The camera is now in Manual Mode. b) The Shutter speed and aperture opening will now appear at the bottom of the screen (as well as the LCD screen).	a) Set the Exposure Mode to "M" (step 2) b) Down-click (nor rotate) the rotary main dial until a green arrow appears on the left hand side of the aperture opening at the bottom of the screen. c) Rotate the rotary Main Dial until the desired value is set. G5's aperture opening can be set from f-2 to f-8 in 1/3 stop divisions. Numbers are: 2, 2.2, 2.5, 2.8, 3.2, 3.5, 4, 4.5, 5.0, 5.6, 6.3, 7.1, and 8.	a) Press the rotary Main Dial (do not rotate!) until the green arrow on the back of the camera points to the shutter speed. b) Rotate the Main Dial to set it to the desired value. Standard (full) shutter speeds are 15" (15 seconds), 8", 4", 2", 1", 2 (1/2 sec.), 4 (1/4 sec.), 8, 15, 30, 60, 125, 250, 500, 1000, and 1000.	a) Press the Light Metering Button on the back of the camera so that the spot symbol appears in the viewfinder and at the top left hand side of the LCD screen. The spot metering area is now within the "[]" symbol at the center of the viewfinder. Please note that the spot metering area is within the Auto Focus Frame (AF frame).	a) Follow instructions in step 5. b) For outside shots, turn the main dial to choose a shutter speed that is close to the ISO of the film. For example for a 100 ISO film, set the shutter speed to 1/125 sec. (step 4). c) Point the spot metering frame of the camera, located at the center of the viewfinder ([]) towards the desired *simple tone*. Now press the shutter release partially (and gently) and wait for a second or so. The scale -2 to +2 appears on the LCD screen. Change the aperture opening or shutter speed to get the index dot in the middle. This WILL correspond to +0 on the top left hand corner of the monitor.

Canon PowerShot G5

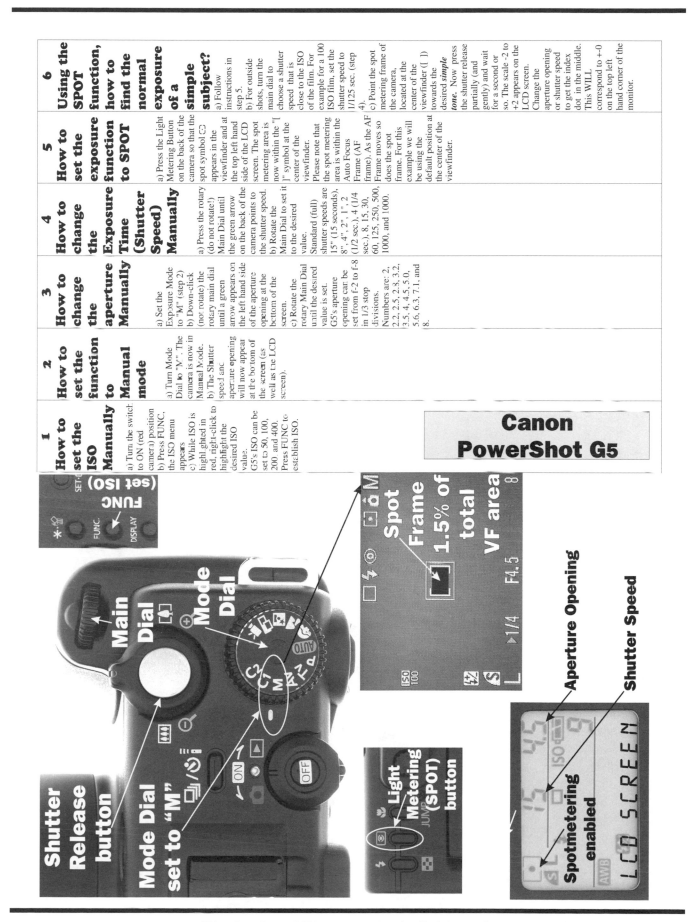

SET (ISO)
FUNC
Main Dial
Mode Dial
Shutter Release button
Mode Dial set to "M"
Light Metering (SPOT) button
Spot Frame 1.5% of total VF area
Aperture Opening
Shutter Speed
Spotmetering enabled
LCD SCREEN

1 How to set the ISO Manually	2 How to set the function to Manual Mode	3 How to change the aperture Manually	4 How to change the Exposure Time (shutter speed) Manually	5 How to set the exposure function to SPOT	6 How to find the normal exposure of a simple subject?
If you do not have DX coded film (i.e., you roll your own film): a) Turn the power switch to the [ON] position. Please note that the power switch must be turned on for steps 1 through 6 of this cheat sheet. b) Turn the Function Dial to ISO c) Press and hold down the FUNC button. The ISO appears on the LCD screen. d) Turn the control dial to set the desired ISO	a) Rotate the Function Dial so that the white index points to the PASM setting. b) Hold-down the FUNC button and rotate the Control Dial so that the letter "M" appears on the LCD screen. The shutter speed (exposure time) and aperture opening will appear on the LCD screen. Your camera is now in "M"anual exposure mode.	a) Set your camera mode to Manual [M] (see step 2). b) While the AV(+/-) button is pushed down, rotate the control dial to set the desired aperture opening, the value of which will be displayed in the viewfinder as well as the LCD panel. Typical values for AV (Aperture Value) are: 4, 5.6, 8, 11, 16, 22 and 1/2 stop values are: 6.7, 9.5, 13, and 19.	a) Set your camera mode to Manual [M] (see step 2). b) By rotating the front Control dial you can set your shutter exposure time. It will be displayed in the viewfinder as well as on the LCD panel.	a) Set the camera to Manual [M] mode. b) Push and hold-down the SPOT button on the back of your camera. The SPOT symbol [⊡] will now appear in the viewfinder. As long as the SPOT button is pushed down, the camera is in Spot metering mode.	a) Choose a shutter speed. If you are not sure what to set your shutter speed to, for outside shots, set it to a number close to the ISO of the film. For example if your film's ISO is 100, set it to 1/125 sec. (see step 4). b) Point your camera's spot at the desired SIMPLE subject so that the spot frame falls WITHIN the boundaries of this subject. c) Push and hold-down the [SPOT] button. This can be done by following directions in step 5. While the spot button is pressed press the AV (+/-) button. This will lock the exposure. Now release the spot button. The [⊡] will REMAIN in your viewfinder. While AV is pressed you can change the aperture opening until the pointer in your viewfinder is positioned exactly above the [0] mark.

Minolta Maxxum 5

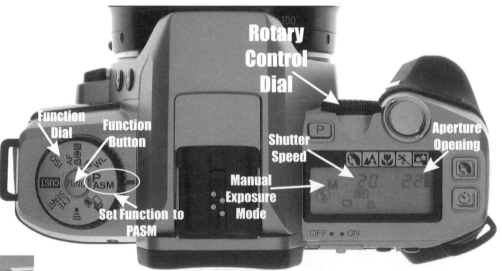

Rotary Control Dial

Function Dial

Function Button

Set Function to PASM

Shutter Speed

Manual Exposure Mode

Aperture Opening

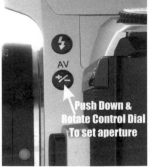

Push Down & Rotate Control Dial To set aperture

-2.1.0.1.2+

EV / Exposure Scale indicating Normal Exposure

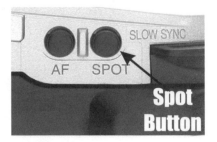

AF SPOT SLOW SYNC

Spot Button

1 How to set the ISO Manually	2 How to set the function to Manual Mode	3 How to change the aperture Manually	4 How to change the Exposure Time (shutter speed) Manually	5 How to set the exposure function to SPOT	6 How to find the normal exposure of a simple subject?
If you do not have DX coded film (i.e., you roll your own film): a) Turn the power switch to the [ON] position. b) Open the Control-panel door in the back of the camera and press the ISO button. c) Turn the front or rear control dials to set it to the desired ISO.	a) Slide the main switch to the [ON] position. b) Press the lock-release button at the center of the exposure mode dial and set it to [M]. The shutter speed (exposure time) and aperture opening will appear in a small LCD panel located at the top right hand corner of the camera. At the top of the screen is the shutter speed and at the bottom of the screen is the aperture opening.	a) Slide the Main switch to the [ON] position. b) Set your camera mode to Manual [M] (see step 2). c) By rotating the rear Control dial you can set your aperture opening. The shutter speed (exposure time) and aperture opening will appear in a small LCD panel located at the top right hand corner of the camera. At the top of the screen is the shutter speed and at the bottom of the screen is the aperture opening.	a) Slide the Main switch to the [ON] position. b) Set your camera mode to Manual [M] (see step 2). c) By rotating the front Control dial you can set your shutter speed/exposure time.	a) Slide the Main switch to the [ON] position. b) Set the camera to Manual [M] mode. c) Turn the Metering mode switch (with letters AEL) in the back (top center) of the camera to [.] the spotmeter then the spotmeter symbol [⊙] will appear in the viewfinder.	a) Set the exposure mode to Manual [M] (step 2). b) Choose a shutter speed (exposure time). If you are not sure what to set your shutter speed to, for outside shots, set it to a number close to the ISO of the film. For example if your film's ISO is 100, set it to 1/90 or 1/125 sec. This can be done following directions in step 4. c) Turn your metering to [SPOT]. This can be done by following directions in step 5. Then by pointing the center of the viewfinder at the desired simple subject and by changing the aperture and/or shutter speed, find the simple subject's normal exposure. This is when the pointer in your viewfinder is positioned exactly above the [0] mark located in the middle of [-3] and [+3] signs.

Minolta Maxxum 7

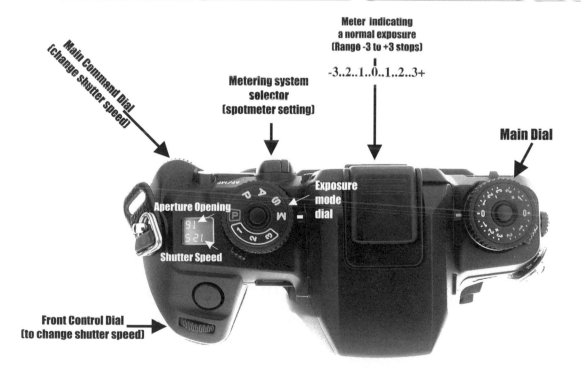

Meter indicating a normal exposure (Range -3 to +3 stops)

-3..2..1..0..1..2..3+

Metering system selector (spotmeter setting)

Main Command Dial (change shutter speed)

Main Dial

Exposure mode dial

Aperture Opening

Shutter Speed

Front Control Dial (to change shutter speed)

1 How to set the ISO Manually	2 How to set the function to Manual Mode	3 How to change the aperture Manually	4 How to change the Exposure Time (shutter speed) Manually	5 How to set the exposure function to SPOT	6 How to find the normal exposure of a simple subject?
If you do not have DX coded film (i.e., you roll your own film): a) Turn the power switch to the [ON] position. b) Open the Control-panel door located at the right hand side of the camera and press the ISO button. c) Turn the front or rear control dials to set it to the desired ISO. The ISO can be changed from 6 to 6400 in 1/3 stop increments. d) Press the shutter-release button partially down to register the ISO.	a) Slide the main switch from [lock] to [ON] position. b) Turn the exposure mode dial and set it to [M]. The shutter speed and aperture opening will appear in a small LCD panel located at the top right hand corner of the camera. At the top of the screen is the shutter speed and at the bottom of the screen is the aperture opening.	a) Turn the Main switch from [Lock] to [ON] position. b) Set your camera mode to Manual [M] (see step 2). c) By rotating the *rear* Control dial you can set your aperture opening. The shutter speed (exposure time) and aperture opening will appear in a small LCD panel located at the top right hand corner of the camera. At the top of the screen is the shutter speed and at the bottom of the screen is the aperture opening. It will also appear at the bottom of your viewfinder.	a) Turn the Main switch from [Lock] to [ON] position. b) Set your camera mode to Manual [M] (see step 2). c) By rotating the front Control dial you can set your shutter speed/exposure time. The Shutter speed will also appear at the bottom of your viewfinder. The shutter speed can be set from 30 seconds [30"] to 1 sec. [1"] through 1/12000 sec. In 1/2 stop increments.	a) Slide the Main switch to the [ON] position. b) Set the camera to Manual [M] mode. c) Turn the Metering mode switch (with letters AEL) in the back of the camera so that the index marker aligns with the spotmetering dot.	a) Turn the main switch from [Lock] to [ON] position. b) Set the exposure mode to Manual [M] (step 2). c) Choose a shutter speed. If you are not sure what to set your shutter speed to, for outside shots, set it to a number close to the ISO of the film. For example if your film's ISO is 100, set it to 1/125 sec. (see step 4). d) Turn your metering to [SPOT]. This can be done by following directions in step 5. Then by pointing the center of the viewfinder at the desired simple subject and by changing the aperture and/or shutter speed, find the simple subject's normal exposure. This is when the pointer in your viewfinder is positioned exactly above the [0] mark located in the middle of [-3] and [+3] signs.

Minolta Maxxum 9

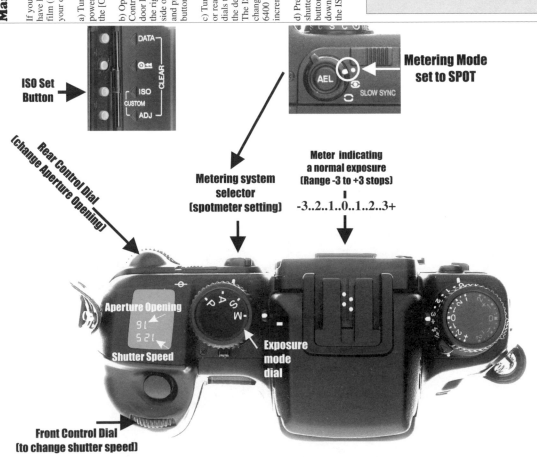

ISO Set Button

Metering Mode set to SPOT

Rear Control Dial [change Aperture Opening]

Metering system selector (spotmeter setting)

Meter indicating a normal exposure (Range -3 to +3 stops)

-3..2..1..0..1..2..3+

Aperture Opening

16

125

Shutter Speed

Exposure mode dial

Front Control Dial (to change shutter speed)

1 How to set the ISO Manually	2 How to set the function to Manual Exposure mode	3 How to change the aperture Manually	4 How to change the Exposure Time (shutter speed) Manually	5 How to set the exposure function to Spot	6 How to find the normal exposure of a simple subject?
If you do not have DX coded film (i.e., you roll your own film): a) Slide the power switch to the [ON] position. b) Turn the Function Dial to ISO c) Push the Function Button and hold down. The ISO value will appear on the LCD screen (Data Panel).	a) Turn the power switch to the [ON] position. b) Turn the Function Dial until the black mark points to PASM value. c) While holding down the Function button, rotate the Control Dial until the letter [M] appears at the center of the LCD panel. Now your camera is set to the Manual Exposure [M] mode.	a) Turn the main switch to the [ON] position. b) Set the camera mode to Manual [M] (see step 2). c) Now with your left thumb press and hold the round [AV button] located in front of the camera with symbols [+/-] and turn the control dial until the desired aperture is displayed. Typical full-stop aperture openings are 4, 5.6, 8, 11, and 16. Their typical 1/2 stop divisions are 4.5, 6.7, 9.5, 13, 19, 27, and so on.	a) Turn the main switch to the [ON] position. b) Set the camera mode to Manual [M] (see step 2).	a) Slide the main switch to the [ON] position. b) Set the camera to Manual [M] mode (step 2). c) Point the camera towards the subject and press the shutter release button partially down to focus.	a) Turn on the camera and set the mode to Manual [M] (step 2). b) Choose a shutter speed (exposure time). If you are not sure of your shutter speed setting, for outside shots, set it to a number close to the ISO of the film. For example if your film's ISO is 100, set it to 1/125 sec. This can be done following the directions in step 4.

Minolta Maxxum STsi

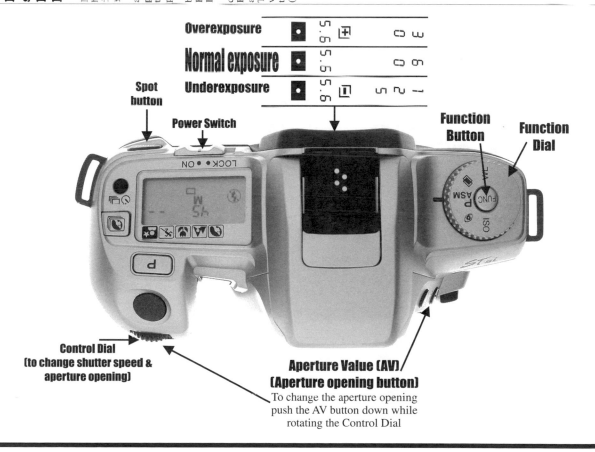

Overexposure

Normal exposure

Underexposure

Spot button

Power Switch

LOCK ● ● ON

Function Button

Function Dial

Control Dial (to change shutter speed & aperture opening)

Aperture Value (AV) (Aperture opening button)
To change the aperture opening push the AV button down while rotating the Control Dial

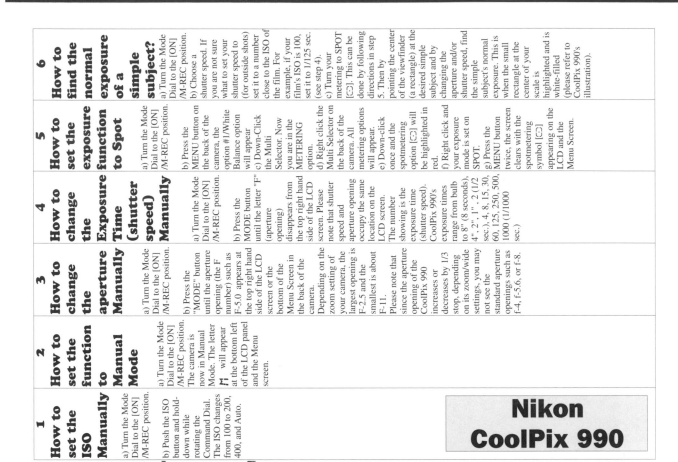

1 How to set the ISO Manually	2 How to set the function to Manual Mode	3 How to change the aperture Manually	4 How to change the Exposure Time (shutter speed) Manually	5 How to set the exposure function to Spot	6 How to find the normal exposure of a simple subject?
a) Turn the Mode Dial to the [ON] /M-REC position. b) Push the ISO button and hold-down while rotating the Command Dial. The ISO changes from 100 to 200, 400, and Auto.	a) Turn the Mode Dial to the [ON] /M-REC position. The camera is now in Manual Mode. The letter *M* will appear at the bottom left of the LCD panel and the Menu screen.	a) Turn the Mode Dial to the [ON] /M-REC position. b) Press the "MODE" button until the aperture opening (the F number) such as F-5.0 appears at the top right hand side of the LCD screen or the Menu Screen in the bottom of the camera. Depending on the zoom setting of your camera, the largest opening is F-2.5 and the smallest is about F-11. Please note that since the aperture opening of the CoolPix 990 increases or decreases by 1/3 stop, depending on its zoom/wide settings, you may not see the standard aperture openings such as f-4, f-5.6, or f-8.	a) Turn the Mode Dial to the [ON] /M-REC position. b) Press the MODE button until the letter "F" (aperture opening) disappears from the top right hand side of the LCD screen. Please note that shutter speed and aperture opening occupy the same location on the LCD screen. The number showing is the exposure time (shutter speed). CoolPix 990's exposure times range from bulb to 8" (8 seconds), 4", 2", 1", 2 (1/2 sec.), 4, 8, 15, 30, 60, 125, 250, 500, 1000 (1/1000 sec.)	a) Turn the Mode Dial to the [ON] /M-REC position. b) Press the MENU button on the back of the camera, the option #1/White Balance option will appear c) Down-Click the Multi Selector. Now you are in the METERING option. d) Right click the Multi Selector on the back of the camera. All metering options will appear. e) Down-click once and the spotmetering option [⊙] will be highlighted in red. f) Right click and your exposure mode is set on SPOT. g) Press the MENU button twice, the screen clears with the spotmetering symbol [⊙] appearing on the LCD and the Menu Screen.	a) Turn the Mode Dial to the [ON] /M-REC position. b) Choose a shutter speed. If you are not sure what to set your shutter speed to (for outside shots) set it to a number close to the ISO of the film. For example, if your film's ISO is 100, set it to 1/125 sec. (see step 4). c) Turn your metering to SPOT [⊙]. This can be done by following directions in step 5. Then by pointing the center of the viewfinder (a rectangle) at the desired simple subject and by changing the aperture and/or shutter speed, find the simple subject's normal exposure. This is when the small rectangle at the center of your scale is highlighted and is white-filled (please refer to CoolPix 990's illustration).

Nikon CoolPix 990

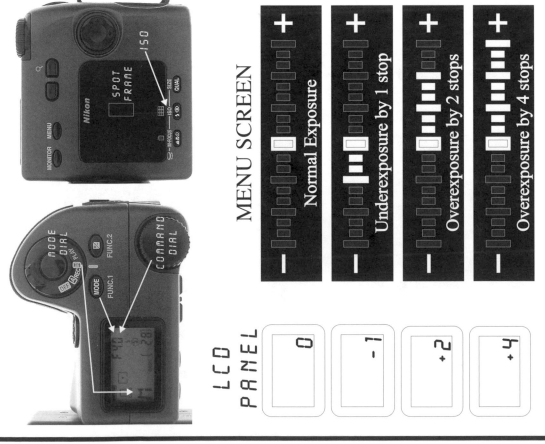

MENU SCREEN

Normal Exposure

Underexposure by 1 stop

Overexposure by 2 stops

Overexposure by 4 stops

LCD PANEL

0

-1

+2

+4

1 How to set the ISO Manually	2 How to set the function to Manual Mode	3 How to change the aperture Manually	4 How to change the Exposure Time (shutter speed) Manually	5 How to set the exposure function to Spot	6 How to find the normal exposure of a simple subject?
a) Turn the Mode Dial to the [ON] /M position.	a) Turn the Mode Dial to the [ON] /M position. The camera is now in Manual Mode. The letter **M** will appear at the bottom left of the LCD panel and the Menu screen.	a) Turn the Mode Dial to the [ON] /M position.	a) Turn the Mode Dial to the [ON] /M-REC position.	a) Turn the Mode Dial to the [ON] /M position.	a) Turn the Mode Dial to the [ON] /M-REC position.
b) Push the ISO button and hold-down while rotating the Command Dial. The ISO changes from 100 to 200, 400, 800, and Auto.	Please Note: If any letter other than "M" such as "A", "P", or "S" appear on your LCD screen, while holding down the "FUNC. 1" button, rotate the Command dial until the letter "M" appears.	b) Press the "MODE" button until the aperture opening 'the F number) such as F-5.0 appears at the top right hand side of the LCD screen or the bottom of the Menu Screen in the back of the camera. Depending on the zoom setting of your camera, the largest opening is F-2.6 and the smallest is about F-10.3.	b) Press the MODE button until the letter "F" (aperture opening) disappears from the top right hand side of the LCD screen. Please note that shutter speed and aperture opening occupy the same location on the LCD screen.	b) Press the MENU button on the back of the camera, the option #1/White Balance option will appear c) Down-Click the Multi Selector. Now you are in the METERING option d) Right click the Multi Selector on the back of the camera. All metering options will appear e) Down-click once and the spotmetering option [⊡] will be highlighted in red.	b) Choose a shutter speed (exposure time). If you are not sure what to set your shutter speed to (for outside shots) set it to a number close to the ISO of the film. For example, if your film's ISO is 100, set it to 1/125 sec. (see step 4). c) Turn your metering to SPOT [⊡]. This can be done by following directions in step 5. Then by pointing the center of the viewfinder (a rectangle) at the desired simple subject and by changing the aperture and/or shutter speed, find the simple subject's normal exposure. This is when the small rectangle at the center of your scale is highlighted and is white-filled (please refer to CoolPix 995's illustration).

Nikon CoolPix 995

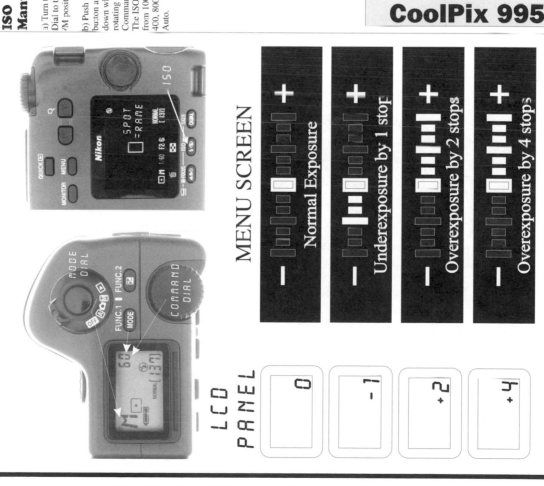

MENU SCREEN

Normal Exposure

Underexposure by 1 stop

Overexposure by 2 stops

Overexposure by 4 stops

LCD PANEL

0

-1

+2

+4

1 How to set the ISO Manually	2 How to set the function to Manual Mode	3 How to change the aperture Manually	4 How to change the Exposure Time (shutter speed) Manually	5 How to set the exposure function to Spot	6 How to find the normal exposure of a simple subject?
a) Turn the Power Switch to the [ON] position. b) While holding down the ISO button, the ISO can be changed by rotating the Command Dial. ISO values can be set to 100, 200, 400, and 800.	a) Turn the Power Switch to the [ON] position. b) Press the "MODE" button until the letter appears at the bottom left of the screen on the back. Other exposure modes include "A", "P", "S", "Auto" and so on.	a) Turn the Power Switch to the [ON] position. b) Press the "MODE" button until the aperture opening (the F number) such as F-5.0 appears at the bottom of the Menu Screen on the back of the camera. Depending on the zoom setting of your camera, the largest opening is F-2.6 and the smallest is about F-10.3.	a) Turn the Mode Dial to the [ON] position. b) Press the MODE button once until the shutter speed is highlighted (green) at the bottom of the screen. The number showing is the exposure time (shutter speed). CoolPix 4500's exposure times range from Bulb 5min to 8" (8 seconds), 4", 2" (1/2 sec.), 1", 2 (1/2 sec.), 4, 8, 15, 30, 60, 125, 250, 500, 1000 (1/1000 sec.), and 2000 (1/2000 sec.)	a) Turn the Mode Dial to the [ON] position. b) Press the MENU button on the back of the camera, until the SHOOTING MENU appears. c) Down-Click the SET Selector once, now you are in the METERING section. d) Right click the Multi Selector on the back of the camera. All metering options will appear e) Down-click once and the spotmetering option [⊡] will be highlighted in red.	a) Turn the Power Switch to the [ON] position. b) Choose a shutter speed (exposure time). If you are not sure what to set your shutter speed to (for outside shots) set it to 1/500 sec. (see step 4). c) Turn your metering to SPOT [⊡]. This can be done by following directions in step 5. Then by pointing the center of the viewfinder (a rectangle) at the desired simple subject and by changing the aperture and/or shutter speed, find the simple subject's normal exposure. This is when the small rectangle at the center of your scale is highlighted and is white-filled (please refer to CoolPix 4500's illustration).

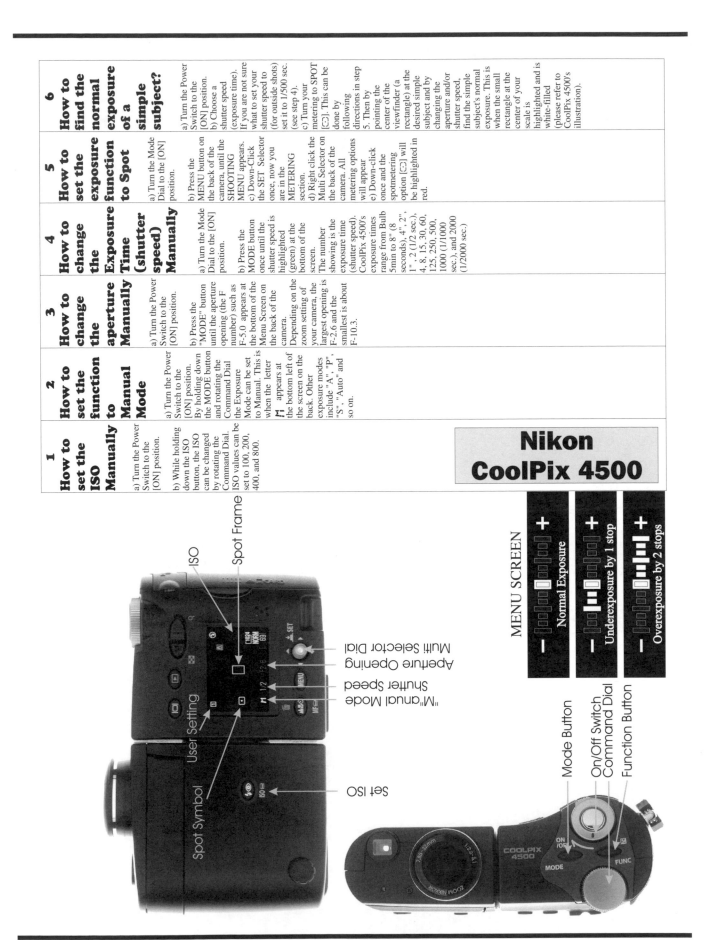

Nikon CoolPix 4500

ISO

Spot Frame

User Setting

Spot Symbol

Multi Selector Dial

Aperture Opening

Shutter Speed

"M"anual Mode

Set ISO

MENU SCREEN

Normal Exposure

Underexposure by 1 stop

Overexposure by 2 stops

Mode Button

On/Off Switch
Command Dial

Function Button

COOLPIX 4500

1 How to set the Camera to Manual Exposure Mode	2 How to set the ISO Manually	3 How to change the aperture Manually	4 How to change the Exposure Time (shutter speed) Manually	5 How to set the camera to Spot	6 How to find the normal exposure of a simple subject?
a) Turn the Mode Dial to the [ON] position. b) Unfold open) the Monitor located on the back of the camera. If desired, the Monitor can be rotated so that the three control buttons are on the top or bottom. c) Press the middle button (Menu Button). If the red bar appears on digit 1, 2 or 3, your camera is set to User Mode. You can now go to the next step. d) When you press the MENU button, if SET-UP Menu appears with User Settings highlighted, then right click the Multi Selector Dial to get to User Setting, then down click so that 1, 2, or 3 is highlighted. Right click again. Depending on the option you chose, a 1, 2, or 3 will appear highlighted with a rightward arrow. Click the menu Button TWICE to get back to the standard Menu. Now while holding FUNC button down, rotate the Command Dial until " M " appears on the bottom left hand side with 1, 2, or 3 appearing on top left hand side of the screen. Your CP 5000 is now set for Manual Exposure.	a) Turn the Mode Dial to the [ON] position. Follow step 1 so that your camera is in Manual Exposure Mode with 1, 2, or 3 appearing on the top left hand side and letter " M " appearing at the bottom Left of the screen. b) While holding down the ISO button located on the back of the camera, rotate the command dial. The ISO can now be set to 100, 200, 400, and 800 as indicated on the right-center of the Monitor.	a) Turn the Mode Dial to the [ON] position. Follow step 1 so that your camera is in the Manual Exposure Mode with 1, 2, or 3 appearing on the top left hand and letter " M " appearing at the bottom Left of the screen. b) Press the "MODE" button until the aperture (the F number) opening such as F2.8, F3.1, F3.5, F4.0 at the bottom-center of the screen is highlighted with a green tint. Depending on the zoom setting of your camera, the largest opening is F-2.8 and the smallest opening is about F-8. Please note that since the aperture opening of the CoolPix 5000 increases or decreases by 1/3 stop, depending on its zoom/wide settings, you may not always see the standard aperture openings such as f-4, f-5.6 or f-8. Typical F numbers at fully wide-angled lens are 2.8, 3.1, 3.5, 4.0, 4.4, 5.0, 5.6, 5.3, 7.1, and 8.0. Typical F numbers with fully zoomed (zoomed) lens are 4.8, 5.4, 6.0, 6.8, and 7.6.	a) Turn the Mode Dial to the [ON] position. Follow step 1 so that your camera is in Manual Exposure Mode with 1, 2, or 3 appearing in the top left hand and the letter " M " appearing at the bottom left of the screen. b) Press the "MODE" button until the Shutter Speed (between Manual " M " and the aperture opening (F) is highlighted in green. By rotating the command dial, the shutter speed can be changed from BULB (1 Minute) to 8 sec, 4 sec., 2 sec., 1 sec., 1/2 sec. 1/4, 1/8, 1/15, 1/30, 1/60, 1/125, 1/250, 1/500, 1/1000, and 1/2000 second.	a) Turn the Mode Dial to the [ON] position. Follow step 1 so that your camera is in Manual Exposure Mode with 1, 2, or 3 appearing on the top left and letter " M " appearing at the bottom Left of your monitor. b) When you click the Menu button ONCE, the user-setting sub menu will appear with 1, 2, or 3 highlighted. Now down click twice until the "METERING" menu is highlighted and the word "METERING" appears at the top of the monitor. By right-clicking the metering once, four metering options will appear. Down click once and choose the spotmetering option [·]. Now right click to choose the spotmetering option. Click the Menu button TWICE to get back to your standard menu. The [·] symbol will appear on the bottom left hand side of the monitor. The spotmetering frame (a vertical rectangle) will appear from wide to telephoto range of the lens. Th s frame and the symbol will disappear when the extended (X) zoom is used.	a) Choose a shutter speed. If you are not sure what to set your shutter speed to (for outside shots) set it to a number close to the ISO of the film. For example, if your film's ISO is 100, set it to 1/125 sec. (see step 4). b) Turn your metering to SPOT [·]. This can be done by following directions in step 5. Then by pointing the spot frame (a vertical rectangle) at the desired simple subject so that the frame falls within the boundaries of your simple subject. Now by changing the aperture and/or shutter speed, find the simple subject's normal exposure (see diagram). This is when the small rectangle at the center of your scale is highlighted and is white-filled (please refer to CoolPix 5000's illustration). If the scale does not show, turn the command dial and it will appear.

Nikon CoolPix 5000

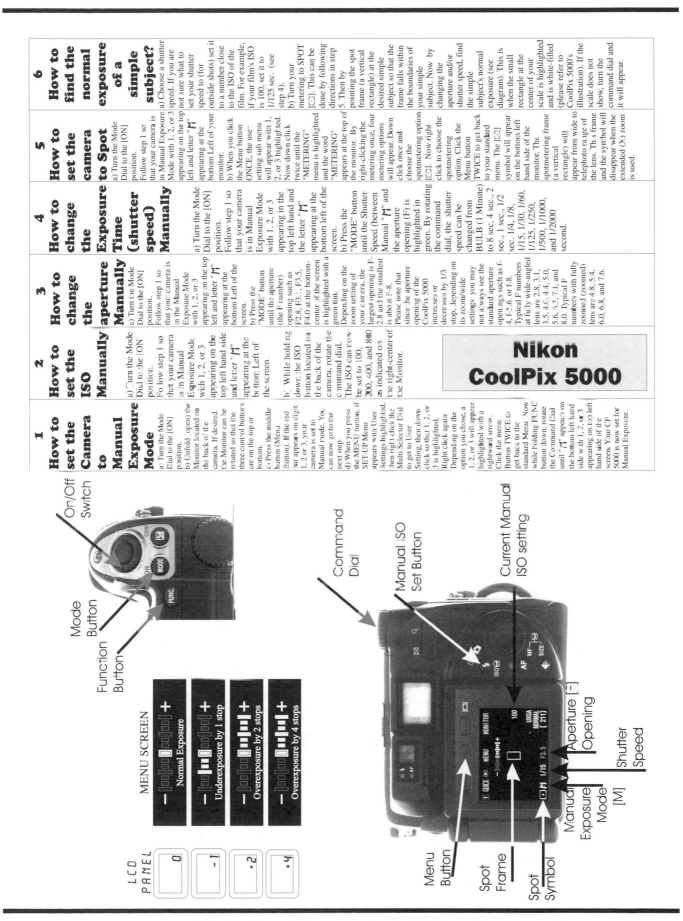

On/Off Switch

Mode Button

Function Button

MENU SCREEN

Normal Exposure

Underexposure by 1 stop

Overexposure by 2 stops

Overexposure by 4 stops

LCD PANEL

0

-1

+2

+4

Command Dial

Manual ISO Set Button

Current Manual ISO setting

Aperture [F] Opening

Shutter Speed

Manual Exposure Mode [M]

Spot Symbol

Spot Frame

Menu Button

Nikon CoolPix 5700

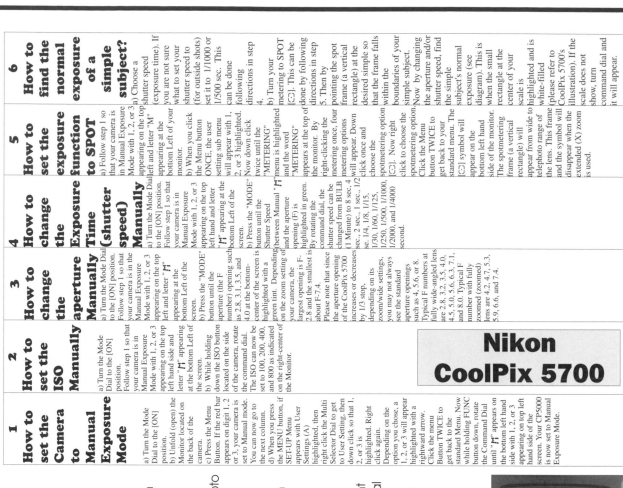

1 How to set the Camera to Manual Exposure Mode	2 How to set the ISO Manually	3 How to change the aperture Manually	4 How to change the Exposure Time (shutter speed) Manually	5 How to set the exposure function to SPOT	6 How to find the normal exposure of a simple subject?
a) Turn the Mode Dial to the [ON] position. b) Unfold (open) the Monitor located on the back of the camera. c) Press the Menu Button. If the red bar appears on digit 1, 2 or 3, your camera is set to Manual mode. You can now go to the next column. d) When you press the MENU button, if SET-UP Menu appears with User Settings (A) highlighted, then right click the Multi Selector Dial to get to User Setting, then down click so that 1, 2, or 3 is highlighted. Right click again. Depending on the option you chose, a 1, 2, or 3 will appear highlighted with a rightward arrow. Click the menu Button TWICE to get back to the standard Menu. Now while holding FUNC button down, rotate the Command Dial until "M" appears on the bottom left hand side with 1, 2, or 3 appearing on top left hand side of the screen. Your CP5000 is now set to Manual Exposure Mode.	a) Turn the Mode Dial to the [ON] position. Follow step 1 so that your camera is in Manual Exposure Mode with 1, 2, or 3 appearing on the top left hand side and letter "M" appearing at the bottom Left of the screen. b) While holding down the ISO button located on the side of the camera, rotate the command dial. The ISO can now be set to 100, 200, 400, and 800 as indicated on the right-center of the Monitor.	a) Turn the Mode Dial to the [ON] position. Follow step 1 so that your camera is in the Manual Exposure Mode with 1, 2, or 3 appearing on the top left and letter "M" appearing at the bottom Left of the screen. b) Press the "MODE" button until the F aperture (the F number) opening such as 2.8, 3.1, 3.5, and 4.0 at the bottom-center of the screen is highlighted with a green tint. Depending on the zoom setting of your camera, the largest opening is F-2.8 and the smallest is about F-7.4. Please note that since the aperture opening of the CoolPix 5700 increases or decreases by 1/3 stop, depending on its zoom/wide settings, you may not always see the standard aperture openings such as 4, 5.6, or 8. Typical F numbers at fully wide-angled lens are 2.8, 3.2, 3.5, 4.0, 4.5, 5.0, 5.6, 6.3, 7.1, and 8.0. Typical F number with fully zoomed (zoomed) lens are 4.2, 4.7, 5.3, 5.9, 6.6, and 7.4.	a) Turn the Mode Dial to the [ON] position. Follow step 1 so that your camera is in Manual Exposure Mode with 1, 2, or 3 appearing on the top left hand and letter "M" appearing at the bottom Left of the screen. b) Press the "MODE" button until the Shutter Speed (between Manual and the aperture opening (F) is highlighted in green. By rotating the command dial, the shutter speed can be changed from BULB (1 Minute) to 8 sec, 4 sec, 2 sec, 1 sec, 1/2 se, 1/4, 1/8, 1/15, 1/30, 1/60, 1/125, 1/250, 1/500, 1/1000, 1/2000, and 1/4000 second.	a) Follow step 1 so that your camera is in Manual Exposure Mode with 1, 2, or 3 appearing on the top left of your monitor. b) When you click the Menu button ONCE, the user setting sub menu will appear with 1, 2, or 3 highlighted. Now down click twice until the "METERING" menu is highlighted and the word "METERING" appears at the top of the monitor. By right-clicking the metering once, four metering options will appear. Down click once and choose the spotmetering option [⊡]. Now right click to choose the spotmetering option. Click the Menu button TWICE to get back to your standard menu. The [⊡] symbol will appear on the bottom left hand side of the monitor. The spotmetering frame (a vertical rectangle) will appear from wide to telephoto range of the lens. This frame and the symbol will disappear when the extended (X) zoom is used.	a) Choose a shutter speed (exposure time). If you are not sure what to set your shutter speed to (for outside shots) set it to 1/1000 or 1/500 sec. This can be done following directions in step 4. b) Turn your metering to SPOT [⊡]. This can be done by following directions in step 5. Then by pointing the spot frame (a vertical rectangle) at the desired simple so that the frame falls within the boundaries of your simple subject. Now by changing the aperture and/or shutter speed, find the simple subject's normal exposure (see diagram). This is when the small rectangle at the center of your scale is highlighted and is white-filled (please refer to CoolPix 5700's illustration). If the scale does not show, turn command dial and it will appear.

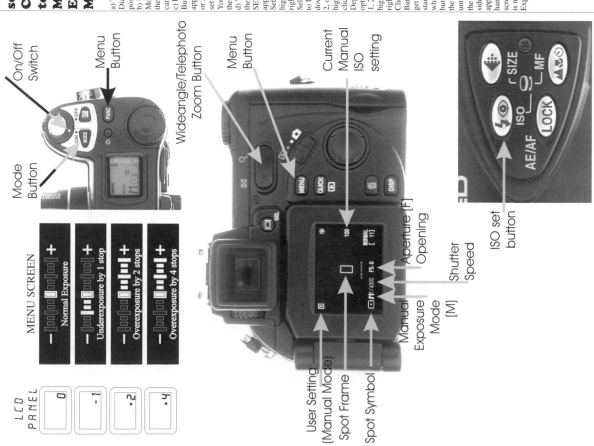

On/Off Switch — Menu Button — Mode Button — Wideangle/Telephoto Zoom Button — Menu Button — Current Manual ISO setting — Aperture [F] Opening — Shutter Speed — Manual Exposure Mode [M] — User Setting (Manual Mode) — Spot Frame — Spot Symbol — ISO set button

MENU SCREEN
- Normal Exposure
- Underexposure by 1 stop
- Overexposure by 2 stops
- Overexposure by 4 stops

LCD PANEL
0 -1 +2 +4

1 How to set the Camera to Manual Exposure Mode	2 How to set the ISO Manually	3 How to change the aperture Manually	4 How to change the Exposure Time (shutter speed) Manually	5 How to set the exposure function to SPOT	6 Finding the normal exposure of a simple subject
a) Turn the Dial to [Mode] / [ON] position. b) Unfold (open) the Monitor located on the back of the camera. c) Press the Menu Button. If a [1] appears in a square on the top le t hand side of the screen, you are almost there! Just go to step d). However, when you pressed the MENU button if the Shooting Menu (Auto) appears, then by down-clicking the Multi Selector Dial (MSD) highlight the User Setting, then right click the MSD. The User Setting Menu will now appear. By down-clicking MSD twice, highlight the Custom 1 option, then right click. A [1] in a square will appear on the top left hand side of the screen d) Now rotate the Command Dial while the Mode Button is held down until the letter "M" appears on the bottom left hand side of the screen and the number [1] appearing on top left hand side of the screen. The letter "M" must also appear on the LCD screen located on the top right hand side of the camera Your CP 8700 is now set to Manual Exposure Mode.	a) Turn the Dial to [Mode] / [ON] position. Follow step 1 so that your camera is in Manual Exposure Mode with a [1] appearing on the top left hand side of the screen and the letter "M" appearing at the bottom left of the screen as well as on the LCD screen. b) While holding down the ISO button located on the lens of the camera, rotate the command dial. The ISO can now be set to 50, 100, 200, and 400 as indicated on the right-center of the screen.	a) Turn the Dial to [Mode] / [ON] position. Follow step 1 so that your camera is in the Manual Exposure Mode with a [1] appearing on the top left and the letter "M" appearing at the bottom left of the screen. Yhe letter "M" MUST also appear on the LCD screen. b) Press the "MODE" button until the aperture (the F number) opening such as F2.8, F3.1, F3.5, F4.0 at the bottom-center of the screen is highlighted with a green tint. Depending on the zoom setting of your camera, the largest opening is F-2.8 and the smallest is about F-8. Please note that since the aperture opening of the CoolPix 8700 increases or decreases by 1/3 stop, depending on its zoom/wide settings, you may not always see the standard aperture openings such as f-4, f-5.6, or f-8. Typical F-numbers for a fully wide-angled lens are F2.8, F3.2, F3.5, F4.0, F4.5, F5.0, F5.6, F6.3, F7.1, and F8.0. Typical F-numbers for a fully zoomed lens are 4.2, 4.7, 5.3, 5.9, 6.6, and 7.4.	a) Turn the Dial to [Mode] / [ON] position. Follow step 1 so that your camera is in Manual Exposure Mode with 1, or 2 appearing on the top left hand and letter "M" appearing at the bottom Left of the screen as well as the LCD screen. b) Press the "MODE" button until the Shutter Speed (between Manual "M" and the aperture opening (F) is highlighted in green. By rotating the command dial, the shutter speed can be changed from BULB (10 Minutes) to 8 sec, 4 sec., 2 sec., 1 sec., 1/2. 1/4, 1/8, 1/15, 1/30, 1/60, 1/125, 1/250, 1/500, 1/1000, 1/2000, and 1/4000 second.	a) Turn the Dial to [Mode] / [ON] position. Follow step 1 so that your camera is in Manual Exposure Mode with 1 or 2 appearing on the top left and letter "M" appearing at the bottom left of your monitor as well as your LCD panel. b) When you click the Menu button once, "MY MENU" screen will appear. Now down click MSD once and the metering menu will be highlighted. Right click MSD once and all metering options will appear. Choose spot and right click MSD. Press Menu button to exit. The spotmetering symbol will appear on the back screen as well as on the LCD screen.	a) Choose a shutter speed (exposure time). If you are not sure what to set your shutter speed to, for outside shots, set it to 5 times the ISO, i.e. 250. For 200 ISO it is 1/1000. b) Turn your metering to SPOT []. This can be done by following directions in step 5. Then by pointing the spot frame (a vertical rectangle) at the desired simple so that the frame falls within the boundaries of your simple subject. Now by changing the aperture and/or shutter speed, find the simple subject's normal exposure (see diagram). This is when the small rectangle at the center of your scale is highlighted and is white-filled (please refer to CoolPix 8700's illustration). If the scale does not show, turn command dial and it will appear.

Nikon CoolPix 8700

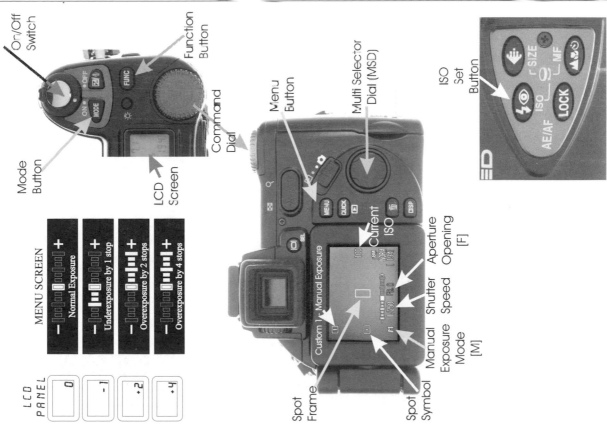

Nikon D70 Digital

1 How to set the ISO Manually	2 How to set the function to Manual Mode	3 How to change the aperture Manually	4 How to change the Exposure Time (shutter speed) Manually	5 How to set the exposure function to SPOT	6 How to find the normal exposure of a simple subject?
a) Turn the power switch to the [ON] position. b) While holding down the [ISO] button on the back, turn the rear Main Command Dial (notched wheel located near the LCD panel behind the camera●) until the desired ISO appears on the screen. Release the ISO button and you are set! You can set the ISO on the D70 in 1/3 stop divisions to: **200, 250,** 320, **400,** 500, 640, **800,** 1000, 1250, and **1600.**	a) Turn the power switch to the [ON] position. b) Turn the MODE Dial to "M". The shutter speed and the Aperture Opening will now appear on the LCD panel.	a) If you are NOT using type "G" lens, please make sure your aperture opening on your lens is set to its minimum, i.e., it is set to [f-22] or [f-32]. By pushing the minimum aperture lock (a lock with a little white dot on the lens) towards the camera, lock the lens in the minimum-aperture position so that the aperture ring can no longer be rotated. b) Set the camera mode to Manual [M] (see step 2). By rotating the Sub-Command Dial (the ● notched rotary dial in front of the camera right under the shutter release button) numbers such as 3.5, 4, 4.5, 5, 5.6, 6.3, 7.1, 8, 9, 10, 11, 13, 14, 16, 18, 20, and 22 in 1/3 stop divisions will appear on the LCD panel.	a) Turn the main switch to the [ON] position. b) Set your camera mode to Manual [M] (see step 2). c) By rotating the rear Main-Command Dial you can change the shutter speed from [bulb], [30"] (thirty seconds), [25"], ... to [1"] second and from there to [1.3], [1.6], [2], and finally to [8000]. PLEASE NOTE: after 1 second, all values are in fractions of a second or [1/]. For example 250 on the dial means 1/250th of a second and 8000 means 1/8000 sec. and so on.	a) While holding down the Metering Mode button, turn the Main Command Dial until ⊡ appears on the LCD screen. b) To simplicity, we will activate the center focus areas located at the center of the viewfinder. If the AF area mode on the LCD screen has one [] at its center with no dots, your camera is set correctly. If the [] is not at the center, use Multi Selector (with Focus Selector Lock button set to (.) and click on the (.) and click on the menu button. Once menu appears, down-click twice until the "PEN" tool in the Custom Setting /CSM menu is highlighted. Now right-click once and down-click until "03 AF area mode" is highlighted. Now right-click again and highlight Single Area, then right click to establish the single area focusing feature. Press menu twice to exit. You can verify this setting by checking the LCD screen (please see illustration). Also if shutter release is partially pressed, the center focus area in the viewfinder will be outlined in red.	a) Set the exposure mode to Manual [M] (step 2). b) Choose a shutter speed. If you are not sure what to set your shutter speed to, for outside shots, set it to a number close to the ISO of the camera. For example if your film's ISO is 100, set it to 1/125 sec. (see step 4). c) Turn your metering to [SPOT] and activate the center spot circle. This can be done by following directions in step 5. Now by pointing the *approximate* spot metering frame (which fortunately with this Nikon model follows very closely the frame of the center-single-focus area) at the desired simple subject. By changing the aperture and/or shutter speed, find the surface's normal exposure. This is when only ONE line appearing under the [0] mark located in the middle of [+] and [-] signs.

+..0..-

ISO set to 200 as is displayed on the LCD screen

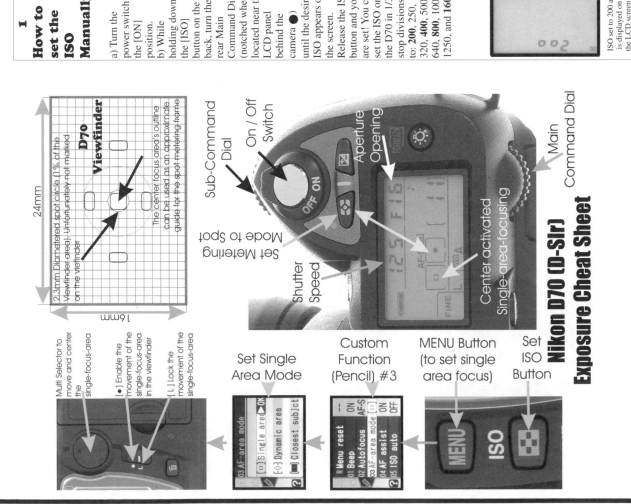

Nikon D70 (D-Slr) Exposure Cheat Sheet

D70 Viewfinder

24mm / 16mm

2.3mm Diameter ed spot ciIcle (1% of the Viewfinder area). Unfortunately not marked on the viewfinder

The center focus area's outline can be used as an approximate guide for the spot metering frame

Sub-Command Dial

On / Off Switch

Aperture Opening

Main Command Dial

Set Metering Mode to Spot

Shutter Speed

Center activated Single-area-focusing

Multi Selector to move and center the single-focus-area

[●] Enable the movement of the single-focus-area in the viewfinder

[L] Lock the movement of the single-focus-area

Set Single Area Mode

03 AF-area mode ▶ OK — [⊡] Single area — [⋯] Dynamic area — [▣] Closest subject

Custom Function (Pencil) #3

R Menu reset — 01 Beep ON — 02 Autofocus AF-S — 03 AF-area mode [⊡] — 04 AF assist ON — 05 ISO auto OFF

MENU Button (to set single area focus)

Set ISO Button

1 How to set the ISO Manually	2 How to set the function to Manual Mode	3 How to change the aperture Manually:	4 How to change the Exposure Time (shutter speed) Manually	5 How to set the exposure function to SPOT	6 How to find the normal exposure of a simple subject?
a) While holding down the ISO ring unlock button, turn the ISO ring until the white marker points at the desired ISO. The ISO for F4 can be set manually from 6 to 6400. b) To set the ISO back to DX, follow the step (a) until the marker points to "DX" symbol.	a) By setting the shutter speed dial to 4 (4 sec.) to 1/8000 sec. (8000), your F4 will operate in the manual mode. If you can not turn the dial, there is a good chance that your dial is locked on "X" for flash synchronization. While holding-down the release button in the middle of shutter speed dial ring, turn the ring and it will be unlocked.	a) By rotating the aperture ring on the lens, the aperture opening can be set to the desired value. Depending on your lens these *could* include aperture openings of 1.4, 2, 2.8, 4, 5.6, 8, 11, 16, 22, and 32.	a) The Shutter speed ring can be set to exposure times ranging from 4 (4 sec.) To 8000 (1/8000 sec.) If you can not turn the dial, there is a good chance that your dial is locked on "X" for flash synchronization. While holding-down the release button in the middle of shutter speed dial ring, turn the ring and it will be unlocked.	a) Turn the metering selection dial located on the top of the camera close to shutter speed dial to the dot [.] symbol. Your camera's metering mode is now set to spotmetering.	a) While holding down the power switch button, rotate the main switch so that it no longer points to "L". b) Set the exposure mode to Manual (step 2) by selecting any speed from 4 sec. To 1/8000 sec. c) Choose a shutter speed. If you are not sure what to set your shutter speed to, for outside shots, set it to a number close to the ISO of the film. For example if your film's ISO is 100, set it to 1/125 sec. (step 4) d) Turn your metering to [SPOT]. This can be done by following directions in step 5. 5. Then by pointing the F4's exact spotmetering circle/frame at the desired simple subject and changing the aperture and/or shutter speed, find the surface's normal exposure. This is when the pointer in your viewfinder is positioned exactly under the [0] mark located in the middle of [+] and [-] signs.

Nikon F4

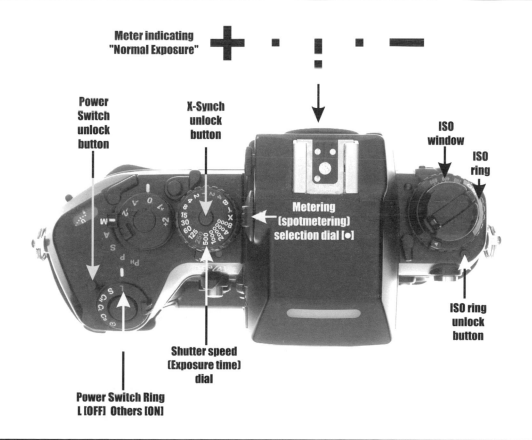

Meter indicating "Normal Exposure"

Power Switch unlock button

X-Synch unlock button

Metering (spotmetering) selection dial [●]

ISO window

ISO ring

ISO ring unlock button

Shutter speed (Exposure time) dial

Power Switch Ring L [OFF] Others [ON]

Nikon F5

1 How to set the ISO Manually	2 How to set the function to Manual Mode	3 How to change the aperture Manually	4 How to change the Exposure Time (shutter speed) Manually	5 How to set the exposure function to SPOT	6 How to find the normal exposure of a simple subject?
If you do not have DX coded film (i.e., you roll your own film): a) Slide the power switch to the [ON] position. b) While holding down the [ISO] button, located on the back of the camera turn the rear Command Dial (notched wheel located near the LCD panel behind the camera ●) until the desired ISO appears on the screen. Release the ISO button and you are set! c) To set it back to DX, turn the rear Control Dial decreasing the ISO. The [DX] letters will appear after ISO 6 (the lowest ISO supported by the camera). PLEASE NOTE: The manual ISO will remain in effect indefinitely unless it is changed to another ISO or the dial is set back to DX for DX coded films.	a) Turn the power switch to the [ON] position. b) While holding down the [MODE] button, turn the rear Command Dial (notched wheel located behind the LCD panel) until letter [F] appears on the LCD screen.	a) Make sure your aperture opening on your lens is set to its smallest setting, depending on your lens, it is set to [f-22] or [f-32]. By pushing the minimum aperture lock (a lock with a little white dot on the lens) towards the camera, lock the lens in the minimum-aperture position so that the aperture ring on your lens can no longer be rotated. b) Set the camera mode to Manual [F] (see step 2). By rotating the Sub-Command Dial ● (the notched rotary dial in front of the camera right under the shutter release button) numbers such as **2.8**, 3.2, 3.5, **4**, 4.5, 5, **5.6**, 6.3, 7.1, **8**, 9, 10, **11**, 13, 14, **16**, 18, 20, **22**, etc. in 1/3 stop divisions will appear). The f-number will appear on the top right hand side of your LCD screen prefixed with letter [F].	a) Turn the main switch to the [ON] position. b) Set your camera mode to Manual [F] (see step 2). c) By rotating the rear Main-Command Dial you can change the shutter speed from [bulb], [30"] (thirty seconds), [25"],... to [1"] second and from there to [1.3], [1.6], [2],... and finally to [8000]. PLEASE NOTE: after 1 second, all values are in fractions of a second or [1/]. For example 250 on the dial means 1/250th of a second and 8000 means 1/8000 sec. and so on.	a) Set the camera to Manual [F] mode (see step 2). b) Turn the Metering System Selector in the back (top center) of the camera to a white dot [.] so that ⊡ appears in the viewfinder. c) To simplify, Set the Focus Selector in front of the camera to "M"anual Focus. d) Choose Single AF Area by turning the Mode Selector on the back of the camera to []. e) If locked "L", unlock the Focus Area Selector to set to " ". Use thumb pad to activate the CENTER AF area so that the rectangle at the center of the viewfinder is lit (red). f) Lock the focus area selector to "L". g) The 4mm-diametered spot circle (frame) at the center is now active. Please note that you can NOT see the circle and have to guess at its approximate location!	a) Set the exposure mode to Manual [F] mode (see step 2). b) Choose a shutter speed (exposure time). If you are not sure what to set your shutter speed to, for outside shots, set it to a number close to the ISO of the film. For example if your film's ISO is 100, set it to 1/125 sec. (see step 4). c) Turn your metering to [SPOT] and activate the imaginary center spot circle. This can be done by following directions in step 5. Now by pointing the *approximate* spot metering circle at the desired simple subject and changing the aperture and/or shutter speed, find the surface's normal exposure. This is when the pointer in your viewfinder is positioned exactly under the [0] mark located in the middle of [+] and [-].

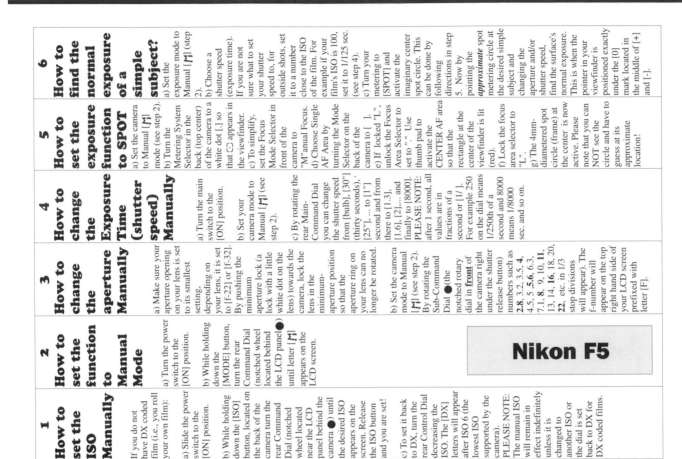

The 4mm-diametered invisible (fuzzy) center Spot Circle is activated when the center AF element is set to active (please see text)

12mm-diametered partial metering Circle

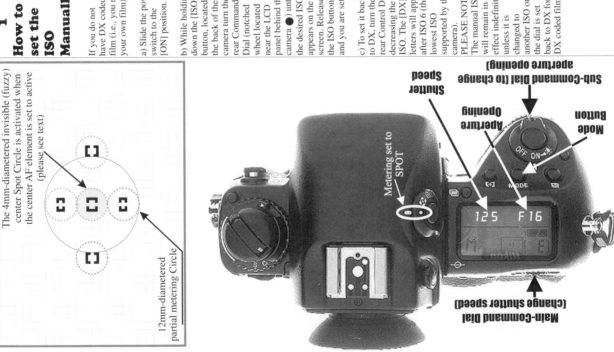

Shutter Speed

Sub-Command Dial (to change aperture opening)

Aperture Opening

Mode Button

Metering set to SPOT

Main-Command Dial (change shutter speed)

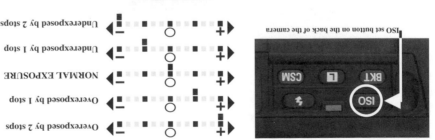

Underexposed by 2 stops
Underexposed by 1 stop
NORMAL EXPOSURE
Overexposed by 1 stop
Overexposed by 2 stops

ISO set button on the back of the camera

CSM L BKT

ISO

Nikon F100

1 How to set the ISO Manually	2 How to set the function to Manual Mode	3 How to change the aperture Manually	4 How to change the Exposure Time (shutter speed) Manually	5 How to set the exposure function to SPOT	6 How to find the normal exposure of a simple subject?
If you do not have DX coded film (i.e., you roll your own film): a) Slide the power switch to the [ON] position. b) While holding down the [ISO] button, turn the rear Command Dial (notched wheel located near the LCD panel behind the camera ●) until the desired ISO appears on the screen. Release the ISO button and you are set! c) To set it back to DX, turn the rear Control Dial decreasing the ISO. The [DX] letters will appear after ISO 6 (the lowest ISO supported by the camera).	a) Slide the power switch to the [ON] position. b) While holding down the [MODE] button, turn the rear Command Dial (notched wheel located behind the LCD panel) until letter [M] appears on the LCD screen.	a) Make sure your aperture opening on your lens is set to minimum, i.e., it is set to [f-22] or [f-32] on your lens. By pushing the minimum aperture lock (a lock with a little white dot on the lens) towards the camera, lock the lens in the minimum-aperture position so that the aperture ring can no longer be rotated. b) Set the camera mode to Manual [M] (see step 2). By rotating the Sub-Command Dial ● (the notched rotary dial in front of the camera right under the shutter release button) numbers such as **2.8**, 3.2, 3.5, **4** 4.5, 5, **5.6**, 6.3, 7.1, **8**, 9, 10, **11**, 13, 14, **16**, 18, 20, **22**, etc in 1/3 stop divisions will appear), the f-number will appear on the top right hand side of your LCD screen prefixed with letter [F].	a) Slide the main switch to the [ON] position. b) Set your camera mode to Manual [M] (see step 2). c) By rotating the rear Main-Command Dial you can change the shutter speed from [bulb], [30"] (thirty seconds), [25"],... to [1"] second and from there to [1.3], [1.6], [2],... and finally to [8000]. PLEASE NOTE: after 1 second, all values are in fractions of a second or [1/]. For example 250 on the dial means 1/250th of a second and 8000 means 1/8000 sec. and so on.	a) Set the camera to Manual [M] mode (see step 2). b) Turn the Metering System Selector in the back (top center) of the camera to a white dot [.] so that ⊡ appears in the viewfinder. c) To simplify your metering set the Focus Mode Selector in front of the camera to "M"anual Focus. d) Choose Single AF Area by turning the Mode Selector on the back of the camera to []. e) If locked "L", unlock the Focus Area Selector to set to " ". Use thumb pad to activate the CENTER AF area so that the rectangle at the center of the viewfinder is lit (red). f) Lock the focus area selector (set to "L"). g) The CENTER 4mm-diametered spot circle (frame) is now active. Please note that you can NOT see the circle and have to guess at its approximate location!	a) Set the exposure mode to Manual [M] (step 2). b) Choose a shutter speed. If you are not sure what to set your shutter speed to, for outside shots, set it to a number close to the ISO of the film. For example if your film's ISO is 100, set it to 1/125 sec. (see step 4). c) Turn your metering to [SPOT] and activate the imaginary center spot circle. This can be done by following directions in step 5. Now by pointing the *approximate* spot metering circle at the desired simple subject and changing the aperture and/or shutter speed, find the surface's normal exposure. This is when the pointer in your viewfinder is positioned under the [0] mark located in the middle of [+] and [-] signs.

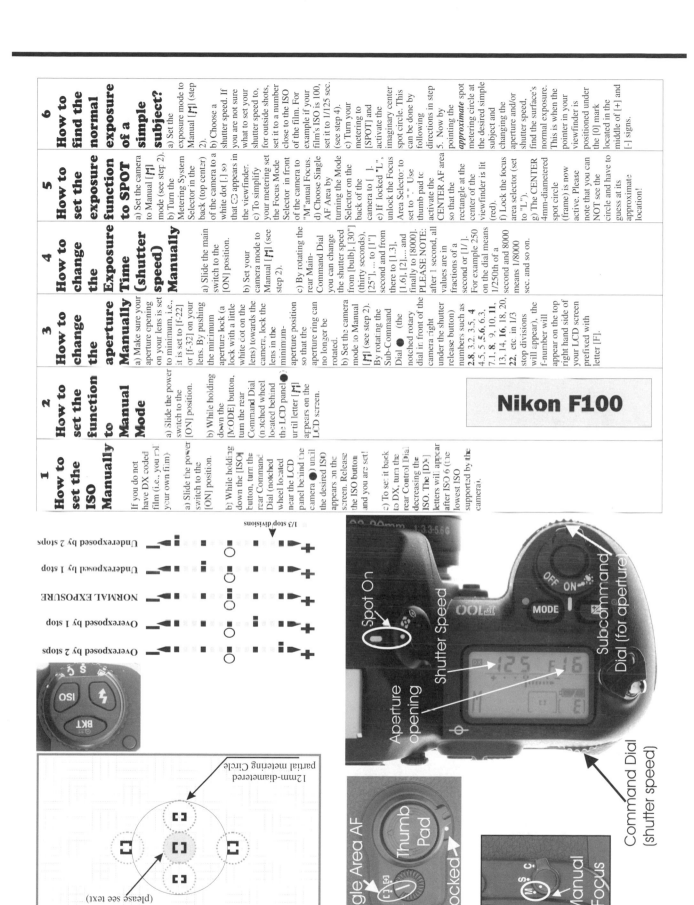

Underexposed by 2 stops
Underexposed by 1 stop
NORMAL EXPOSURE
Overexposed by 1 stop
Overexposed by 2 stops
1/3 stop divisions

"Fuzzy" Spot Circle activated when the center AF element is set to active (please see text) 4mm-diametered

12mm-diametered partial metering Circle

Spot On
Shutter Speed
Subcommand Dial (for aperture)
Aperture opening
Command Dial (shutter speed)
Single Area AF
Thumb Pad
Unlocked
Manual Focus

1 How to set the ISO Manually	2 How to set the function to Manual Mode	3 How to change the aperture Manually	4 How to change the Exposure Time (shutter speed) Manually	5 How to set the exposure function to Partial Meter	6 How to find the normal exposure of a simple subject?
Nikon N55's ISO cannot be set manually. You **must** use a DX coded film or a non-DX coded film with an ISO of 100. With a DX coded film, N55 is capable of registering ISO settings of 25 to 5000.	a) Turn the power switch to the [ON] position. b) Turn the Exposure Mode Dial on the top left hand side of the camera to [M]. The shutter speed (exposure time) and aperture opening will appear at the top of the LCD Screen. If the screen is blank, gently touch the shutter release button and they will display.	a) Set the camera mode to Manual [M] (see step b). If you are using a "G-Type" lens, please skip to step 2. For other CPU Nikkor lenses, by pushing the minimum aperture lock on the lens close to the lens mount so that the lens is locked in position and can no longer be rotated. For many lenses it is at f-22. If you can not find it, look for the focal length of the lens (mm). On my 28-80mm lens it is located under the letters 'mm'. If the lens is not locked or set on any aperture opening other than its minimum (highest number), a "F E E" message (F-stop Error) will blink on the LCD panel. b) By rotating the Command dial, while holding the aperture set button ⊛, the aperture opening can be changed. You can see the aperture opening on top right side of the prefixed by the letter F.	a) Turn the power switch to the [ON] position. b) Set your camera mode to Manual [M] (see step 2). c) By rotating the Command Dial (located on the bottom right hand side of your LCD panel on the back of the camera ⊛), your exposure times (shutter speeds) will change. The new exposure time is indicated on the top left hand side of the LCD screen. If you do not see the numbers, gently (and partially) press the shutter release button and they will appear. Shutter speeds on N55 range from 30" (30 sec.) to 1/2000 sec.	a) Turn the Power switch to the [ON] position. b) Set the camera to Manual [M] mode. c) When in the Manual mode, the camera's metering will automatically be set to center weighted (Partial Metering). The unmarked rectangular frame which occupies 13% of the viewfinder area, measures 75% of light going through while the rest of the viewfinder lets in 25% of light [75/25]. Although N55 is NOT specifically designed for true partial metering, however, the amount of light going through this circle is enough to help the photographer to learn the technique.	a) Turn the power switch to the [ON] position and set the exposure mode to Manual (step 2). b) Choose a shutter speed. If you are not sure what to set your shutter speed to, for outside shots, set it to a number close to the ISO of the film. For example if your film's ISO is 100, set it to 1/90 or 1/125 sec. (See step 4). c) Since your Partial metering (center weighted metering) is already activated, by pointing the approximate partial metering circle at the desired simple subject and changing the aperture and/or shutter speed, you can find the surface's normal exposure. This is when only one index pointer in your viewfinder is positioned exactly under the [0] mark located in the middle of [+2] and [-2].

When using D-type CPU lenses, lock the aperture at its smallest opening (highest number). In this case f-22. Failure to do so causes the aperture opening [F E E] error.

D-Type (Non-G) CPU Lens

 Over Exposure Normal Exposure Under Exposure

8mm by 18mm (shaded) Center Partial Metering area (about 16% of the viewfinder area) It lacks a distinct frame and one has to guess at it

⊏ [] ⊐

G-Type CPU Lens

Exposure Mode dial set to "M" (Manual)

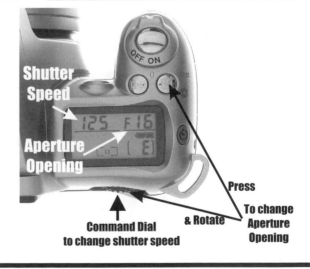

Shutter Speed

Aperture Opening

125 F 16

Command Dial to change shutter speed

Press

& Rotate

To change Aperture Opening

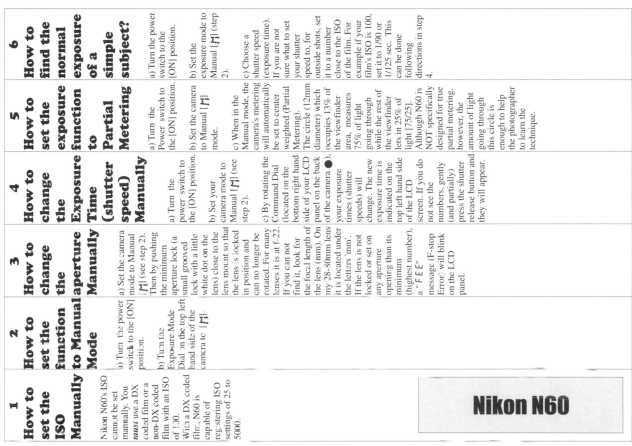

1 How to set the ISO Manually	2 How to set the function to Manual Mode	3 How to change the aperture Manually	4 How to change the Exposure Time (shutter speed) Manually	5 How to set the exposure function to Partial Metering	6 How to find the normal exposure of a simple subject?
Nikon N60's ISO cannot be set manually. You *must* use a DX coded film or a non-DX coded film with an ISO of 100. With a DX coded film, N60 is capable of registering ISO settings of 25 to 5000.	a) Turn the power switch to the [ON] position. b) Turn the Exposure Mode Dial on the top left hand side of the camera to [M].	a) Set the camera mode to Manual [M] (see step 2). Then by pushing the minimum aperture lock (a small grooved lock with a little white dot on the lens) close to the lens mount so that the lens is locked in position and can no longer be rotated. For many lenses it is at f-22. If you can not find it, look for the focal length of the lens (mm). On my 28-80mm lens it is located under the letters 'mm'. If the lens is not locked or set on any aperture opening than its minimum (highest number), a "F E E" message (F-stop Error) will blink on the LCD panel.	a) Turn the power switch to the [ON] position. b) Set your camera mode to Manual [M] (see step 2). c) By rotating the Command Dial (located on the bottom right hand side of your LCD panel on the back of the camera ●), your exposure times (shutter speeds) will change. The new exposure time is indicated on the top left hand side of the LCD screen. If you do not see the numbers, gently (and partially) press the shutter release button and they will appear.	a) Turn the Power switch to the [ON] position. b) Set the camera to Manual [M] mode. c) When in the Manual mode, the camera's metering will automatically be set to center weighted (Partial Metering). The circle (12mm diameter) which occupies 13% of the viewfinder area, measures 75% of light going through while the rest of the viewfinder lets in 25% of light [75/25]. Although N60 is NOT specifically designed for true partial metering, however, the amount of light going through this circle is enough to help the photographer to learn the technique.	a) Turn the power switch to the [ON] position. b) Set the exposure mode to Manual [M] (step 2). c) Choose a shutter speed (exposure time). If you are not sure what to set your shutter speed to, for outside shots, set it to a number close to the ISO of the film. For example if your film's ISO is 100, set it to 1/90 or 1/125 sec. This can be done following directions in step 4.

Nikon N60

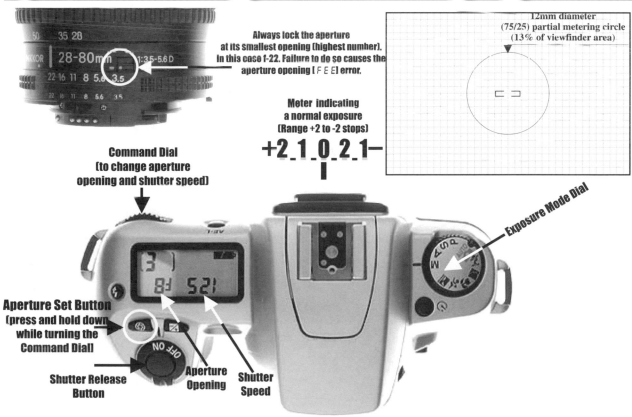

Always lock the aperture at its smallest opening (highest number). In this case f-22. Failure to do so causes the aperture opening [F E E] error.

12mm diameter (75/25) partial metering circle (13% of viewfinder area)

Meter indicating a normal exposure (Range +2 to -2 stops)

+2 .1. .0. .2 .1 −

Command Dial (to change aperture opening and shutter speed)

Exposure Mode Dial

Aperture Set Button (press and hold down while turning the Command Dial)

Shutter Release Button

Aperture Opening

Shutter Speed

Nikon N65

1 How to set the ISO Manually	2 How to set the function to Manual Mode	3 How to change the aperture Manually	4 How to change the Exposure Time (shutter speed) Manually	5 How to set the exposure function to SPOT/Partial Meter	6 How to find the normal exposure of a simple subject?
Nikon N65's ISO cannot be set manually. You **must** use a DX coded film or a non-DX coded film with an ISO of 100. With a DX coded film, N65 is capable of registering ISO settings of 25 to 5000.	a) Turn the power switch to the [ON] position. b) Turn the Exposure Mode Dial on the top left hand side of the camera to [M].	1) Set the camera mode to Manual [M] (see step 2). Then by pushing the minimum aperture lock (a small grooved lock with a little white dot on the lens) close to the lens mount so that the lens is locked in position and can no longer be rotated. For many lenses it is at f-22. If you can not find it, look for the focal length of the lens (mm). On my 28-80mm lens it is located under the letters 'mm'. If the lens is not locked or set on any aperture opening than its minimum (highest number), a "FEE" message (F-stop Error) will blink on the LCD panel.	a) Turn the power switch to the [ON] position. b) Set your camera mode to Manual [M] (see step 2). c) By rotating the Command Dial (located on the bottom right hand side of your LCD panel on the back of the camera ●), your exposure times (shutter speeds) will change. The new exposure time is indicated on the top left hand side of the LCD screen. If you do not see the numbers, gently (and partially) press the shutter release button and they will appear.	a) Turn the Power switch to the [ON] position. b) Set the camera to Manual [M] mode. c) When in the Manual mode, the camera's metering will automatically be set to center weighted (Partial Metering). The circle (12mm diameter) which occupies 13% of the viewfinder area, measures 75% of light going through while the rest of the viewfinder lets in 25% of light [75/25]. Although N65 is NOT specifically designed for true partial metering, however, the amount of light going through this circle is enough to help the photographer to learn the technique.	a) Turn the power switch to the [ON] position. b) Set the exposure mode to Manual [M] (step 2). c) Choose a shutter speed (exposure time). If you are not sure what to set your shutter speed to, for outside shots, set it to a number close to the ISO of the film. For example if your film's ISO is 100, set it to 1/90 or 1/125 sec. This can be done following directions in step 4.

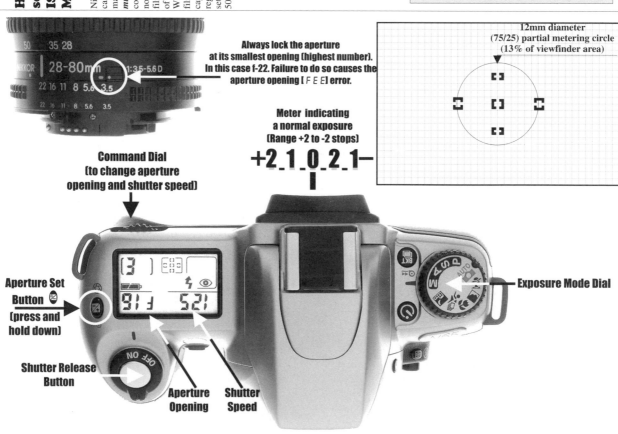

Always lock the aperture at its smallest opening (highest number). In this case f-22. Failure to do so causes the aperture opening [FEE] error.

12mm diameter (75/25) partial metering circle (13% of viewfinder area)

Meter indicating a normal exposure (Range +2 to -2 stops)

+2.1.0.2.1-

Command Dial (to change aperture opening and shutter speed)

Aperture Set Button (press and hold down)

Shutter Release Button

Aperture Opening

Shutter Speed

Exposure Mode Dial

1 How to set the ISO Manually	2 How to set the function to Manual	3 How to change the aperture Manually	4 How to change the Exposure Time (shutter speed) Manually	5 How to set the exposure function to SPOT	6 How to find the normal exposure of a simple subject?
If you do not have DX coded film (i.e., you roll your own film): a) Slide the power switch to the [ON] position. b) While holding down the [FUNCTION] button (the large button labeled [FUNCTION] at the top left hand side of the camera), rotate the [Command Dial] (a notched black wheel located under the LCD screen●) until a small arrow appears in the ISO sector (the first sector from the right).	a) Slide the main switch to the [ON] position. While holding down the [FUNCTION] button, turn the circular command dial [●] until the arrow appears in the fourth sector from the right where one of these letters [A], [S], [P], or [M] will also appear. If the letter is anything other than [M], while holding down the [SET] button turn the control dial until the letter [M] appears.	a) Set the camera mode to Manual [M] (see step 2). b) Push the minimum aperture lock (a lock with a little white dot on your lens) forward and release the aperture ring so that it can be freely rotated. c) By rotating the aperture ring on the lens (the ring with numbers such as 4, 5.6, 8, 11 etc.), the f-number will appear on the middle right hand side of your LCD screen. Please note that at times, when you are using zoom lenses, due to the lens extension the f-number engraved on the ring may not match the f-number that is displayed on the LCD dial. *The LCD dial always indicates the correct f-stop.*	a) Turn your camera on and set the camera mode to Manual [M] (see step 2). b) When rotating the Circular Control Dial (located behind the LCD panel), your exposure times (shutter speeds) will change. The new exposure time is indicated on the top left hand side of the LCD screen.	a) Slide the Main switch to the [ON] position. b) Set the camera to Manual [M] mode. c) While pressing the [FUNCTION] button, rotate the Command Dial so that the tip of the arrow appears in the metering sector (sector with a rectangular outline, fifth sector from right).	a) After sliding the main switch to the [ON] position set the exposure mode to Manual [M] (step 2). b) Choose a shutter speed (exposure time). If you are not sure of your shutter speed setting, particularly for outside shots, set it to a number close to the ISO of the film. For example if your film's ISO is 100, set it to 1/125 sec. This is done by following directions in step 4.

Nikon N70

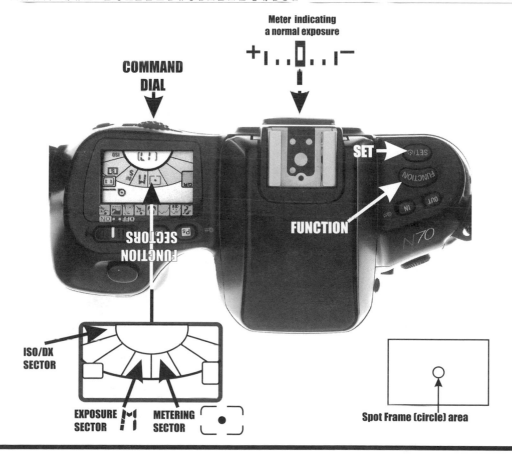

Meter indicating
a normal exposure

COMMAND DIAL

SET →

FUNCTION

FUNCTION SECTORS

ISO/DX SECTOR

EXPOSURE SECTOR

METERING SECTOR

Spot Frame (circle) area

Nikon N75

1 How to set the ISO Manually	2 How to set the camera to Manual Exposure [M] Mode	3 How to set the camera to Shutter Priority Mode [S]	4 How to change the aperture opening manually	5 How to change the Exposure Time (shutter speed) manually	6 How to activate the center spot circle	7 How to find the normal exposure of a simple subject?
Nikon N75's ISO cannot be set manually. You must use a DX coded film or a non-DX coded film with an ISO of 100. With a DX coded film, N75 is capable of registering ISO settings of 25 to 5000. Before activating many of the camera's features, you must turn the power switch to the [ON] position. Unlike many Nikon cameras, N75 does *not* lend itself easily to	Turn the Exposure mode dial to [M]. Shutter speed and Aperture opening values will appear on the LCD screen. In this mode the camera's metering will automatically be set to its center weighted (Partial Metering).	Turn the Exposure mode dial to [S]. The shutter speed and the aperture opening values will appear on the LCD screen.	While in Manual mode, the aperture opening can be changed by rotating the Command dial, *while the aperture set button is pushed-down.* You can see the aperture opening on the top right side of the LCD panel prefixed by the letter F. If the letter F is followed by '- -', you must be using a non-CPU lens or a lens that is not compatible with the metering system of N75. Only use G-type or D-type compatible lenses to utilize all the features of this camera.	With the camera's mode set to Manual [M], the shutter speeds can be changed by rotating the Command Dial. The new exposure time will appear on the top left hand side of the LCD screen. If these numbers disappear, lightly touch the shutter release button.	a) Push the Custom Setting Selector to CSM. Rotate the Command Dial until '7' appears on the left hand side of the LCD screen. Now push the "Aperture button" until the digit "2" appears in the sub-function location. With the LCD reading '7 - 2' the metering mode is now set to SPOT. Please make sure the word "CUSTOM" appears at the bottom of the screen. Push back the metal Custom Setting Selector to Single [S]. b) On the back of the camera, activate the 'Center Area Mode' with Center-Subject Priority (see diagram). Now the N75's spotmetering feature is activated within the spot circle located at the center of the viewfinder (see diagram).	a) Set the exposure mode to [S]. b) Choose a shutter speed (exposure time). If you are not sure what to set your shutter speed to, for outside shots, set it to a number close to the ISO of the film. For example if your film's ISO is 100, set it to 1/90 or 1/125 sec. c) Point the approximate center spot circle at the desired simple subject while you are pressing the AE-L (Auto Exposure Lock) button (very important). *The normal exposure of the simple subject will appear at the bottom of the viewfinder (say 1/125@F-5.6).* Please remember the aperture opening (in this case 5.6). Now set the exposure mode to Manual [M]; interpret the reading, adjust the aperture / shutter speed accordingly and shoot.

Notes for Step 7:
With the Shutter priority, the scale at the bottom of the viewfinder will disappear. It will appear again when it is set back to Manual exposure mode. Once you revert back to Manual mode, please ignore the scle's readings since the results are the outcome of meter's partial metering feature and NOT the activated spotmetering circle that you used in the 'S' mode to determine the exact normal exposure for a much smaller surface.

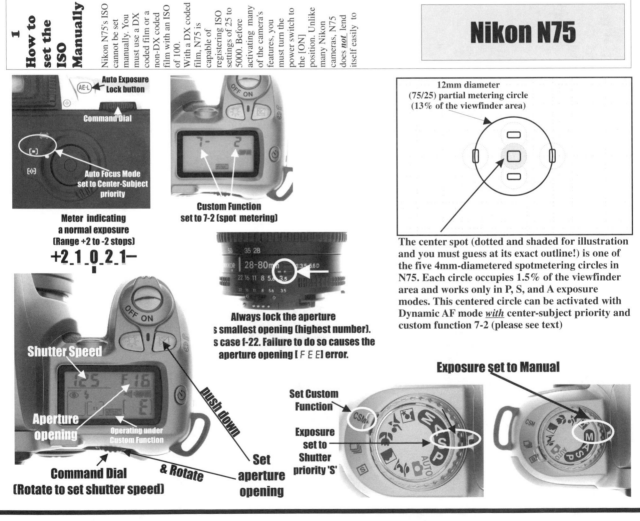

Auto Exposure Lock button

Command Dial

Auto Focus Mode set to Center-Subject priority

Meter indicating a normal exposure (Range +2 to -2 stops)

+2 . 1 . 0 . 2 . 1 –

Custom Function set to 7-2 (spot metering)

28-80mm

Always lock the aperture s smallest opening (highest number). s case f-22. Failure to do so causes the aperture opening [F E E] error.

Shutter Speed

125 F 16

Aperture opening

Operating under Custom Function

push down

Command Dial (Rotate to set shutter speed)

& Rotate

Set aperture opening

12mm diameter (75/25) partial metering circle (13% of the viewfinder area)

The center spot (dotted and shaded for illustration and you must guess at its exact outline!) is one of the five 4mm-diametered spotmetering circles in N75. Each circle occupies 1.5% of the viewfinder area and works only in P, S, and A exposure modes. This centered circle can be activated with Dynamic AF mode *with* center-subject priority and custom function 7-2 (please see text)

Exposure set to Manual

Set Custom Function

Exposure set to Shutter priority 'S'

1 How to set the ISO Manually	2 How to set the function to Manual Mode	3 How to change the aperture Manually	4 How to change the Exposure Time (shutter speed) Manually	5 How to set the exposure function to SPOT	6 How to find the normal exposure of a simple subject?
If you do not have DX coded film (i.e., you roll your own film). a) Turn the power switch to the [ON] position. b) Turn the Main Dial on the top left hand side of the camera so that ISO appears by the white dash [-]. Now turn the Main Command Dial (notched wheel located by the LCD panel on the back of the camera ●) until the desired ISO appears on the screen. c) To set it back to DX, turn Control Dial clockwise and decrease the ISO. The [DX] letters will appear after ISO 6 (the lowest ISO supported by the camera) or after ISO 640) (the highest ISO supported by your camera).	a) Turn the power switch to the [ON] position. b) Turn the Main Dial on the top left hand side of the camera so that [M] appears at the top of the LCD panel.	a) Set the camera mode to Manual [M] (see step 2). b) For non-G-type lenses, push the minimum aperture lock on your lens towards the back of the camera so that the lens is locked in position and can no longer be rotated. For many lenses it is f-22. If you can not find it, look for the focal length of the lens (mm). If the lens is not locked or set on any aperture opening than its minimum (highest number), a "FEE" message will blink on the LCD panel. Now by rotating the Sub-Command dial, the aperture opening can be changed.	a) Slide the main switch to the [ON] position. b) Set your camera mode to Manual [M] (see step 2). c) By rotating the main Command Dial (located on the bottom right hand side of your LCD panel on the back of the camera ●, your exposure times (shutter speeds) will change. The new exposure time is indicated on the top left hand side of the LCD screen. If you do not see the numbers, gently (and partially) press the shutter release button.	a) Set the camera to Manual [M] mode (see step 2). b) Turn the Metering System Selector in the back (top center) of the camera to "●", the spotmetering symbol. c) Simplify your spot metering and set the Focus Mode Selector to "M"anual Focus. d) Choose Single AF Area by turning the Mode Selector on the back of the camera to []. e) If locked "L", unlock the Focus Area Selector to set to "●". Use thumb pad to activate the CENTER AF area so that the rectangle at the center of the viewfinder is lit (red). f) Lock the focus area selector to "L". g) Your 4mm-diametered spot circle (frame) is now active. Please note that you canNOT see the circle and have to guess at its location!	a) Set the exposure mode to Manual [M] (step 2). b) Choose a shutter speed. If you are not sure what to set your shutter speed to, for outside shots, set it to a number close to the ISO of the film. For example if your film's ISO is 100, set it to 1/125 sec. (see step 4). c) Turn your metering to [SPOT] and activate the imaginary center spot circle (see step 5). Now by pointing the *approximate* spotmetering circle at the desired simple subject and changing the aperture and/or shutter speed, find the surface's normal exposure. This is when the pointer in your viewfinder is positioned exactly under the [0] mark located in the middle of [+] and [-] signs.

Normal exposure shortcut:

If you want to obtain the normal exposure of a simple surface (subject) quickly, while in "Manual Exposure" mode, you can set the camera to the desired Shutter Speed (say 1/125 sec.). Then turn the Main Dial to Shutter Priority "S". In this mode, by partially pressing the shutter release button and pointing the spotmetering frame at the desired simple tone, the aperture opening for the "Normal Exposure" quickly appears in the viewfinder. Now you should take note of this aperture opening, change the exposure mode to Manual, interpret the reading, set the aperture to its interpreted value and then shoot.

Nikon N80

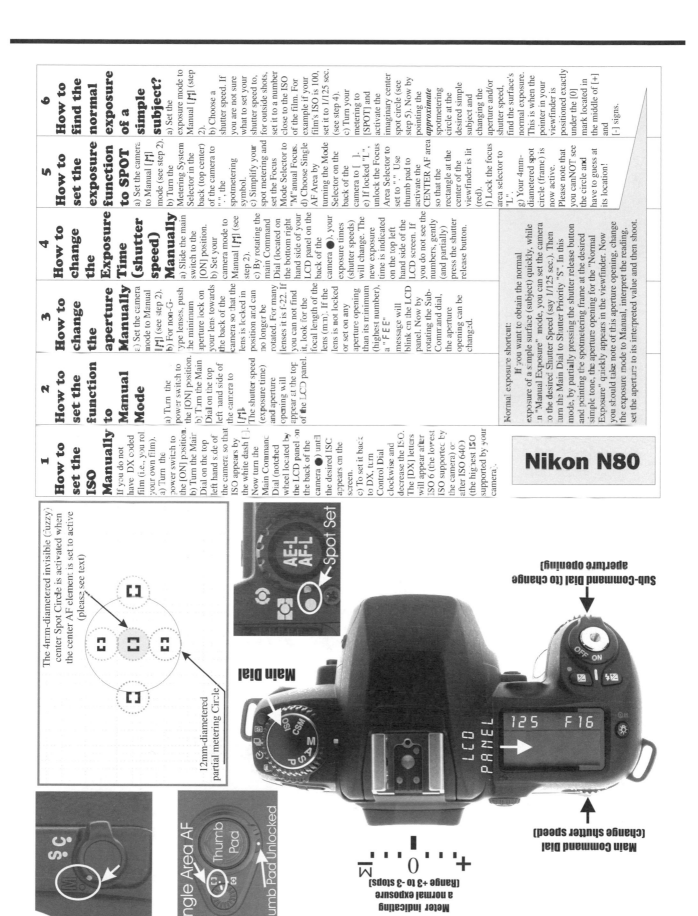

The 4mm-diametered invisible (fuzzy) center Spot Circle is activated when the center AF element is set to active (please, see text)

12mm-diametered partial metering Circle

Spot Set

Main Dial

Single Area AF

Thumb Pad

Thumb Pad Unlocked

Sub-Command Dial (to change aperture opening)

LCD PANEL 125 F16

Main Command Dial (change shutter speed)

Meter indicating a normal exposure (Range +3 to -3 stops)

1 How to set the ISO Manually	2 How to set the function to Manual Mode	3 How to change the aperture Manually	4 How to change the Exposure Time (shutter speed) Manually	5 How to set the exposure function to SPOT	6 How to find the normal exposure of a simple subject
If you do not have DX coded film (i.e., you roll your own film): a) Slide the power switch to the [ON] position. b) While holding down the [ISO] button, turn the Command Dial (notched wheel located by the LCD panel ●) until the desired ISO appears on the screen. Press ISO button so that DX disappears from the LCD screen. c) To set it back to DX, turn Control Dial clockwise and decrease the ISO. The [DX] letters will appear after ISO 6 (the lowest ISO supported by the camera).	a) Slide the camera mode to Manual [ℳ] (see step 2). b) While holding down the [MODE] button, turn the Command Dial (notched wheel located beside the LCD panel ●) until letter [ℳ] appears on the LCD screen.	a) Set the camera mode to Manual [ℳ] (see step 2). b) By pushing the minimum aperture lock towards the front of the lens, release the aperture ring so that it can be freely rotated. c) By rotating the aperture ring on the lens (the ring with numbers such as 4, 5.6, 8, 11 etc.), the f-number will appear on the top right hand side of your LCD screen prefixed with letter [F]. Please note that at times, when you are using zoom lenses, use the f-number that is displayed on the LCD dial. *The LCD dial always indicates the correct aperture opening.*	a) Slide the main switch to the [ON] position. b) Set your camera mode to Manual [ℳ] (see step 2). c) By rotating the Command Control Dial (located on the bottom right hand side of your LCD panel ●), your exposure times (shutter speeds) will change. The new exposure time is indicated on the top left hand side of the LCD screen. If you do not see the numbers, gently (and partially) press the shutter release button.	a) Slide the Main switch to the [ON] position. b) Set the camera to Manual [ℳ] mode. c) Press and hold down the Metering Mode Selection Button, located to the top left of the camera and marked with ❀ and rotate Command Dial so that the spotmeter symbol ❍ appears on your LCD panel.	a) Set the exposure mode to Manual [ℳ] (step 2). b) Choose a shutter speed. If you are not sure what to set your shutter speed to, for outside shots, set it to a number close to the ISO of the film. For example if your film's ISO is 100, set it to 1/125 sec. (see step 4). c) Turn your metering to [SPOT]. This can be done by following directions in step 5. Then by pointing the spotmetering circle at the desired simple subject and turning the aperture ring on the lens, find the surface's normal exposure. This is when the pointer in your viewfinder is positioned exactly under the [0] mark located in the middle of [+] and [-] signs.

Obtaining the Normal exposure automatically:

If you want to obtain the normal exposure of a simple surface (subject) quickly, while in "Manual Exposure" mode, you can set Shutter Speed to say 1/125 sec. Then change the exposure mode to Shutter Priority "S". This can be done by holding down the [MODE] button, turn the Command Dial until letter [S] appears on the LCD screen. In this mode, by partially pressing the shutter release button and pointing the spotmetering frame at the desired simple tone, the aperture opening for the "Normal Exposure" quickly appears in the viewfinder. Now you should take note of this aperture opening, change the exposure mode to Manual, interpret the reading, set the aperture to its interpreted value and then shoot.

Nikon N90s

METERING MODE

MODE

ISO

COMMAND DIAL

$+\ \cdot\ \cdot\ 0\ \cdot\ \cdot\ -$

Meter indicating a normal exposure

1 How to set the ISO Manually	2 How to set the function to Manual mode	3 How to change the aperture Manually	4 How to change the Exposure Time (shutter speed) Manually	5 How to set the exposure function to SPOT	6 How to find the normal exposure of a simple subject?
If you do not have DX coded film (i.e., you roll your own film): a) Slide the power switch to the [ON] position: b) While pressing the shift button, a round golden button marked with a square located at the top left hand side of the LCD display [●], press the ISO button so that DX disappears from the LCD screen.	After sliding the power switch to the [ON] position: a) While holding down the [MODE] button, turn the circular Command Dial, a large golden notched wheel located at the bottom right side of the LCD screen [●] until the letter [M] appears at the top left hand side of the LCD panel and in the viewfinder.	a) Set the camera mode to Manual [M] (see step 2). b) By pushing the minimum aperture lock (a lock with a little white dot on the lens) towards the front of the lens, then release the aperture ring so that it can be freely rotated. c) By rotating the aperture ring on the lens (the ring with numbers such as 4, 5.6, 8, 11 etc.) the f-number will appear on the middle right hand side of your LCD screen. Please note that at times, when you are using zoom lenses, due to the lens extension, the f-number engraved on the ring may not match the f-number that is displayed on the LCD dial. *The LCD dial always indicates the correct f-stop.*	a) Slide the main switch to the [ON] position. b) Set your camera mode to Manual [M] (see step 2). c) By rotating the Circular Command Dial, located on the bottom left hand side of your LCD panel [●], your exposure times (shutter speeds) will change. The new exposure time is indicated on the left hand side of the LCD screen.	a) Slide the Main switch to the [ON] position. b) Set the camera to Manual [M] mode (see step 2). c) Press the metering system button (a four segmented button with a circle in the middle ⊙), then rotate the Command Dial [●] so that the spotmetering symbol (a rectangle with a small black dot ⊙) appears on your LCD panel.	a) Set the exposure to Manual mode [M] (see step 2). Then choose a shutter speed (exposure time). If you are not sure of your shutter speed setting, particularly for outside shots, set it to a number close to the ISO of the film being used. For example if your film's ISO is 100, set it to 1/125 sec. This can be done by following directions in step 4. b) Turn your metering to [SPOT]. This can be done by following directions in step 5.

Nikon N6006

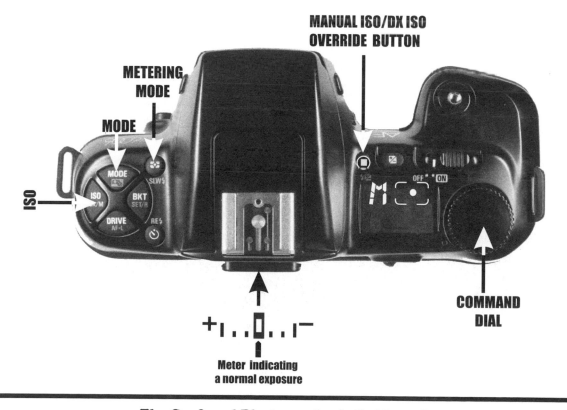

MANUAL ISO/DX ISO OVERRIDE BUTTON

METERING MODE

MODE

ISO

COMMAND DIAL

+⊢ ... ▯ ... ⊣−

Meter indicating a normal exposure

Nikon N8008s

1 How to set the ISO Manually	2 How to set the function to Manual Mode	3 How to change the aperture Manually	4 How to change the Exposure Time (shutter speed) Manually	5 How to set the exposure function to SPOT	6 How to find the normal exposure of a simple subject?
If you do not have DX coded film (i.e., you roll your own film): a) Turn the power switch to the [ON] position. b) Push and hold down the ISO set button while turning the control dial. Release the button when the desired ISO is set. c) To turn back the ISO to DX, follow step (b) and turn the Command Dial until DX appears on the LCD Panel. It is before [6] ISO and after [6400] ISO.	a) Slide the main switch to the [ON] position. b) While pushing and holding down the Exposure Mode button, turn the Command Dial until letter [M] appears on top left hand side of the LCD panel.	a) Slide the Main switch to the [ON] position. b) Set your camera mode to Manual [M] (see step 2). c) By rotating the aperture ring on the lens, the aperture opening will appear on the LCD Panel. If the LCD reading does not reflect the same value as is indicated on the ring, The LCD reading indicates the correct aperture opening.	a) Slide the Main switch to the [ON] position. b) Set your camera mode to Manual [M] (see step 2). c) By rotating the Command Dial, the shutter speed (exposure time) will change from Bulb, 30" (30 seconds) to 1" (1 second) and to 8000 (1/8000 sec.)	a) Slide the Main switch to the [ON] position. b) Set the camera to Manual [M] mode. c) While pushing down the Metering mode button [•] turn the Command Dial until the spotmetering symbol [⋅] appears on the LCD panel.	a) Set the exposure mode to Manual [M] (step 2). b) Choose a shutter speed. If you are not sure what to set your shutter speed to, for outside shots, set it to a number close to the ISO of the film. For example if your film's ISO is 100, set it to 1/125 sec. (see step 4). c) Turn your metering to [SPOT]. This can be done by following directions in step 5. Then by pointing the approximate spotmetering circle at the desired simple subject and changing the aperture and/or shutter speed, find the surface's normal exposure. This is when the pointer in your viewfinder is positioned exactly under the [0] mark located in the middle of [+] and [-] signs.

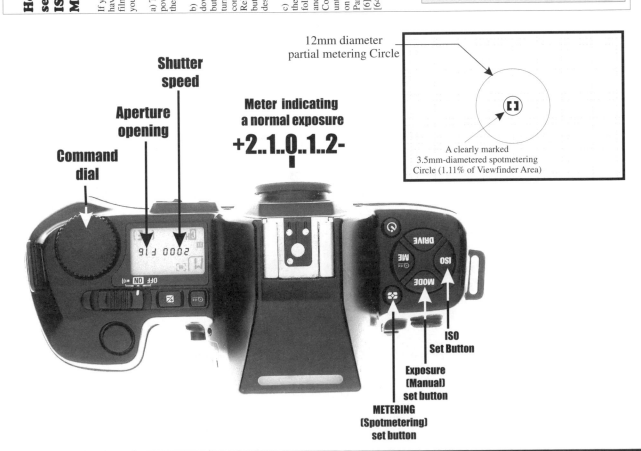

12mm diameter partial metering Circle

A clearly marked 3.5mm-diametered spotmetering Circle (1.11% of Viewfinder Area)

Command dial

Aperture opening

Shutter speed

Meter indicating a normal exposure

+2..1..0..1..2-

ISO Set Button

Exposure (Manual) set button

METERING (Spotmetering) set button

1 How to set the ISO Manually	2 How to set the function to Manual mode	3 How to change the aperture Manually	4 How to change the Exposure Time (shutter speed) Manually	5 How to set the exposure function to SPOT	6 How to find the normal exposure of a simple subject
a) Slide the power switch to [ON] and turn the SIMPLE/ADVANCED Dial to [ADVANCED]. b) Press the main Set/Adjust Menu button [±] twice and the word ISO appears on the LCD screen. Now press the adjust button located exactly on top of the word [ISO] (the second adjust button from the top right of the LCD screen).	a) Slide the power switch to [ON] and turn the SIMPLE/ADVANCED Dial to [ADVANCED]. b) Press the [MENU] button. This button is located at the extreme top left hand side of the LCD screen and marked with a white rectangle [▱]. a) Once this button is pressed, the letters [P S A M] will appear on your LCD screen. Press the SET/ADJUST button on at the top of the letter [M] and your camera is set to Manual mode.	a) Slide the power switch to [ON] and turn the SIMPLE/ADVANCED Dial to [ADVANCED]. b) Set the camera mode to Manual [M] (see step 2). c) Once it is set to Manual mode, the exposure time and aperture opening will appear on the LCD screen. By pressing the two rightmost buttons, on top of the [F] display, the aperture can be opened-up or closed-down as desired. Aperture openings from the largest to smallest for some selected lenses are: 1.8, 2, 2.4, 2.8, 3.3, 4, 4.8, 5.6, 6.7, 8, 9.5, 11, 13, 16, 19, 22, 27, and 32.	a) Slide the main switch to [ON] position and set your camera mode to Manual [M] (see step 2). b) Once it is set to Manual, the exposure time and aperture opening will appear on the LCD screen. By pressing the second pair of [SET/ADJUST] buttons, you can choose the appropriate shutter speed. The following is a list of full range of shutter speeds (exposure times) in seconds ["] and fractions of a second: 30", 20", 15", 10", 8", 6", 4", 3", 2", 1.5", 1", 1/1.5, 1/2, 1/3, 1/4, 1/6, 1/8, 1/10, 1/15, 1/20, 1/30, 1/45, 1/60, 1/90, 1/125, 1/80, 1/250, 1/350, 1/500, 1/750, 1/1000, 1/1500, 1/2000.	a) Slide the power switch to [ON] and turn the SIMPLE/ADVANCED Dial to [ADVANCED]. b) Set the camera to Manual [M] mode. By setting the camera to [M] mode, the center weighted (partial metering) function of the camera becomes activated.	a) Turn the SIMPLE/ADVANCED Dial to [ADVANCED]. b) Set the exposure mode to Manual [M] (step 2) and choose a starting shutter speed (exposure time). If you are not sure of your shutter speed setting, particularly for outside shots, set it to a number close to the ISO of the film being used. For example if your film's ISO is 100, set it to 1/125 sec. This can be done by following directions in step4.

Nikon N50

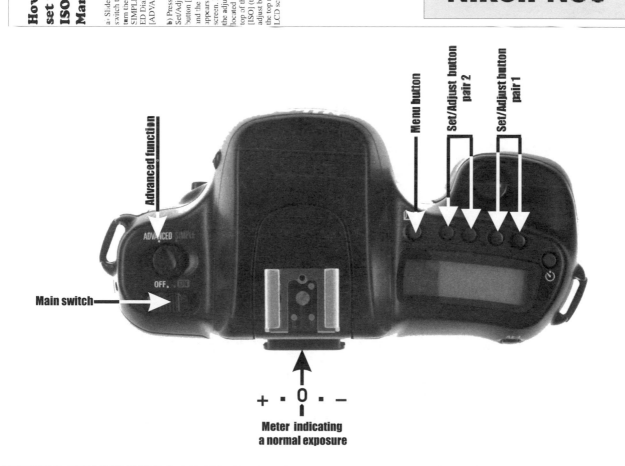

Advanced function

Menu button

Set/Adjust button pair 2

Set/Adjust button pair 1

Main switch

Meter indicating a normal exposure

1 How to set the ISO Manually	2 How to set the function to Manual Mode	3 How to change the aperture Manually	4 How to change the Exposure Time (shutter speed) Manually	5 How to set the exposure function to SPOT	6 How to find the normal exposure of a simple subject?
If you do not have DX coded film (i.e., you roll your own film)					
a) Turn the main switch to the [ON] position.	a) Turn the main switch to the [ON] position.	a) Set the camera to the Manual mode (see step 2).	a) Set the camera to the Manual mode (see step 2).	a) Turn the main switch to the [ON] position.	a) Turn the main switch to the [ON] position.
b) Turn the outer ring of the Mode Dial until it aligns with letters ISO (as shown). The ISO of the film now appears on the LCD panel on the back of your camera.	b) Turn the Mode Dial until the letter "M" aligns with the black index mark on the outer ring.	b) While holding-down the AV button turn the select dial until the desired aperture opening is displayed on the LCD screen. Typical values for a 28-80mm lens depending on the extension of the zoom are as follows: 4, 4.5, 5.6, 6.7, 8, 9.5, 11, 13, 16, 19, 22, 27, and 32.	b) By turning the Select dial you can set the shutter speed to the desired value. Shutter speed settings range from bu (Bulb), 30 seconds (30") to 4000 (1/4000 sec.)	b) Turn the metering mode switch, located under the Mode Dial to point to the [SPOT] mode (a rectangle with a small black dot in the middle ⊏·⊐) as shown.	b) Set the exposure mode to Manual (see step 2). Then choose a starting shutter speed (exposure time). If you are not sure of your shutter speed setting, particularly for outside shots, set it to a number close to the ISO of the film being used. For example if your film's ISO is 100, set it to 1/125 sec. This can be done by following the directions in step 4.

PENTAX *ist

Meter indicating a normal exposure

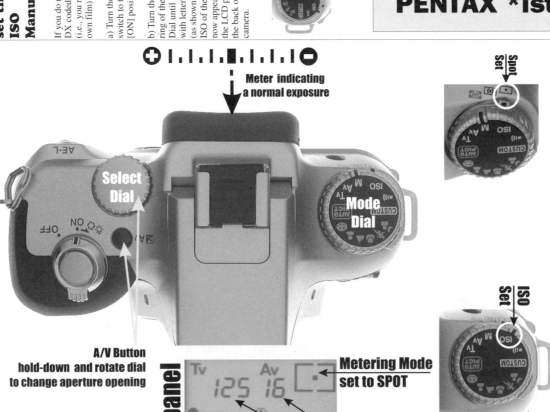

Select Dial

Mode Dial

Spot Set

ISO Set

A/V Button
hold-down and rotate dial
to change aperture opening

LCD panel

Tv 125 Av 16

Metering Mode set to SPOT

Aperture Opening (Aperture Value) AV
Shutter Speed (Time Value) TV

1 How to set the ISO Manually	2 How to set the Exposure to Manual Mode	3 How to change the aperture [Av] Manually	4 How to change the Exposure Time (shutter speed / Tv) Manually	5 How to set the exposure Mode to SPOT	6 Finding the normal exposure of a simple subject
a) Turn the Main Switch to [ON] position. b) Set the Mode Dial to ISO. The Mode Dial is a notched wheel located on the top left of the camera. c) Now turn the Tv Dial (a notched wheel located right under the On/Off switch) to change the film sensitivity (ISO). *Ist-D's ISO can be set to 200, 400, 800, and 1500.	a) Turn the Main Switch to [ON] position. b) Set the Mode Dial to letter [M]. The Mode Dial is a notched wheel located on the top left of the camera. Your *ist-D is now set to Manual Exposure Mode. The shutter speed (exposure time) and aperture opening will now appear on the LCD panel located on the top right hand side of the camera.	a) Turn the Main Switch to [ON] position. b) Set the Mode Dial to letter [M]. The Mode Dial is a notched wheel located on the top left of the camera (step 2). c) Turn the dial on your lens to [A] and leave it there. d) The aperture opening can be changed using the Av (Aperture Value) dial located on the back (top right hand side) of the camera. Depending on the lens used on the camera the aperture opening can be changed say from f-4 to f-22. Full stop values are 4, 5.6, 8, 11, 16, and 22. The half-stop values in this case are (yours may be different) 4.5, 6.7, 9.5, 13, and 19.	a) Turn the Main Switch to [ON] position. b) Set the Mode Dial to letter [M]. The Mode Dial is a notched wheel located on the top left of the camera (step 2). c) The Shutter Speed (exposure time now appears on the LCD screen prefixed by letters [Tv]. The shutter speed can now be changed manually by turning the Tv (Time Value) dial located on the front (right under the On/Off switch). The exposure times in seconds can be set to: 30", 20", 15", 10", 8", 6", 4", 3", 2", 1.5", 1". This dial can be set in fractions of a second to: 0.7, 0.5, 0.3, 4, 6, 8, 10, 15, 20, 30, 45, 60, 90, 125, 180, 250, 350, 500, 750, 1000, 1500, 2000, 3000, and 4000.	a) Turn the Main Switch to [ON] position. b) Turn the Metering Mode Select Lever (located right under the mode dial on the top left hand side of the camera) to spot metering symbol [⊡].	a) Set the Mode Dial to letter [M] (step 2). b) Choose a shutter speed (exposure time). If you are not sure what to set your shutter speed to (for outside shots) set it to a number close to the ISO of the film. For example, if your film's ISO is 200, set it to 1/250 sec. This can be done following directions in step 4. c) Turn your metering to SPOT [⊡]. This can be done by following directions in step 5. Then by pointing the camera to the center of the viewfinder "()" at the desired simple subject and by changing the aperture and/or shutter speed, find the simple subject's normal exposure. This is when only one small dot is appears exactly in the middle of the "+" and "-" sign on the right hand side of your viewfinder,

PENTAX *ist-D

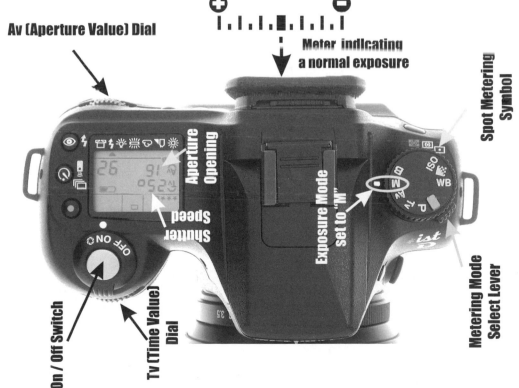

Av (Aperture Value) Dial

Meter indicating a normal exposure

Spot Metering Symbol

Aperture Opening

Shutter Speed

Exposure Mode Set to "M"

On / Off Switch

Tv (Time Value) Dial

Metering Mode Select Lever

1 How to set the ISO Manually	2 How to set the function to Manual	3 How to change the aperture Manually	4 How to change the Shutter Speed Manually	5 How to set the exposure function to SPOT	6 How to find the normal exposure of a simple subject?
a) Slide the power switch to the [ON] position. b) While pushing (and holding) the ISO-set lever in the arrow's direction, align the white squared index mark with the ISO mark (a small circle). c) Use the Increase/Decrease ISO arrows to set the desired ISO, the value of which will be displayed in the small LCD panel.	a) Press the shutter speed release button and turn the shutter speed dial so that it is NOT set to "A".	a) Change the aperture opening ring on your lens to set the aperture to the desired value. It could be 2.8, 4, 5.6, 8, 11, 16, or 22. If the aperture opening is set on "A" and the ring can not be rotated, press the aperture lock release (a small black button on the ring) and then change the aperture opening.	a) Push the shutter speed release button so that you can turn the shutter speed rotary dial to the desired value. Shutter speeds (exposure times) range from Bulb [B], 4 seconds [4s] to 1000 (1/1000th of a second).	a) Turn the metering mode selector until it is set to spot [⊡].	a) After sliding the main switch to the [ON] position set the exposure mode to Manual (step 2). b) Choose a shutter speed (exposure time). If you are not sure of your shutter speed setting, particularly for outside shots, set it to a number close to the ISO of the film. For example if your film's ISO is 100, set it to 1/125 sec. This is done by following the step 4.

Pentax 645N

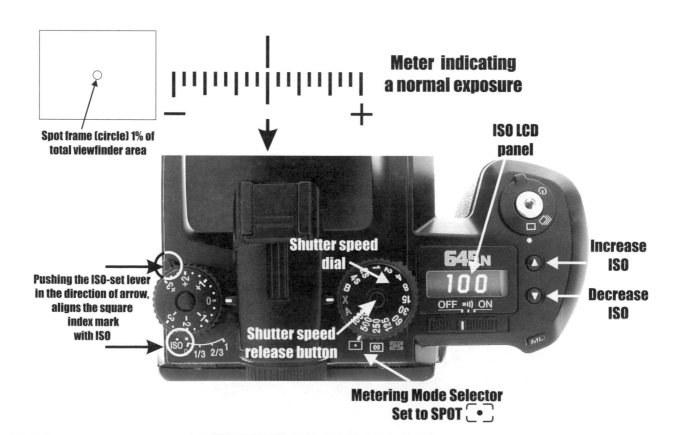

Spot frame (circle) 1% of total viewfinder area

Meter indicating a normal exposure

ISO LCD panel

645N
100
OFF)))) ON

Increase ISO

Decrease ISO

Pushing the ISO-set lever in the direction of arrow, aligns the square index mark with ISO

Shutter speed dial

Shutter speed release button

Metering Mode Selector Set to SPOT ⊡

1 How to set the ISO Manually	2 How to set the function to Manual Mode	3 How to change the aperture Manually	4 How to change the Exposure Time (shutter speed) Manually	5 How to set the exposure function to SPOT	6 How to find the normal exposure of a simple subject?
If you do not have a DX coded film (i.e., you roll your own film) a) Turn the main switch to [ON] position. b) While pressing the lock-release button, turn the exposure compensation dial until gray index mark (right under the flash pop-up button) points to "ISO". Now the letters "ISO" will appear on the LCD screen. By turning the [Select Dial] the desired value can be set. The ISO range of MZ-S is from 6 to 6400.	a) Turn the main switch to [ON] position. b) If lens aperture ring is set to [A], while holding down the aperture lock button, turn the aperture ring so that the pointer [♦] no longer points to [A]. Now the letters [M] or [Av] will appear on the top right hand side of the LCD screen.	a) Turn on the camera and set your exposure mode to [M] (see step 2). b) If the lens aperture ring is set to [A], while holding down the aperture lock button, turn the aperture ring so that the pointer [♦] no longer points to [A]. Now the letters [M] or [Av] will appear on the top right hand side of your LCD screen. By turning the aperture ring on your lens, you can set the aperture to the desired value. If instead of the aperture opening you see [F--], gently touch the shutter release button and the aperture opening will appear again. Aperture values on a typical lens may include: 2.8, 4, 5.6, 8, 11, 16, and 22. When using zoom lenses, if the aperture value on the lens is different than the LCD reading, LCD indicates the correct number.	a) Set your camera to Manual mode (see step 2). b) While [M] is showing on the top right hand side of the LCD screen, by turning the [Select Dial] you can set the shutter speed to the desired value. Shutter speed settings range from Bu (Bulb), 30 seconds (30"), to 1/6000 second in ½ stop increments. Typical sequence is: 30", 20", 15", 10", 8", 6", 4", 3", 2", 1.5", 1", 0.7", 1/2, 1/3, 1/4, 1/6, 1/8, 1/10, 1/15, 1/20, 1/30, 1/45, 1/60, 1/90, 1/125, 1/180, 1/250, 1/350, 1/500, 1/750, 1/1000, 1/1500, 1/2000, 1/3000, 1/4000, and 1/6000 second.	a) Turn the main switch to [ON] position. b) Turn the metering mode until it points to SPOT [⊙].	a) Turn the main switch to [ON] position. b) Set the exposure mode to Manual (see step 2). Then choose a starting shutter speed (exposure time). If you are not sure of your shutter speed setting, particularly for outside shots, set it to a number close to the ISO of your film. For example if your film's ISO is 100, set it to 1/125 sec. This can be done by following the directions in step 4.

PENTAX MZ-S

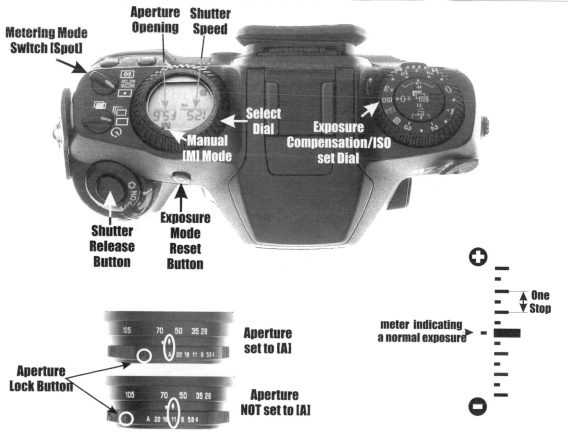

Metering Mode Switch [Spot]

Aperture Opening

Shutter Speed

Select Dial

Manual [M] Mode

Exposure Compensation/ISO set Dial

Shutter Release Button

Exposure Mode Reset Button

Aperture set to [A]

Aperture Lock Button

Aperture NOT set to [A]

One Stop

meter indicating a normal exposure

1 How to set the ISO Manually	2 How to set the function to Manual mode	3 How to change the aperture Manually	4 How to change the Exposure Time (shutter speed) Manually	5 How to set the exposure function to SPOT	6 How to find the normal exposure of a simple subject?
If you do not have DX coded film (i.e., you roll your own film): a) Slide the power switch forward to the [ON] position. b) Turn the Mode dial (notched wheel on the left of the camera) so that the mode is set to [ISO].	a) Turn the Mode dial so that the mode set dial points to [MODE]. b) While pressing the Mode set button, turn the [Tv] direct dial (a notched wheel located above the shutter release button) until [Hy M] appears on the LCD screen. If the [Hy M] does not appear on the LCD screen, chances are you have set the main switch to [USER] rather than to the [ON] position!	a) Set the camera mode to Manual [Hy M] (see step 2). b) By rotating the aperture ring on the lens (the ring with numbers such as 4, 5.6, 8, 11 etc.) the f-number will appear on the bottom right hand side of your LCD screen. Please note that at times, especially when you are using long zoom lenses, due to the lens extension the f-number engraved on the ring may not match the f-number that is displayed on the LCD screen or the viewfinder. *The LCD dial always indicates the correct f-stop.*	a) Set the camera mode to Manual [Hy M] (see step 2). If the shutter speed does not appear on the LCD screen, press the shutter release button partially to activate the LCD screen. b) By rotating the Time value [Tv] direct dial (a notched wheel located right above the shutter release button) the shutter speed (exposure time) can be changed. Sample exposure times are: 30" to 1", then .7, 1/2, 1/3, 1/4, 1/6, 1/8, 1/10, 1/15, 1/20, 1/30, 1/45, 1/60, 1/90, 1/125, 1/180, 1/250, 1/350, 1/500, 1/750, 1/1000, 1/1500, 1/2000, 1/3000, 1/4000, 1/6000, and 1/8000.	a) Slide the main switch forward to the [ON] position. b) Set the camera to Manual [Hy M] (see step 2). c) Press and hold down the spot button on the back of the camera (a small dot in the middle of a rectangle) while rotating the [Tv] dial (a notched wheel located above the shutter release button). When the spotmetering symbol appears at the bottom right hand side of the external LCD screen, your camera's meter is set to [SPOT].	a) Set the exposure mode to Manual [Hy M] by following directions in step 2. b) Choose a starting shutter speed (exposure time). If you are not sure of your shutter speed setting, particularly for outside shots, set it to a number close to the ISO of the film being used. For example if your film's ISO is 100, set it to 1/125 sec. This can be done by following the directions in step 4. Now turn your metering to [SPOT]. This can be done by following directions in step 5.

PENTAX PZ1p

Menu button

Mode set button

Mode dial

Meter indicating a normal exposure

Metering mode switch button

Aperture value (Av) direct dial

IF button

1 How to set the ISO Manually	2 How to set the function to Manual Mode	3 How to change the aperture Manually	4 How to change the Exposure Time (shutter speed) Manually	5 How to set the exposure function to SPOT	6 How to find the normal exposure of a simple subject?
If you do not have DX coded film (i.e., you roll your own film) a) Turn the main switch to the [ON] position. b) While pushing the exposure compensation release button (located at the center of the exposure compensation dial or the left hand side of the camera) turn the dial until the word [ISO] appears *slightly above or under* the solid marker (a solid black line). Now the ISO will appear in the LCD screen	a) Turn the main switch to the [ON] position. b) Press the shutter dial lock button and rotate the shutter dial so that it does NOT point to [A]. c) Your camera is now set to Manual mode.	a) Set the camera to the Manual mode (see step 2). b) By turning the aperture ring on your lens, you can set the aperture to its desired value. Aperture values on a typical lens may include: 2.8, 4, 5.6, 8, 11, 16, and 22.	a) Set the camera to the Manual mode (see step 2). b) By turning the shutter dial you can set the shutter speed to the desired value. Shutter speed settings range from 2" (2 seconds) to 2000 (1/2000 sec.) in one stop increments.	a) Turn the main switch to the [ON] position. b) Press the shutter dial button and rotate the shutter dial, so that the shutter speed dial does NOT point to [A].	a) Turn the main switch to the [ON] position. b) Set the exposure mode to Manual (see step 2). Then choose a starting shutter speed (exposure time). If you are not sure of your shutter speed setting, particularly for outside shots, set it to a number close to the ISO of the film being used. For example if your film's ISO is 100, set it to 1/125 sec. This can be done by following the directions in step 4.

PENTAX ZX5N

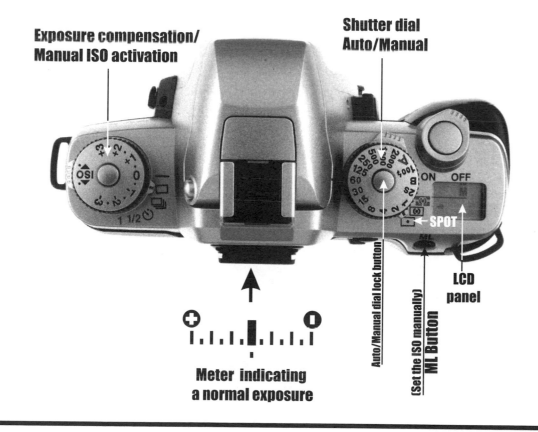

Exposure compensation/
Manual ISO activation

Shutter dial
Auto/Manual

SPOT

Auto/Manual dial lock button

[Set the ISO manually]
ML Button

LCD panel

➕ ➖
Meter indicating
a normal exposure

1 How to set the function to Manual Exposure Mode:	2 How to set the ISO Manually	3 How to change the aperture Manually	4 How to change the Exposure Time Manually	5 How to set the exposure function to SPOT	6 How to find the normal exposure of a simple subject?
a) Slide the power switch to [ON] position. b) Turn the [MODE Dial] to [M] position. Shutter speed and aperture opening settings now appear on the right hand side (towards the middle) of the screen with a yellow arrow pointing towards one of them.	a) Slide the power switch to the [ON] position and set the mode dial to "M" (step 1). b) Press the [MENU] button on the back of the camera. If the ISO scale at the bottom of the screen is not highlighted, left-click the [Control Button] until it is highlighted. Now the ISO values will appear on the screen. c) By up-clicking or Down-clicking the [Control Button] place the pointer over the desired ISO. d) Establish the ISO by pushing down the center of the [Control Button]. DSC-F717 can be set to 100, 200, 400, and 800 ISO.	a) Follow step 1. b) If the arrow's color is white push-down the Jog Dial until the arrow is Yellow (active). If the Yellow arrow does not point at the aperture opening (a letter "F" followed by a number such as 4.5, 5.3, or 5.6) then rotate the Jog Dial until it does. c) Once the yellow dial points at the aperture opening, Down-Click the Jog Dial. The arrow becomes white and the letter "F" and the number becomes yellow. By "Rotating" the Jog Dial the desired aperture values can be set. Typical values are: 2, 2.2, 2.5, 2.8, 3, 3.2, 3.5, 4.0, 4.5, 5.0, 5.6, 6.3, 7.1, and 8.0. These values are obtained when the lens is set to its maximun wideangle position. Press Jog Dial to establish the desired aperture opening.	a) Follow step 1. b) If the arrow's color is white push-down the Jog Dial until the arrow is Yellow (active). If the Yellow arrow does not point at the shutter speed value (a number such as 60, 80, 100, or 125) then rotate the Jog Dial until it does. c) Once the yellow dial points at the shutter speed (exposure time), Down-Click the Jog Dial. The arrow becomes white and the shutter speed value becomes yellow. By "Rotating" the Jog Dial the desired shutter speed can be set. DSC-F717 exposure time values are prefixed with letters "NR" if the exposure time is longer than 1/30 second. Typical values are: NR30" (30 seconds), 25", 20", 15", 13", 10", 8", 7", 5", 4", 3", 2.5", 2", 1.6", 1.3", 1" (1 second), 1.3, 1.6, 2, 2.5, 3, 4, 5, 6, 8, 10, 13, 15, 20, 25, 30, 40, 50, 60, 80, 100, 125, 160, 200, 250, 320, 400, 500, 640, 800, and 1000. Press Jog Dial to establish the exposure time.	a) Slide the power switch to [ON] position. b) Turn the [MODE Dial] to [M] position. Shutter speed and aperture opening settings now appear on the right hand side (towards the middle) of the screen with a yellow arrow pointing towards one of them. e) Repeat pressing the spotmetering button until [⊡] appears on the middle left hand side of the screen on the back of the camera. Your exposure mode is now set to SPOT.	a) Set your camera to manual exposure (step 1) and set the metering feature to Spot (step 5). b) Choose a shutter speed. If you are not sure what to set your shutter speed to (for outside shots) set it to a number close to the ISO of the film. For example, if your film's ISO is set to 100 or 125, set it to 1/125 sec. (see step 4). c) Now by pointing the center of the viewfinder (a cross +) at the desired simple subject and by changing the aperture and/or shutter speed, find the simple subject's normal exposure. This is when the exposure dial (on the top of the aperture value) shows "0EV". PLEASE NOTE: Any other number with a prefix of "-" or "+" indicates underexposure or overexposure.

Sony DSC-F717

Overexposure by 2 stops	Overexposure by 1 stop	Normal Exposure	Underexposure by 1 stop	Underexposure by 2 stops
+2.0EV F5.6◀ 30	+1.0EV F5.6◀ 60	0EV F5.6◀ 125	-1.0EV F5.6◀ 250	-2.0EV F5.6◀ 500

Shutter Speed/Exposure Time of 1/30 sec.

Aperture Opening of F-5.6

Normal Exposure Indicator

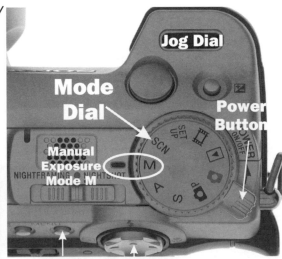

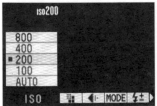

ISO dial set to 200

Activate Spotmetering function button

Mode Dial

Jog Dial

Power Button

Manual Exposure Mode M

MENU Button

Control Button

AE LOCK

Average Metering, Partial Metering, and Spotmetering

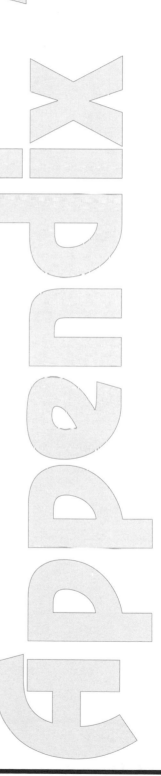

What is covered in this section?

Learn how to apply spotmetering techniques with any camera in order to get better-exposed pictures.
Also what to look for when buying a camera with spotmetering feature.

D.1 Average (Broad Angle) Metering with older cameras:

Since there is a good chance that some of you have a few functional cameras with interchangeable lenses that are left over from the 1980s, 1970s, and even the 1960s. I will show you how to use them in order to obtain better exposures. The only condition is that your on-camera meter must be fully functional and accurate. Just make sure you have a new battery for your meter. This is the most important thing that you can do for your old camera.

Checking meter accuracy and calibration:

You can easily check the accuracy of the meter by holding a plastic gray card in the _noon_ sun after setting your ISO (ASA in those days) to 100, your shutter speed to 1/125 sec., and your aperture to f-16. With these settings, your camera MUST show a "normal exposure," i.e., the needle must be in the middle. If not keep on changing your ISO (ASA) until it does. Leave the ASA/ISO on this setting for your ISO 100 film. Your camera is now calibrated to read the correct exposure. Your typical ASA setting could be 125, 160, or 200. In some cases I have seen a camera whose ISO had to be set to 800 in order to correctly expose a 100 ISO film. You can also apply the same technique with other ISOs. For ISO 64 the setting is 1/60@f-16, for ISO 200 it is 1/250@f-16, and for ISO 400 it is 1/500@f-16 and so on.

Using your old camera's meter as a spotmeter:

The only difference between a spotmeter and a broad-angled average meter is the angle that it views the subject. Therefore if you reduce / decrease the angle that the camera sees the subject, you have converted your average meter with an angle of vision of 46 degrees with a normal 50mm lens to a spotmeter with an angle of measure (acceptance) of only a few degrees.

Simply replace your 50mm lens with a telephoto (the stronger, the better). In this case the outline of your viewfinder also becomes your spot frame.

By looking at diagram D-1.2, you can see how to make your older camera function as good as newer electronic cameras.

Average Metering

This type of metering was utilized in most cameras of the 60s, 70s, and the early 80s. This type of metering is ideal for subjects with an average tone (resembling the tone of an 18% Standard Gray card). Average meters, traditionally measure the the entire viewfinder area with many of them emphasizing tones that are closest to the center. These cameras have a 46 degree diagonal angle of measure with a 50mm lens. For more accurate readings of non-average subjects one can narrow this angle by using a telephoto lens. A 100mm lens narrows this angle to about 23°, a 200mm lens narrows this angle to about 12°, and an 800mm lens narrows it down to about 3°. With this set up one can use the spotmetering techniques we discussed in this book to correctly expose a given subject.

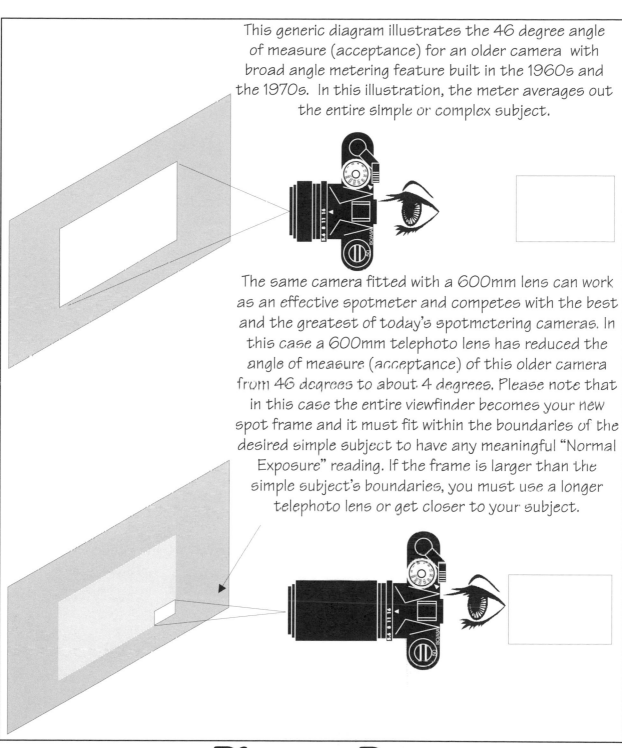

This generic diagram illustrates the 46 degree angle of measure (acceptance) for an older camera with broad angle metering feature built in the 1960s and the 1970s. In this illustration, the meter averages out the entire simple or complex subject.

The same camera fitted with a 600mm lens can work as an effective spotmeter and competes with the best and the greatest of today's spotmetering cameras. In this case a 600mm telephoto lens has reduced the angle of measure (acceptance) of this older camera from 46 degrees to about 4 degrees. Please note that in this case the entire viewfinder becomes your new spot frame and it must fit within the boundaries of the desired simple subject to have any meaningful "Normal Exposure" reading. If the frame is larger than the simple subject's boundaries, you must use a longer telephoto lens or get closer to your subject.

Diagram D-1
Average Metering

By using longer telephoto lenses (200mm, 400mm, 600mm or longer) with your older camera, you can apply all spotmetering techniques that you've learned in this book. Does it work? Yes! Is it accurate? Yes! Is it convenient? NO!

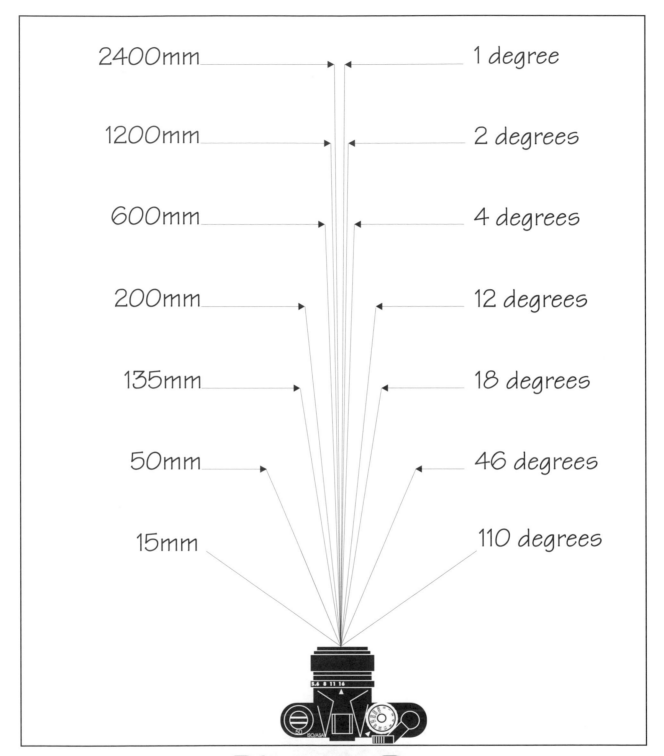

2400mm — 1 degree

1200mm — 2 degrees

600mm — 4 degrees

200mm — 12 degrees

135mm — 18 degrees

50mm — 46 degrees

15mm — 110 degrees

Diagram D-2

Diagram showing the approximate angle of measure (acceptance) for a 35mm camera with different lens attachments. With a 2400mm lens, a standard camera has approximately the same angle of measure (acceptance) as a 1 degree spotmeter.

D.2 Partial Metering:

"Partial Metering" is one step ahead of "Average Metering" and one step behind Spotmetering. An "Average Meter" usually occupies 100% of your viewfinder area where a Partial Meter covers about 7 to 13 percent (7%-13%) of the viewfinder area. Some newer cameras have multiple "Partial Metering" areas (segments). With these cameras the photographer can activate the partial metering segment that is located in the desired area of the viewfinder.

With some partial metering cameras, 100% of light that passes through the center of the viewfinder is measured. With others, the meter only measures about 70% to 80% of the light that passes through their partial metering area.

The manufacturer that dominates the market for partial metering is Canon. Partial metering is extensively used in their amateur (low-priced) cameras such as Rebel G and Rebel 2000 as well as their popular medium-priced Elan series such as Elan II E and Elan 7 E. With these models the "Partial Metering" area (they have no Partial Metering frame) occupies about 9.5% of the viewfinder area.

Since these cameras do not have a frame, the photographer must place the approximate Partial Metering area well within the boundaries of the simple subject that is being analyzed. To locate the partial metering area of your camera, please refer to the camera's manual or call the manufacturer for guidance.

As was discussed in section D.1, you can use a telephoto or a zoom lens to narrow the measuring angle of these "Partial Meters" from about 11.68 degrees with a 50mm lens to about 3 degrees with a 200mm lens. Other Canon cameras that come to mind with "Partial Metering" that have a distinct frame are Canon EOS 650 and older Elan (circular frame that occupies about 6.5% of the viewfinder area) and Canon A2/E (circular frame that occupies about 3.5% of the viewfinder area). Because of its narrow angle, A2/E can be considered a high-end Partial Meter or a low-end spotmeter. Another manufacturer that uses partial metering with their low-end/amateur cameras is Nikon. The partial meters used with Nikon cameras do not necessarily measure 100% of the light that passes through their metering frame. Cameras like Nikon N-50, N-60, and N-65 have a 12mm-diametered circle located at the center of the viewfinder. This Partial Metering circle occupies about 13% of the viewfinder area. Nikon uses a 75/25 percent philosophy with their partial meters. This means 75% of light being measured comes from the partial metering frame. Your best bet is to zoom the lens as much as possible, so that your simple subject occupies all of your partial metering frame as well as most of your viewfinder.

Partial Metering

Partial Meters *usually* come with some low-to-medium priced cameras. Partial metering is generally designed for the unskilled and less demanding photographer and the meter usually lacks a distinct metering frame. A *skilled* photographer can increase the accuracy of these camera's by using a 200-300mm telephoto or zoom lens. These lenses will narrow the angle of measure and provide the photographer with more accurate normal exposure readings of their desired simple surfaces.

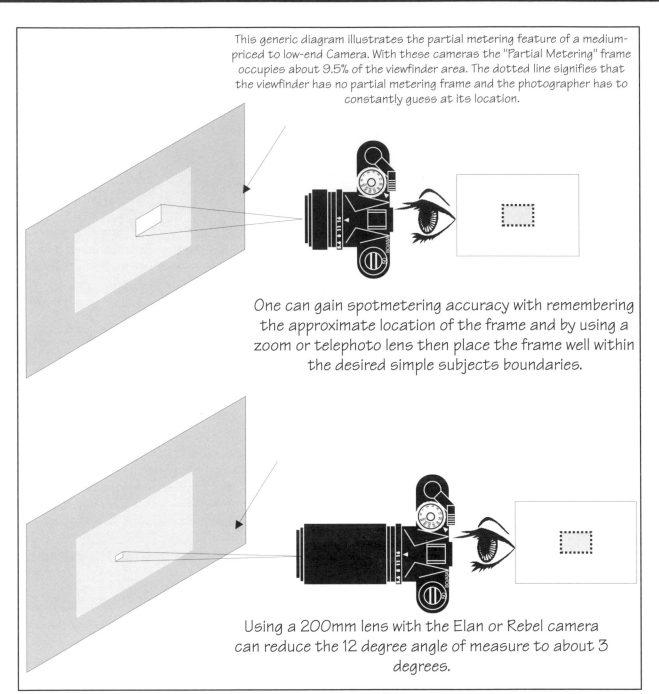

This generic diagram illustrates the partial metering feature of a medium-priced to low-end Camera. With these cameras the "Partial Metering" frame occupies about 9.5% of the viewfinder area. The dotted line signifies that the viewfinder has no partial metering frame and the photographer has to constantly guess at its location.

One can gain spotmetering accuracy with remembering the approximate location of the frame and by using a zoom or telephoto lens then place the frame well within the desired simple subjects boundaries.

Using a 200mm lens with the Elan or Rebel camera can reduce the 12 degree angle of measure to about 3 degrees.

Diagram D-3
Partial Metering

The technique of Partial metering technique is a less accurate form of spotmetering. The "Partial Metering" frame usually occupies about 7% to 13% of the viewfinder area. Cameras that have Partial Metering, without a frame, include: Canon EOS Rebel and Elan series. Cameras with partial metering with a frame include: Canon Eos 650, Canon Elan (older models) Nikon N50, Nikon N60 and Nikon N65. Please note that these diagrams are generic and are for illustration purposes only.

D.3 Spot (Narrow Angle) Metering :

"Spotmetering" is two steps ahead of "Average Metering" and one step ahead of "Partial Metering." An "Average Meter's" sensing element generally senses the entire (100%) of the viewfinder area. A true "Partial Metering" element usually senses 100% of what passes through the partial metering segment that usually occupies 7 to 13 percent (7%-13%) of the viewfinder area. A "Spotmetering" element senses 100% of what passes through the spot frame (circle) that occupies 3% or less (the smaller, the better) of the viewfinder area. Although some of the new cameras on the market have spotmetering feature, they lack a distinct spot frame in the viewfinder. Buying a camera with spotmetering feature that lacks a spot frame is very much like buying a stop watch that lacks 1/100 sec. divisions. More expensive cameras (medium-to-high end) with spotmetering feature include:

Standard Nikon cameras with a distinct spot frame:

N90, N70, N6006, N8008s, F-4, etc.

Standard Nikon cameras without a distinct spot frame:

F-5, F-100, N75, N80, etc.

Standard Pentax Cameras with a distinct spot frame:

ZX-5n (extremely simple to operate), PZ-1P, 645N (medium format), etc.

Standard Minolta Cameras with a distinct spot frame:

Maxxum 5, Maxxum 7, Maxxum 9, Maxxum STsi, etc.

Standard Canon Cameras with a distinct spot frame:

Eos 1n, Eos 3, T90, A2/E (borderline spot), etc.

Standard Olympus Cameras with a distinct spot frame:

OM-2000, OM-2 Spot, OM-3, OM-4, IS-3 DLX, etc.

Spotmetering

Spotmeters usually come with many medium-to- high-priced cameras and are the most versatile and accurate exposure tool ever invented. The most important feature of a spotmeter is its spot frame. The spot frame usually occupies about *3% or less (the smaller the better)* of the viewfinder area and has a distinct (usually circular) border. Greatest (most accurate) spotmetering cameras ever manufactured include: Nikon N70, N90, N6006, N8008s, F4 and Pentax 645N (Medium Format).

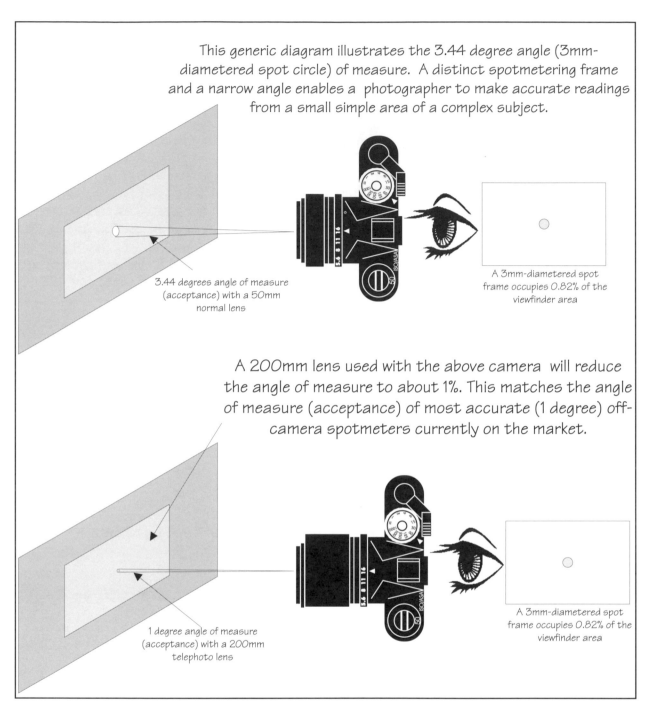

This generic diagram illustrates the 3.44 degree angle (3mm-diametered spot circle) of measure. A distinct spotmetering frame and a narrow angle enables a photographer to make accurate readings from a small simple area of a complex subject.

3.44 degrees angle of measure (acceptance) with a 50mm normal lens

A 3mm-diametered spot frame occupies 0.82% of the viewfinder area

A 200mm lens used with the above camera will reduce the angle of measure to about 1%. This matches the angle of measure (acceptance) of most accurate (1 degree) off-camera spotmeters currently on the market.

1 degree angle of measure (acceptance) with a 200mm telephoto lens

A 3mm-diametered spot frame occupies 0.82% of the viewfinder area

Diagram D-4

Spotmetering

This diagram illustrates spotmetering angles for the same camera using two different lenses. A distinct spot frame is a must for those who take their spotmetering seriously. Please note that these diagrams are generic and are for illustration purposes only.

D.4 Spotmetering: Which Spotmetering camera is right for me?

The following table provides you with some helpful hints when you are shopping for a camera. Since the ability to measure light is the most important foundation of any photograph, therefore you must give the highest priority to what helps you to come up with a correct exposure.

Before you decide what camera to buy, make sure that you walk into your friendly camera store and spend quality time with the camera. Turn it on. Change the mode to Manual. Change the shutter speed and aperture opening. Make sure the spotmetering function can be easily turned on. It is essential that you are comfortable with the camera's operation. Some cameras have all the features, but are hard to operate and with some cameras you simply run out of fingers to push buttons with. Fortunately there are many great choices around with different manufacturers. If you are in doubt and do not have an answer to your question, call or e-mail the manufacturer. They usually get back with you quickly with the answer. If you already have invested in your camera equipment and the current camera does not have the features that you are looking for, simply call the manufacturer and ask them for their recommendations. They can tell you which of their models with spotmetering feature fits your current lenses. You can also go to the camera shop that you bought the camera from and exchange the body with another that serves your spotmetering needs. This is what most of my students do.

Questions that you need to ask yourself	Your answer
Does the camera have a Spotmetering feature?	
Does it have a _distinct_ spot frame in the center of the viewfinder? (A must for accurate spotmetering!)	
Does the spot frame occupy 3% or less of the viewfinder area?	
Can the spotmetering feature be activated quickly and easily?	
Does it fit my budget?	
Can the shutter speed be changed easily?	
Can the aperture opening be changed easily?	
Is the exposure scale in the viewfinder easy to read?	
Am I comfortable with the camera (look, weight, feel, etc.).	

If you answered **_no_** to **_any_** of these questions, look for another camera. Please also note that if a camera does not have a spot frame, it does not make it a bad camera. All it means is that it does not have an accurate spotmetering feature.

Hard-to-find information about your camera's Spotmeter (where the spot frame occupies 3% or less of the Viewfinder area) and Partial Meter (where the spot frame occupies 7% to 13% of the Viewfinder area).				
Camera's make and model	A distinct spot circle / frame in the viewfinder with the standard viewfinder screen (A **MUST** have for accurate metering)	Diameter of the spotmetering / partial metering circle (frame) in mm	Percent area of the viewfinder occupied by the spot circle (spot frame)	Angle of measure (acceptance) in degrees (°) with a 50 mm lens
Nikon N90 / N90s (N-90)	YES	3.00 mm	0.82 %	3.44°
Nikon N70 /F70 (N-70/F-70)	YES	3.00 mm	0.82 %	3.44°
Pentax 645N (Medium format)	YES	6.00 mm	1.00 %	N/A
Nikon N6006	YES	3.50 mm	1.11 %	4.00°
Nikon 8008s	YES	3.50 mm	1.11 %	4.00°
Nikon N80	NO	4.00 mm	1.50 %	4.60°
Nikon D1 Digital	NO	4.00 mm	1.50 %	4.60°
Nikon F100 (F-100)	NO	4.00 mm	1.50 %	4.60°
Nikon F5	NO	4.00 mm	1.50 %	4.60°
Olympus OM-4TI (OM4TI)	YES	4.70 mm	2.00 %	5.40°
Olympus OM-3TI (OM3TI)	YES	4.70 mm	2.00 %	5.40°
Olympus IS-3 DLX	YES	4.70 mm	2.00 %	5.40°
Olympus OM2000	YES	4.70 mm	2.00 %	5.40°
Pentax ZX-5N	YES	5.00 mm	2.30 %	5.80°
Canon EOS 1n	YES	5.00 mm	2.30 %	5.80°
Nikon F4s	YES	5.00 mm	2.30 %	5.80°
Canon EOS 3	YES	5.10 mm	2.40 %	5.90°
Pentax PZ1p	YES	5.24 mm	2.50 %	6.00°
Canon T-90 (T90)	YES	5.45 mm	2.70 %	6.24°
Minolta Maxxum 800si	YES	5.50 mm	2.80 %	6.30°
Minolta Maxxum 700si	YES	5.50 mm	2.80 %	6.30°
Minolta Maxxum STsi	YES	5.50 mm	2.80 %	6.30°
Minolta Maxxum 7	YES	5.50 mm	2.80 %	6.30°
Minolta Maxxum 500si	YES	5.50 mm	2.80 %	6.30°
Canon EOS A2/A2E	YES	6.21 mm	3.50 %	7.11°
Canon EOS 650 (Partial)	YES	8.50 mm	6.50 %	9.67°
Canon EOS Elan II E* (Partial)	NO	10.2 mm	9.50 %	11.68°
Canon EOS Elan 7E * (Partial)	NO	10.2 mm	9.50 %	11.68°
Canon EOS Rebel * (Partial)	NO	10.2 mm	9.50 %	11.68°
Nikon N50 (Partial)	YES	12.0 mm	13.1 %	13.69°
Nikon N65 (75/25 Partial)	YES	12.0 mm	13.1 %	13.69°

* These cameras do not have a circular spot frame. Numbers are approximated.
Approximate information sorted in the order of low (most accurate/SPOT) to high (less accurate/PARTIAL). If you find a mistake in this table, please e-mail it to me at: corrections@spotmetering.com. I will be thankful.

References:

1) The Confused Photographer's Guide to photographic Exposure and the Simplified Zone System, 2003

2) Operating Manuals for different Nikon™ cameras, Pentax™ cameras, Canon™ cameras, Minolta™, and Sony™ cameras.

Elementary Readings and reference:

How to use a spotmeter — Glen Fishback, Article in Petersen's Photographic, January 1973.

Glen Fishback Exposure System — The Glen Fishback School of Photography Inc. 1978.

Photography — Phil Davis, Wm. C. Brown Publishers.

The Encyclopedia of Advanced Photography — Michael Freeman, Chartwell Books, 1985.

Light and Film, Time-Life Books — Library of Photography, 1970.

Intermediate and advanced reading and reference:

Beyond The Zone System — Phil Davis, Focal Press, Butterworth Publishers, 1988.

The New Zone System Manual — White, Zakia, Lorenz, Morgan & Morgan, 1989.

Index